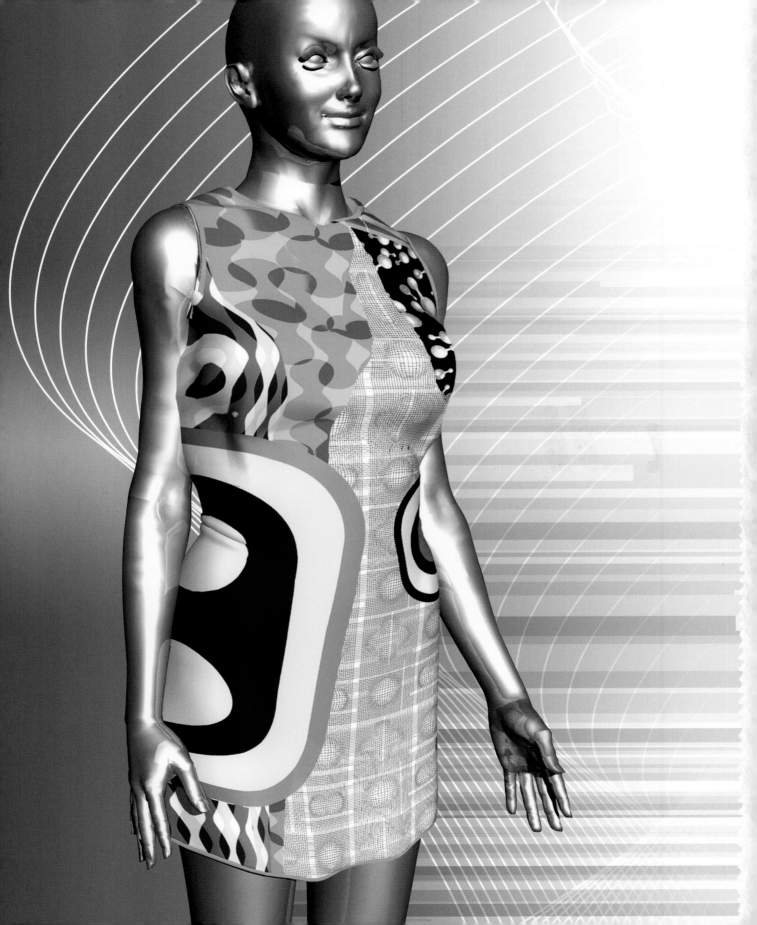

karim rashid

digipop

TASCHEN

KÖLN LONDON LOS ANGELES MADRID PARIS TOKYO

contents

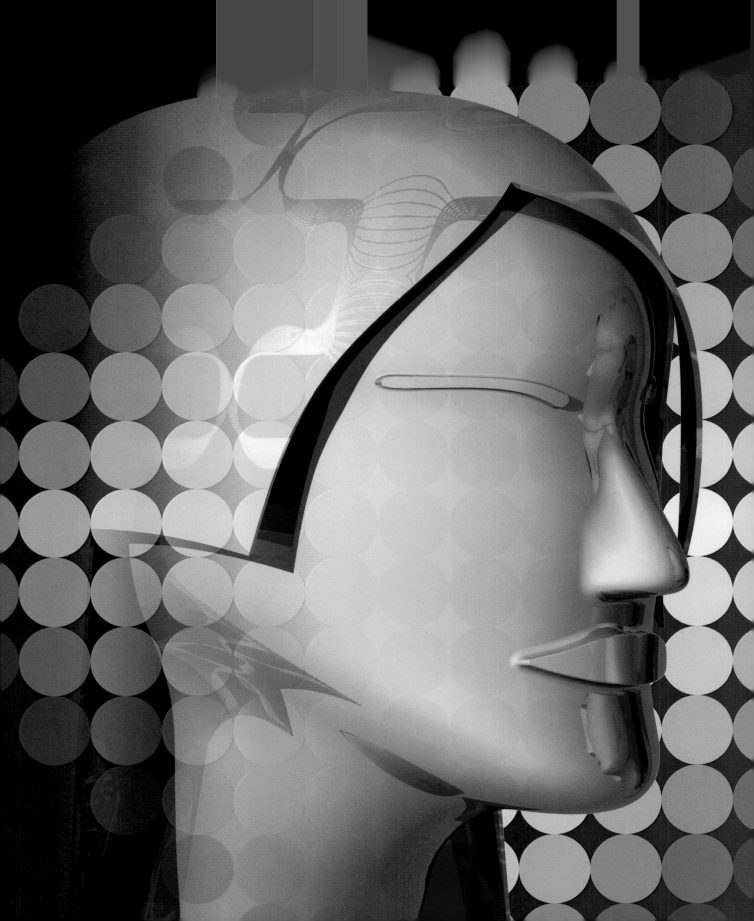

digipop

Karim Rashid

I never agreed completely with Adolf Loos' proclamation in the early part of the 20th century that 'Ornamentation is Crime'. Ornamentation is sometimes very necessary. Ornamentation is a *modus operandi* for communication, for providing dimension, texture, pattern, depth, and spirit. It is a way to liven up space, to create complementary conditions, to move the eye and break up surfaces, to bring illusion or entropy, to embellish and give richness to surfaces and materials and objects. Today it can add emotion and meaning to the flat, dull world that modernism has shaped. Why live in a white box, with a plain black couch, a gray shirt, a black box stereo, a gray computer housing, a flat, concrete facade, a textureless landscape, a monotonous highway, etc.? The problem is that ornamentation, with all its good intents, mostly tends to be irrelevant, garish, pattern for the sake of pattern, or pattern to avoid and distract us rather than communicate and touch us emotionally, physiologically, and intellectually.

I believe that the aim of design is to shape a contemporary world—DESIGN is not style. Style is a term that categorizes past movements or trends into periods that we can understand and reference and learn about, but design—at least in the first order—deals with issues of the moment, solves and works within the criteria and constraints of the subject and of the issues at hand. Through Designing with all the relevant issues— social, economic, aesthetic, technological, behavioral, cultural—it becomes documented eventually as a style once it is not relevant to our contemporary milieu or contemporary context. Ornament and decoration can be design when they are deliberate, relevant, designed with the first order in mind, and say something about the day and age in which we live. Patterns, graphic symbols, signs, textures designed today should all be commentaries and messages that bring relevance and meaning to the 21st century. Plaid was designed centuries ago and is completely irrelevant today, although it was used extensively in the last few years by a major fashion brand. But plaid was derived from a certain loom 400 years ago and was 'designed' at that time, taking the issues and conditions of that era into consideration. I believe that we have great opportunities to create contemporary decoration that is part of our digital and information age, part of our shrinking, borderless world, and part of our new movements of individualism, casualism, and spiritualism. I have tried to elucidate these thoughts (not all of them successfully, mind you) here in this book, which I refer to as Digipop—the new DATAration of Decoration.

This volume is an edited version of hundreds of 2-D graphic imagery proposals produced over the last ten years (some realized and some not) for objects, art shows, gallery and museum installations, and architectural products that were meant to suggest, inspire, consider, criticize, document, represent, symbolize and energize the worlds of the decorative, from objects to fashion, textiles, and space.

I have divided my patterns, graphics, and paintings into a number of sections, that are studies of the figurative (SYMBOLIK), iconic (IKONS), graphic (GRAPHIKS), illusory phenomena (OPTIKAL), and information aesthetics (INFOSTETHIKS). I call this nexus in which we now live the Digipop movement—a new graphic world that has its roots in the computer age and is driven and inspired by digital technology and infotainment. The premise is to use new tools to create complex 2-D graphic work that is perceived as 3-D and/or as having a strong relevance to our modus and touches a newfound aesthetic sensibility of the technopop age.

SYMBOLIK is a collection of works based on the continual use of digital figures in my design work to create a sense of scale and to focus on the anthropometrics and ergonomics of furniture and objects. These figures turned into robots, which led me to develop body parts for a show of large-format, digitally printed canvases for the Elga Wimmer Gallery in Chelsea, NY, in 2002. The body paintings are proposals for future synthetic body parts, the idea being that we can fire up images on our skin to personalize and graffiti our mass-produced 'injection-molded' beings. I have even taken certain views of products that I designed and turned them into visual compositions based on repetition. The next section is called IKONS, and is the accumulation of 20 years of developing a language based on 54 symbols—each with a meaning, and each symbol varied to create a language of self-invented logos representing key words of this world, from "Access" to "Zen". GRAPHIKS is a section of small graphic concepts, ideas that ended up on carpets, bathrobes, T-shirts, and other 2-D objects that I enjoy designing. The graphic work is always based on trying to communicate 'now' and on my desire and obsession to capture the energetic spirit of this visual age. OPTIKAL is an evolution of the Op-Art period of the 1960s and 1970s—a personal love affair with the mathematics of art. But I have developed and focused on digital proposals that could never have been produced strictly by handicraft and are directly inspired by digital tools and the investigation of 21st-century, post-hypnotic concepts. Intentionally last is INFOSTETHIKS, where I try to capture a new form of decoration that is symbolic of this information age. Historically, decoration communicates the time in which it is created and speaks of religious, cultural, or spiritual meaning. Today the new spiritualism is the digital age, our global tool of communication. If I could only just put on a pair of eyeglasses that could capture information in space and all the data that is perpetually streaming around us…

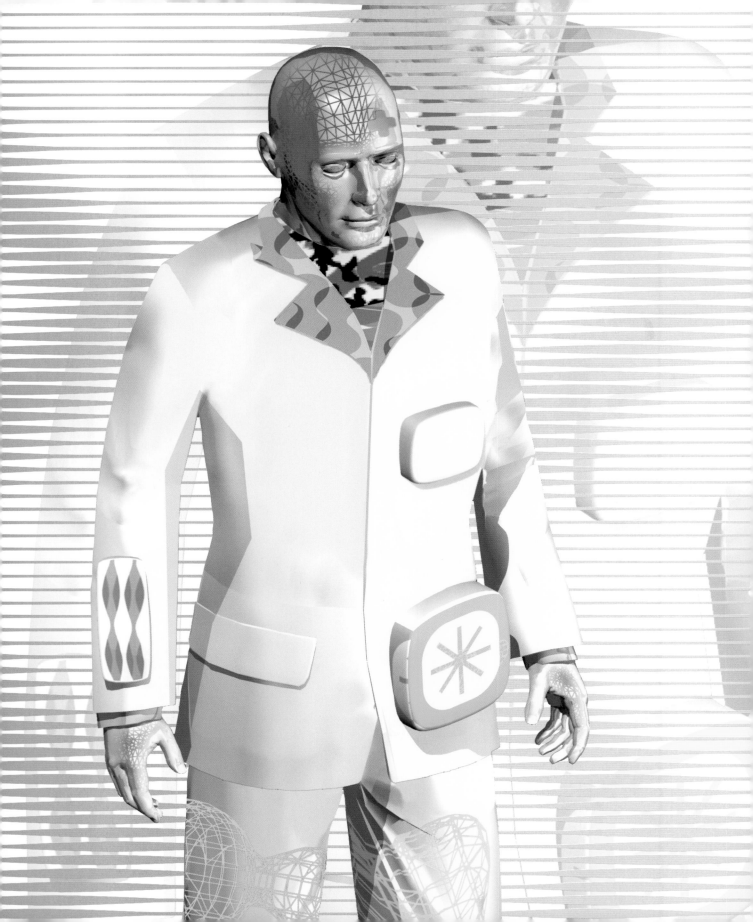

digipop

Karim Rashid

Ich war nie ganz einverstanden mit Adolf Loos, der im frühen 20. Jahrhundert das Ornament zum Verbrechen erklärte. Ornamentierung ist manchmal sehr nötig. Ornamentierung ist ein *Modus Operandi* für Kommunikation, mit dem man einer Sache Dimension, Struktur, Muster, räumliche Tiefe und Leben verleihen kann – sie belebt Räume, schafft komplementäre Bedingungen, führt das Auge, bricht Oberflächen auf, bringt Illusion oder Entropie hervor, verschönert und bereichert Oberflächen, Materialien und Objekte. Heute kann sie Emotionalität und Sinn in die flache, eintönige Welt bringen, die der Modernismus geformt hat. Warum denn in einer weißen Schachtel leben, mit einem schmucklosen schwarzen Sofa, schwarzer, kastenförmiger Stereoanlage, ausdrucksloser Betonfassade, monotonem Highway usw.? Das Problem besteht darin, dass Ornamentierung bei aller guten Absicht oft irrelevant, aufdringlich oder Muster um des Musters willen ist, ein Muster, das uns eher annullieren und ablenken soll als zu kommunizieren und uns emotional, physiologisch oder intellektuell zu berühren.

Ich glaube, dass die Aufgabe des Designs darin besteht, eine zeitgemäße Welt zu erschaffen – DESIGN ist nicht gleichbedeutend mit Stil. Stil ist eine Bezeichnung, mit der man vergangene Bewegungen oder Trends zu Perioden zusammenfasst, die wir verstehen, auf die wir uns beziehen oder von denen wir lernen können, aber Design bedeutet in erster Linie, sich mit den Problemen des Augenblicks auseinander zu setzen und an der Lösung innerhalb der vorgegebenen Bedingungen des bewussten Objekts zu arbeiten. Wenn man beim Design alle relevanten Probleme berücksichtigt – soziale, ökonomische, ästhetische, technologische, verhaltensbedingte, kulturelle –, wird Design letztendlich dann als Stil dokumentierbar, wenn es für unser zeitgenössisches Milieu oder unseren zeitgenössischen Kontext seine Relevanz verloren hat. Ornament und Dekoration können dann Design sein, wenn sie durchdacht sind, relevant sind, wenn sie diesem obersten Prinzip folgen und etwas über unser Heute, unsere Ära aussagen. Alle heute designten Muster, grafischen Symbole, Zeichen, Strukturen sollten Kommentare und Botschaften sein, die für unser 21. Jahrhundert Relevanz und Bedeutung haben. Das Schottenkaro wurde vor Jahrhunderten erfunden und ist heute absolut irrelevant, dennoch wurde es von einer großen Modemarke in den letzten Jahren exzessiv verarbeitet. Das Schottenkaro hat jedoch seinen Ursprung in einer ganz bestimmten, 400 Jahre alten Webart und wurde im Hinblick auf die Anforderungen und Bedingungen der damaligen Zeit „designt". Ich bin davon überzeugt, dass wir hervorragende Chancen haben, zeitgemäße Dekors zu schaffen, die in unser digitales Informationszeitalter gehören, in

unsere zusammenwachsende, grenzenlose Welt und in unsere neue Bewegung des Individualismus, Kasualismus und Spiritualismus passen. Diese Gedanken habe ich (nicht immer erfolgreich, wohlgemerkt) in diesem Buch zusammenzutragen versucht, das ich *Digipop* nenne – die neue DATAration der Dekoration.

Ich habe in diesem Buch Hunderte von 2-D-Grafik-Entwürfen für (realisierte und nicht realisierte) Objekte, Kunstausstellungen, Installationen in Galerien oder Museen und architektonische Produkte thematisch zusammengefasst, die ich in den letzten zehn Jahren in dem Gedanken angefertigt habe, um die Welt des Dekorativen zu beeinflussen, zu inspirieren, zu dokumentieren, zu symbolisieren und mit neuen Impulsen zu versorgen.

Ich habe meine Muster, Grafiken und Malereien in verschiedene Sektionen geordnet, die sich mit dem Figurativen (SYMBOLIK), mit ikonischen (IKONS), grafischen (GRAPHIKS), illusorischen Phänomenen (OPTIKAL) und mit der Informationsästhetik (INFOSTHETIKS) befassen. Ich nenne diesen Nexus, in dem wir heute leben, das Digipop Movement – eine neue grafische Welt, die ihren Ursprung im Computerzeitalter hat und von digitaler Technologie und Infotainment vorangetrieben und inspiriert wird. Die Vorgabe ist dabei, neue Tools einzusetzen, um komplexe 2-D-Grafikarbeiten zu erstellen, die als 3-D wahrgenommen werden und/oder eine neu gewonnene Ästhetikauffassung der Technopop-Ära berühren.

SYMBOLIK ist eine Zusammenstellung von Arbeiten, die mit den digitalen Figuren zu tun haben, die ich in meiner Designarbeit kontinuierlich einzubringen versuche, um einen Eindruck vom Maßstab zu vermitteln und an der Anthropometrie und Ergonomie von Möbeln und Objekten mitzuarbeiten. Aus diesen Figuren wurden dann Roboter, die mich auf die Idee brachten, für eine Ausstellung mit großformatigen, digital bedruckten Leinwänden bei der Galerie Elga Wimmer in Chelsea, NY, im Jahr 2002 Körperteile zu entwickeln. Die Bodypaintings sind Vorlagen für zukünftige synthetische Körperteile, die so konzipiert sind, dass wir Bildsymbole auf unserer Haut aktivieren können, um unsere massenproduzierten Spritzguss-Existenzen individuell anzupassen und zu graffitisieren. Ich habe aus ein paar selbst designten Produkten visuelle Kompositionen gemacht, die auf Wiederholungsmustern basieren. Das nächste Kapitel heißt IKONS und umfasst das Ergebnis von 20 Jahren Entwicklungsarbeit an einer Sprache, die auf 54 Symbolen beruht – jedes mit einer Bedeutung, jedes Symbol so variiert, dass eine Sprache selbst erfundener Logos entsteht, die für die Schlüsselwörter dieser Welt, von „Access" bis „Zen", stehen. Der Abschnitt GRAPHIKS ist kleinen grafischen Konzepten vorbehalten, Ideen, die auf Teppichen, Bademänteln, T-Shirts und anderen 2-D-Objekten endeten, wie ich sie gerne gestalte. Meine grafischen Arbeiten sind immer davon bestimmt, dieses „Jetzt" zu vermitteln, von meinem besessenen Wunsch, den Spirit und die Energie unserer visuellen Ära einzufangen. OPTIKAL ist eine Weiterentwicklung der Op-Art-Periode in den 1960er und 1970er Jahren – eine persönliche Liebesaffäre mit dem Mathematischen in der Kunst. Ich habe mich jedoch auf digitale Spielereien und Entwürfe konzentriert, die unmittelbar von den digitalen Tools und der Erforschung der neuen posthypnotischen Konzepte des 21. Jahrhunderts inspiriert sind. Bewusst an letzter Stelle steht INFOSTHETIKS, und dort versuche ich mich einer neuen Form von Dekor anzunähern, die symbolisch und metaphorisch für unser Informationszeitalter steht. Dekor sagt etwas aus über den historischen Zusammenhang, in dem es entstanden ist, und verrät etwas über religiöse, kulturelle oder spirituelle Bedeutung. Der neue Spiritualismus ist heute das digitale Zeitalter, unser globales Kommunikations-Tool. Könnte ich doch nur einfach eine Brille aufsetzen, die in der Lage wäre, alle Informationen im Raum und die nie versiegenden Datenströme um uns herum einzufangen...

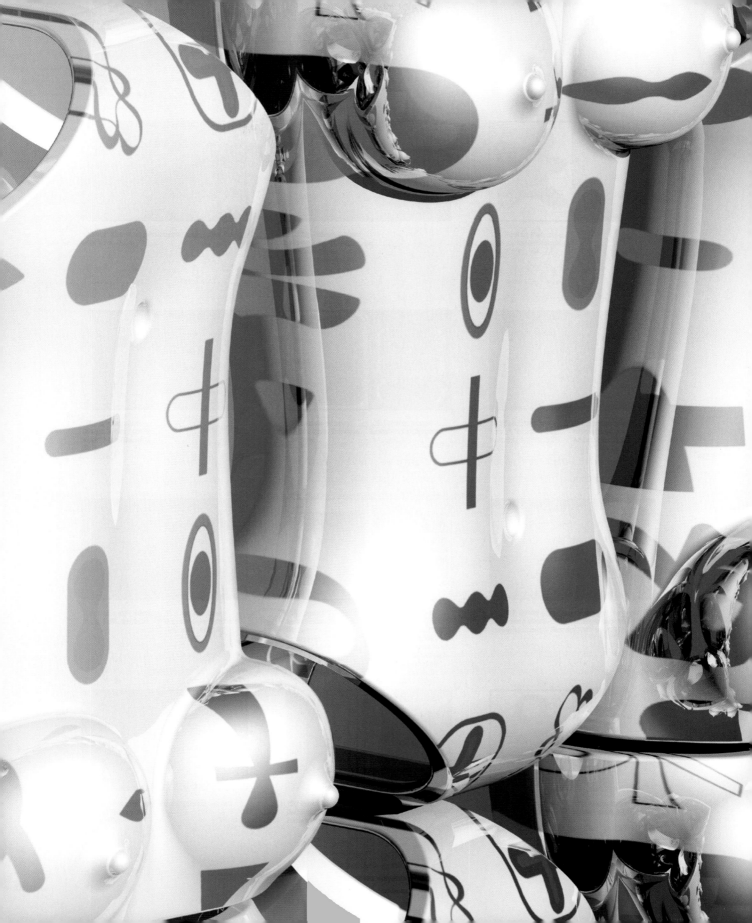

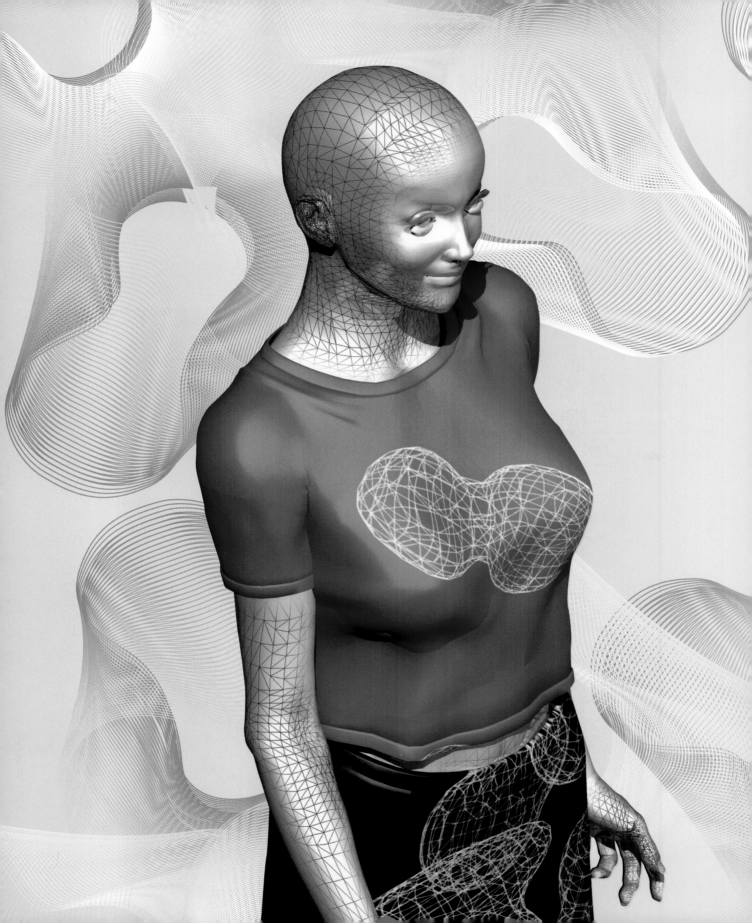

digipop

Karim Rashid

Je n'ai jamais été totalement d'accord avec la déclaration d'Adolf Loos, dans les premières années du XXème siècle et selon laquelle « l'ornement est un crime ». L'ornement est parfois fort nécessaire. Il s'agit souvent d'un *modus operandi* qui permet de fournir dimension, texture, modèle, profondeur, et surtout esprit. C'est une façon d'animer l'espace, de créer des conditions idéales, de déplacer l'œil, de briser les plans, de créer illusion ou entropie, d'embellir et d'enrichir surfaces, matériaux et objets. Aujourd'hui, l'ornement peut ajouter émotion et signification au monde plat et monotone que le modernisme a engendré. Pourquoi vivre dans une boîte blanche, avec un vulgaire sofa noir, une chemise grise, une stéréo de caisses noires, un ordinateur coffré de gris, une façade plate en béton, un environnement sans texture, une autoroute rectiligne, etc... Le problème, c'est que l'ornement, malgré toutes ses bonnes intentions, tend la plupart du temps à être sans rapport avec le sujet, voyant, avec un modèle prévisible, ou conçu pour nous distraire, au lieu de chercher à communiquer, à nous toucher émotionnellement, physiologiquement et intellectuellement.

Je crois que l'objet du design consiste à donner forme à notre monde contemporain : DESIGN ne signifie pas style. Le terme style désigne des mouvements ou des tendances passées, menant à des périodes que nous pouvons comprendre, situer et classer. Alors que le design, du moins dans un premier temps, s'intéresse aux questions du moment, résout et travaille selon des critères, des contraintes et des questions qui le concernent. Car le design, par son respect des questions tant sociales, économiques, esthétiques, technologiques, que comportementales et culturelles, s'enrichit, jusqu'à se transformer en style, dès qu'il prend ses distances avec son milieu ou contexte. Ornementation et décoration deviennent design à partir du moment où celui-ci reflète cette notion première et témoigne de l'époque dans laquelle nous vivons. Les modèles, symboles graphiques, signes et textures, conçus aujourd'hui, devraient s'inscrire comme les commentaires et messages envoyés au XXIème siècle. Conçu il y a des siècles, l'écossais a perdu aujourd'hui toute signification. Il n'empêche qu'il a été largement utilisé, ces dernières années, par une grande marque de mode. Mais l'écossais a été produit par un certain tissage, il y a 400 ans et « le motif » a été conçu en regard des questions et conditions de l'époque. Je pense que nombreuses sont les occasions de créer une « décoration contemporaine » qui témoigne de notre âge numérique et informatique, d'une planète rétrécie,

désormais sans frontières, et de notre nouvel individualisme, de notre détachement et de notre spiritualisme. Dans cet ouvrage que je qualifierai de Digipop – nouvelles Données de décoration –, je me suis efforcé d'illustrer ces pensées (autant que possible, bien sûr).

Ce livre est une version condensée de centaines de propositions graphiques en 2-d élaborées au cours des dix dernières années (certaines réalisées, d'autres pas) pour des objets, expositions, installations pour galeries, musées et produits architecturaux visant à suggérer, inspirer, considérer, critiquer, documenter, représenter, symboliser et stimuler le monde du décoratif, tant pour des objets que pour la mode, le textile, ou l'espace.

J'ai réparti mes motifs, graphiques et peintures selon différents chapitres qui traitent du figuratif (SYMBO-LIK), des icônes (IKONIK), du graphisme (GRAPHIK), des phénomènes optiques (OPTIKAL), et de l'esthé-tique informative (INFOSTETHIK). J'appelle ce réseau dans lequel nous évoluons aujourd'hui, le mouvement de « Digipop » – nouveau monde graphique qui tire ses racines de l'ère des ordinateurs, qui est conduit et inspiré par la technologie numérique et l'« infotainment »/info-spectacle. Il s'agit d'utiliser de nouveaux outils pour créer une œuvre graphique complexe en 2-d, perçue comme une œuvre en 3-d et/ou qui a un rapport étroit avec notre modus, touchant une sensibilité esthétique nouvelle de notre ère « techno-pop ».

SYMBOLIK présente un ensemble d'œuvres basées sur mon utilisation continue du numérique pour créer un sens de l'échelle et travailler sur l'anthropométrique et l'ergonomie des meubles et objets. Ces figures se sont transformées en robots qui m'ont conduit à montrer des parties du corps, dans une exposition de toiles grand format, imprimées numériquement, à la galerie d'Elga Wimmer à Chelsea, NY, en 2002. Ces peintures corporelles sont des propositions pour de futures parties du corps synthétiques, s'articulant autour du concept selon lequel nous pouvons étaler des images sur notre peau, pour personnaliser et couvrir de graffitis ces êtres que nous représentons, produits en série, « moulés par injection ». J'ai même pris certaines vues de produits que j'avais conçus, pour les transformer en compositions visuelles, basées sur la répétition. La section suivante se nomme IKON – et répertorie vingt ans de travail à développer une langue basée sur 54 symboles – chacun doté d'une signification, chacun personnalisé – pour créer une langue de logos auto-inventés, représentant les mots clés de ce monde, du A de « Accès » au Z de « Zen ». GRA-PHIKS représente de petits concepts simples, des idées qui ont fini dans des tapis, peignoirs, T-shirts, et autres objets en 2-d que j'ai eu plaisir à concevoir. Le travail graphique est toujours basé sur la tentative de communiquer « maintenant », ainsi que sur mon désir et mon obsession de capter l'énergie de notre âge visuel. OPTIKAL montre l'évolution de la période Op art, des années 60–70, une histoire d'amour personnel-le avec les mathématiques de l'art. Mais j'ai aussi étudié et me suis concentré sur les jeux numériques et les propositions qui n'auraient jamais pu être élaborés à la période strictement manuelle. Il s'agit surtout de l'emploi d'outils numériques et de recherche sur les nouveaux concepts post-hypnotiques du XXIème siècle. Intentionnellement, INFOSTETHIKS occupe la dernière place, car j'essaye d'y rendre une nouvelle forme de décoration, qui soit symbolique et métaphorique, de cet âge de l'information. Historiquement, la décoration nous renseigne sur l'époque où elle est créée, et nous entretient de sujets religieux, culturels ou spirituels. Aujourd'hui, le nouveau spiritualisme, c'est celui de l'âge numérique, notre outil de communication interna-tional. Ah, si seulement je pouvais chausser une paire de lunettes capables de saisir l'information dans l'espace, ainsi que toutes les données qui, perpétuellement, tourbillonnent autour de nous...

Digipop or the Work of Art in the Age of Digital Reproduction

Albrecht Bangert and Conway Lloyd Morgan

'Big Brother is watching you' is a phrase from George Orwell's dystopian novel *1984*, published in 1949, which describes a future society in which every action by the citizenry was surveyed by the state, and even the language was being reconstructed as 'Newspeak' to avoid any dissent from the official view.

Fifty years on, and Big Brother is a television game about social survival, in which viewers become voting voyeurs and nonentity participants become celebrities. But at the same time, the digital technologies of surveillance, through CCTV, miniature digital cameras, phone-tapping, and computer hacking, have made Orwell's grim vision not only possible but real, exercised under the coy name of Homeland Security. Big Brother has us all on the digital database.

The digital not only infiltrates and strengthens the centers of power, but also quite fundamentally defines human productivity in the 2nd Industrial Revolution.

As in the realm of power politics, it at the same time changes the basis of industrial productivity and thus also the essence of products. Back in the 1930s, German philosopher Walter Benjamin predicted that the arts would be radically changed by the introduction of mechanical reproduction. And like Orwell's visions and analyses, Benjamin's expectations of what was to come have been far exceeded by digital technology today. The essence of the artwork in the age of digital reproduction has been utterly changed by the sheer infinite technical possibilities of morphing, combining, multiplying, communicating, and manipulating. This is the point at which Rashid's digital avant-garde arises.

Karim Rashid's work hovers between reality and cyberspace. Which is what makes it so enticing. Enjoying it can become addictive.

Today, the interface between virtual cyberspace and the analog real world is ubiquitous and so defines trends in art, architecture, and design as well as other media.

From the word go, Karim Rashid has been one of the most provocative advocates of challenging the borderlines between the digital and analog worlds in product, interior, and graphic design.

Eros in Rashid's work, its vibrant inconstancy, or, to put it differently, its modern aura, is engendered by its two sides: its ambivalence, its ambiguity. It was no coincidence that he recently developed a vase that, seen from the side, seems to have a double face looking in all directions. Be it the volume of a simple silhouette rotated in 3-D—or the current artwork created by a traditional Portuguese manufacturer of crystal glass—it always remains an ambivalent hybrid, generated by Karim with consummate ease. Hardly surprisingly, Rashid called the beautiful piece in glass EGO.

Rashid not only creates designs, he produces loud manifesto-like statements. "I want to change the world" was one of the first slogans he chose to encapsulate his work at the close of the last millennium. "Digipop" is his new fast word—and it has a keener, more emphatic socio-cultural meaning and a great range and potential effect.

Digi stands for the second major revolution following its mechanical/industrial predecessor, the digital one. And Pop has evolved from its initially consumer-critical anti-stance of the 1950s and 1960s to become a global consumer-oriented phenomenon. "I consume therefore I am."

However apolitical the second element, namely Pop, may seem, Digi has a pronounced cutting edge, the

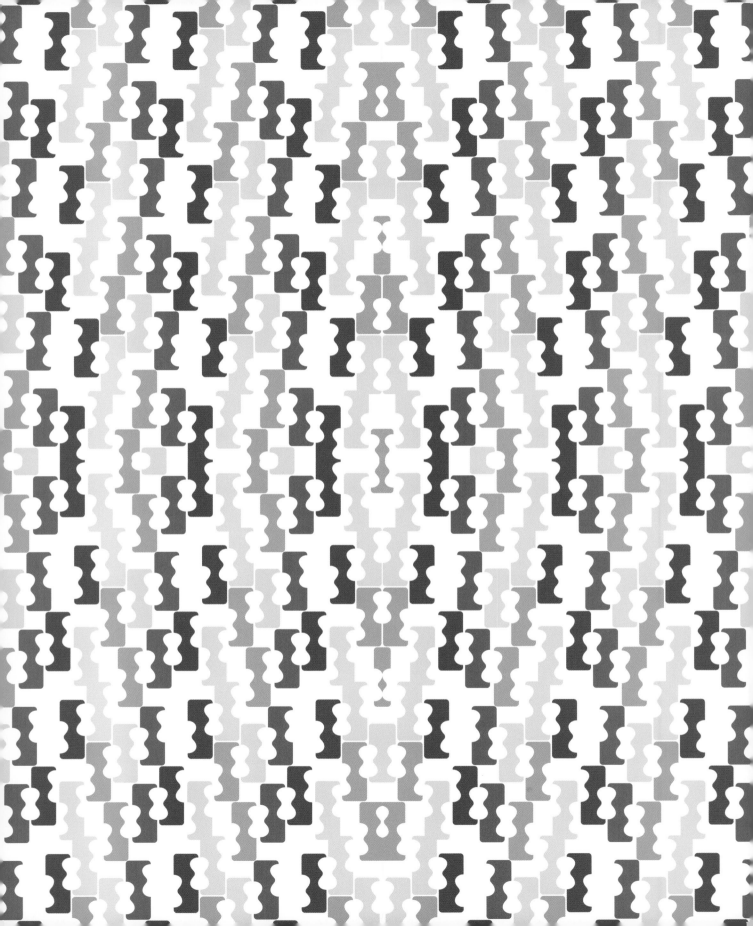

ability to change society, and the ambiguity of digital technology will impact on politics and culture, affecting even those who master it.

The digital revolution has dismantled many hierarchies. Traditionally, popular art was seen to be broad based, so that it sat at the bottom of any cultural pyramid of power, flattened—and in some eyes discredited—by the weight of 'grander' arts above it. That pyramid is in meltdown, partly because of the change in hierarchies, but also because modern popular art, digital art, has a ubiquity that is a wholly new phenomenon. Thanks to digital communications, everything can be everywhere at once. What is new today in Tokyo is new today in Berlin, in London, in New York. There are no primacies of place any more. Distribution time is now download speed.

Ubiquity in place and time is only part of the story. Ubiquity of format is the other key to the digital revolution. Before, content was embedded in form—the pattern was in the carpet, the brushstrokes on the canvas, the light fixed in the silver salts. But a digital image can have many outcomes—as print, as fabric, as transparency, as lightshow—while an analog image has to be re-created for each platform. Digital content translates into any medium, bringing surface, light, and sound together and bridging the gap between two and three dimensions. This in turn subverts the traditional order of design culture.

Take the moves, actions, and sounds of a music video: they have no formal content beyond emotion, no narrative except pattern; they are noise without external information. They are both bewildering and innocent at the same time, dramas without endings, yet not unresolved. Digipop has the same immediacy, poses the same challenge of a language that everyone speaks, but which has different meanings for each person. Take the inventive motifs that populate Karim Rashid's work, or the morphed patterns that cover some of his objects. These are neither decorations nor meaningless symbols. Nor are they just abstract art, gestures by the maker made to satisfy his demons. Rather they are a kind of language without explicit meanings, a dialogue between designer and user and between user and user, in which the interpretation is a series of individual sets of meanings, not a collective one. A non-linear language, not prescriptive, but opportunistic and so ongoing. And quite unlike the coded and introvert symbolisms of graffiti and similar gang-slang, designed to exclude the uninitiated.

What these digipop images invite us to question is the other world of symbols we are forced to inhabit, the space around us delineated by corporate symbols and logos. The logo affirms the mercantile ethic, and the power of that ethic is shown by the way even organizations such as charities and NGOs now seek to mark out their territory with their own logos. Karim Rashid's work subverts the capitalist use of space, and uses the technology of capitalism to do so. It is a mature, engaging, and provocative exercise, with a serious purpose and enjoyable outcome.

Digipop is the first real avant-garde of the digital age. Digipop is a radical alternative to the visual manipulation intended by the logo, a confrontation with the single platforms of traditional design codes, and an empowerment of the user, not a circumscription. Take and enjoy it, be liberated by it. Big Brother may be watching, but he can't see.

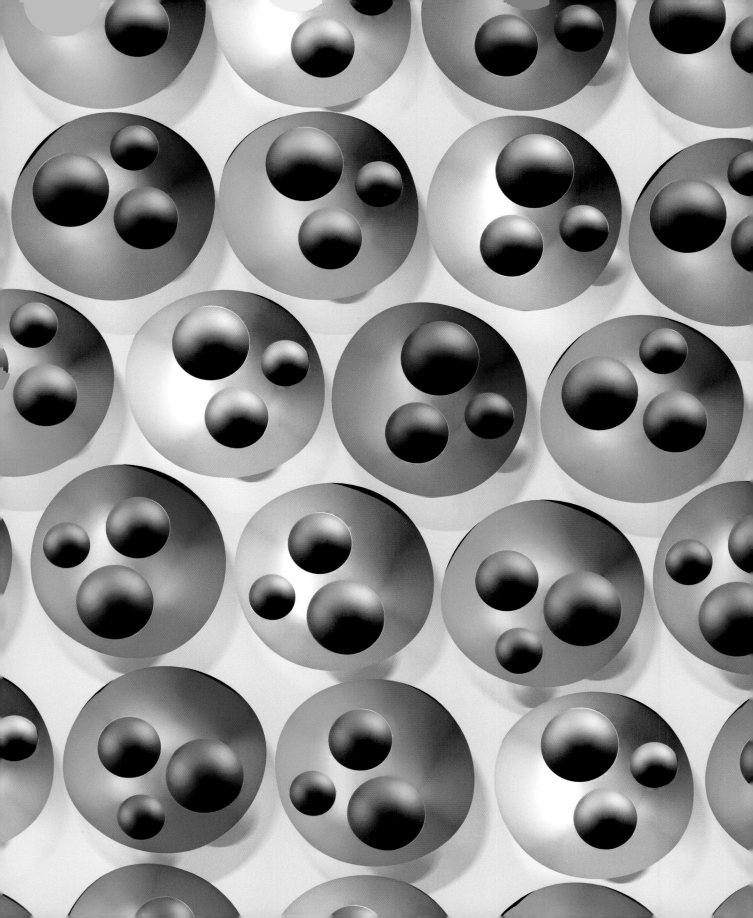

Digipop oder das Kunstwerk im Zeitalter seiner elektronischen Reproduzierbarkeit

Albrecht Bangert und Conway Lloyd Morgan

Der Satz *Big Brother is watching you* stammt aus George Orwells 1949 erschienenem Roman *1984*, einer pessimistischen Zukunftsvision von einer Gesellschaftsordnung, in der jede Bewegung der Bürger vom Staat überwacht wird und selbst die Sprache als *Newspeak* reglementiert ist. So sollten die geringsten Abweichun-gen von der offiziellen Staatsdoktrin unterbunden werden.

50 Jahre später ist Big Brother eine Fernsehshow. Es geht ums soziale Überleben. Die Zuschauer werden zu wahlberechtigten Voyeuren, die namenlosen Kandidaten zu Promis. Gleichzeitig machen digitale Überwachungstechnologien mittels winzigen Videokameras, Wanzen und Computer Hacking Orwells düstere Vision nicht nur allgegenwärtig, sondern unter dem unverfänglichen Etikett *Homeland Security* längst zur Regel. Big Brother hat uns alle in seiner digitalen Datenbank erfasst.

Die Digitalisierung durchdringt und stärkt nicht nur die Zentren der Macht. Sie definiert und bestimmt auf fundamentale Weise die menschliche Produktivität in der zweiten industriellen Revolution.

Wie den Bereich der Machtpolitik verändern die digitalen Möglichkeiten zugleich die Grundlagen der industriellen Produktion und damit auch das Wesen der Produkte. In den 30er Jahren sagte der deutsche Philosoph Walter Benjamin voraus, die Künste würden im Zeitalter ihrer technischen Reproduzierbarkeit eine radikale Veränderung erleben. Ebenso wie Orwells Visionen und Analysen sind Benjamins Zukunftsprognosen heute längst von der digitalen Wirklichkeit überholt worden. Das Wesen künstlerischer Arbeit hat sich im Zeitalter der digitalen Reproduzierbarkeit angesichts der schier endlosen technologischen Manipulationen wie Morphing, Sampling, Cloning, Multiplikation, Copy and Paste von

Grund auf verändert. Das ist der Punkt, an dem Rashids digitale Avantgarde ins Spiel kommt.

Karim Rashids Arbeit interagiert zwischen Realität und Cyberspace. Das macht sie so verführerisch. Ihr Genuss wird zur Sucht.

Die Schnittstelle zwischen virtuellem Cyberspace und analoger Realität ist heute omnipräsent und definiert die entscheidenden Trends in Kunst, Architektur und Design.

Karim Rashid gehört zu den Ersten, die provokativ und konsequent dafür eintraten, im Produkt-, Interior- und Grafikdesign die Trennlinien zwischen den digitalen und den analogen Welten aufzuheben.

Der Eros von Rashids Arbeiten, ihre pulsierende Unbeständigkeit und moderne Aura, ergibt sich aus ihren zwei Seiten, ihrer Mehrdeutigkeit, ihrer Zwiespältigkeit. Es war kein Zufall, dass er vor kurzem eine Vase entwickelte, die im Profil betrachtet wie ein Januskopf aussieht, der in alle Richtungen blickt. Die Form ist zunächst am Rechner aus einem Profil rotiert und dann von der traditionellen portugiesischen Kristallglasmanufaktur Marinha Grande zur Vase umgesetzt worden. Solche Hybriden generiert Karim Rashid mit spielerischer Leichtigkeit. Kaum überrascht der Name, den Rashid dieser genialischen Glasarbeit gegeben hat: EGO.

Rashid geht nicht einfach hin und designt Nützliches. Er produziert eher unüberhörbare, manifestartige Statements. „I want to change the world" war einer der ersten Slogans, mit denen er zum Ausgang des letzten Millenniums seine Arbeit auf den Punkt brachte. „Digipop" heißt sein neues flottes Credo – das eine noch sehr viel einschneidendere, nachdrücklichere soziokulturelle Bedeutung hat und viel in Bewegung setzen wird.

Digi steht für die zweite, entscheidende Revolution nach der vorangegangenen mechanisch-industriellen. Und *Pop* hat sich heute von seiner ursprünglich kon-

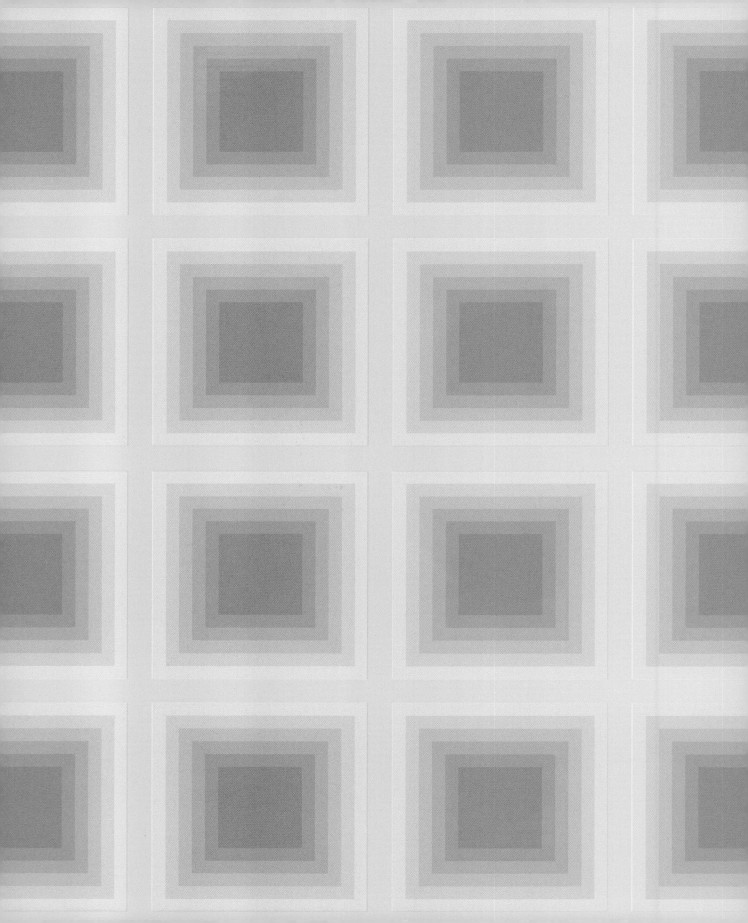

sumkritischen Antihaltung der 50er und 60er zu einem globalen konsumorientierten Fetischismus ausgeweitet. Ich konsumiere, also bin ich.

So apolitisch das zweite Element *Pop* auch erscheinen mag, *Digi* hat eine ausgesprochene Brisanz und das Potential, die Gesellschaft zu verändern; die Ambiguität digitaler Technologien wird sich in Zukunft noch obsessiver auf Politik und Kultur auswirken und alles beherrschen.

Die digitale Revolution hat alle Hierarchien eingerissen. Populäre Kunst galt traditionell als die mit der breitesten Basis, womit gemeint war, dass sie sich an unterster Stelle der kulturellen Einflusspyramide befand. Pop war breitgetreten – und in manchen Augen diskreditiert – vom Gewicht der über ihm stehenden „erhabeneren" Künste. Diese Pyramide beginnt nun zu bröckeln, einesteils durch den Umbruch der Hierarchien, aber auch, weil der modernen populären Kunst der Digital-Art eine Allgegenwärtigkeit und Gleichzeitigkeit zu eigen ist, die ein vollkommen neuartiges Phänomen darstellt. Es gibt kein Original mehr. Dank digitaler Kommunikation kann alles überall zugleich sein. Was heute neu in Tokio ist, ist heute neu in Berlin, in London, in New York. Kein Ort hat mehr Vorrang vor einem anderen. Communication Time ist heute gleich Download Time.

Unbegrenzte Verfügbarkeit jederzeit und an jedem Ort ist nur ein Teilaspekt. Der andere Schlüssel zur digitalen Revolution ist der des Formats. Zuvor waren Inhalte untrennbar an eine Form gebunden – das Muster war auf dem Teppich, die Pinselstriche waren auf der Leinwand, das Licht war in den Silbersalzen fixiert. Aber ein digitales Bild kann heute als alles Mögliche enden – als Druck, als Shirt, als Lightshow, als Mail, als virtueller Content –, während ein analoges Bild für jede Plattform neu erschaffen werden muss. Digitale Inhalte lassen sich in jedes Medium übersetzen, weil sie Oberfläche, Licht und Klang zusammenbringen und so die Lücke zwischen Zwei- und Dreidimensionalität überspielen. Das wiederum unterläuft die traditionelle Ordnung der Designkultur.

Nehmen wir die Bewegungen, Handlungen und Sounds eines Musikvideos: Sie haben keinen formalen Gehalt bis auf Emotionen, keine Erzählstruktur, nur Muster. Sie sind Schwingung ohne externe Information. Sie sind befremdend und unschuldig zugleich, Dramen ohne Ausgang, jedoch nicht ungelöst. Digipop hat dieselbe Unmittelbarkeit, konfrontiert ebenso mit einer Sprache, die jeder spricht, die aber für jeden eine andere Bedeutung hat. Nehmen wir die populären Motive, die in Karims Arbeiten vorkommen, oder die gemorphten Muster auf manchen seiner Objekte. Sie sind weder dekorativ noch bedeutungslose Symbole. Ebenso wenig sind sie bloß abstrakte Kunst, bloße Gesten, mit denen der Schöpfer seine inneren Dämonen befriedigt. Sie sind eher eine Art von Sprache ohne explizite Bedeutung, ein Dialog zwischen Designer und Benutzer oder zwischen Benutzer und Benutzer, deren Interpretation eine Reihe individueller Bedeutungen ergibt, nicht eine kollektive. Eine nichtlineare Sprache, nicht beschreibend, sondern fortlaufend assoziativ. Und dabei ganz anders als die kodierten und introvertierten Symbolismen von Graffiti und ähnlichem Gang-Slang, die darauf abzielen, Uneingeweihte auszugrenzen.

Diese Digipop-Bilder laden dazu ein, die andere Welt der Logos und Brands zu relativieren, in der wir gezwungenermaßen leben. Sie konterkarieren sogar den uns umgebenden Raum, der von Firmenlogos und Markenzeichen dominiert ist. Das Logo bekräftigt die merkantile Ethik, und die Macht dieser Ethik zeigt sich darin, dass sogar Organisationen wie gemeinnützige Vereine oder NGOs danach streben, mit eigenen Logos ihr Revier zu markieren. Karim Rashids Arbeit stört die kapitalistische Nutzung des öffentlichen Raums und bedient sich dazu der Techniken des Kapitalismus. Es ist eine durchdachte und provozierende Kunst mit ernstzunehmendem Anliegen und gleichzeitig unterhaltsamem Ergebnis.

Digipop ist die erste wirkliche Avantgarde des Digitalzeitalters. Digipop ist eine radikale Alternative zu den visuellen Manipulationen der Logowelt, eine Herausforderung an die Eingleisigkeit traditioneller Designcodes. Digipop stärkt den Benutzer, anstatt ihn zu beschränken. Digipop befreit. Big Brother mag überwachen – sehen kann er nichts!

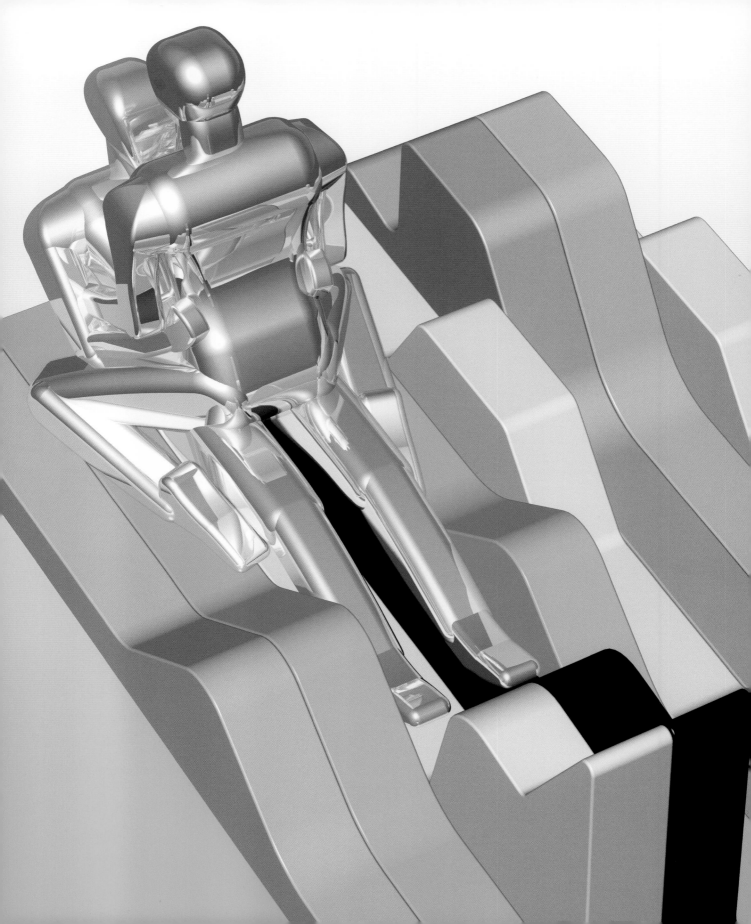

Digipop : l'œuvre d'art à l'époque de sa reproductabilité digitale

Albrecht Bangert et Conway Lloyd Morgan

« Big Brother vous surveille » nous répète-t-on dans *1984*, le roman anti-utopique de George Orwell, publié en 1949, qui décrit une société dans laquelle chaque action des citoyens est surveillée par l'Etat, et la langue est reconstruite comme une Novlang, pour éviter toute dissidence avec le point de vue officiel.

Cinquante ans plus tard, Big Brother est un jeu de télévision, sur la survie sociale, dans lequel les spectateurs deviennent des voyeurs qui votent, et des participants anonymes deviennent des célébrités. Mais parallèlement, la technologie numérique de télésurveillance, grâce à la CCTV, les appareils-photo numériques miniatures, les enregistrements téléphoniques et le piratage informatique, ont rendu la sinistre vision d'Orwell non seulement possible, mais réelle, appliquée sous le faux nom de Sécurité Intérieure. Big Brother nous a tous enregistrés sur sa base de données.

Le numérique non seulement infiltre et renforce les centres du pouvoir, mais il définit – de manière fondamentale – la productivité humaine, en cette deuxième révolution industrielle.

Tout comme la politique du pouvoir, il change non seulement les bases de la productivité industrielle, mais aussi l'essence des produits. Déjà, dans les années 30, le philosophe allemand Walter Benjamin avait prédit que les arts seraient radicalement modifiés par l'introduction de la reproduction mécanique. Comme le prédit et l'analyse Orwell, les espérances de Benjamin, quant aux choses à venir, sont aujourd'hui de loin dépassées par la technologie numérique. L'essence de l'œuvre d'art, à l'âge de la reproduction numérique, a été complètement modifiée par l'infinité des possibilités techniques de donner forme, combiner, multiplier, communiquer, et même manipuler. C'est à ce point qu'intervient l'avant-garde numérique de Rashid.

L'œuvre de Karim Rashid se situe entre réalité et cyberespace. C'est ce qui la rend si attractive. L'apprécier peut provoquer une dépendance.

Aujourd'hui, l'interface entre cyberespace virtuel et monde analogique est omniprésente et définit les tendances de l'art, de l'architecture et du design, ainsi que d'autres médias.

Dans ce domaine, Karim Rashid a été l'un des ardents précurseurs les plus engagés, cherchant à remettre en question la frontière entre les mondes numériques et analogiques des produits, le design intérieur et celui du graphisme.

L'éros, dans l'œuvre de Rashid, son inconsistance vibrante ou, en d'autres termes, son aura moderne, est engendré par ses deux aspects, son ambivalence, son ambiguïté. Ce n'est pas pur hasard, s'il a récemment créé un vase qui, vu d'un côté, semble avoir un visage double qui regarde dans toutes les directions. Que ce soit le volume d'une silhouette simple, tournée en 3-d, ou une œuvre d'art traditionnelle, créée par un artisan portugais, en cristal, cela demeure un hybride ambivalent, que Karim peut produire sans la moindre difficulté. Peu étonnant donc que Rashid nomme cette belle œuvre en verre EGO.

Non seulement Rashid crée le design, mais il se livre à des déclarations tonitruantes. « Je veux changer le monde » a été l'un des premiers slogans qu'il a choisis pour incarner son œuvre, à la fin du dernier millénaire. « Digipop » c'est le dernier mot qu'il a créé, avec une signification plus tranchée, plus socioculturelle, et d'un effet potentiel.

Digi représente une étape majeure après la révolution mécanique/industrielle du numérique. Pop, évoque les manifestations anti-consuméristes du début des années 50 et 60, devenues depuis un phénomène

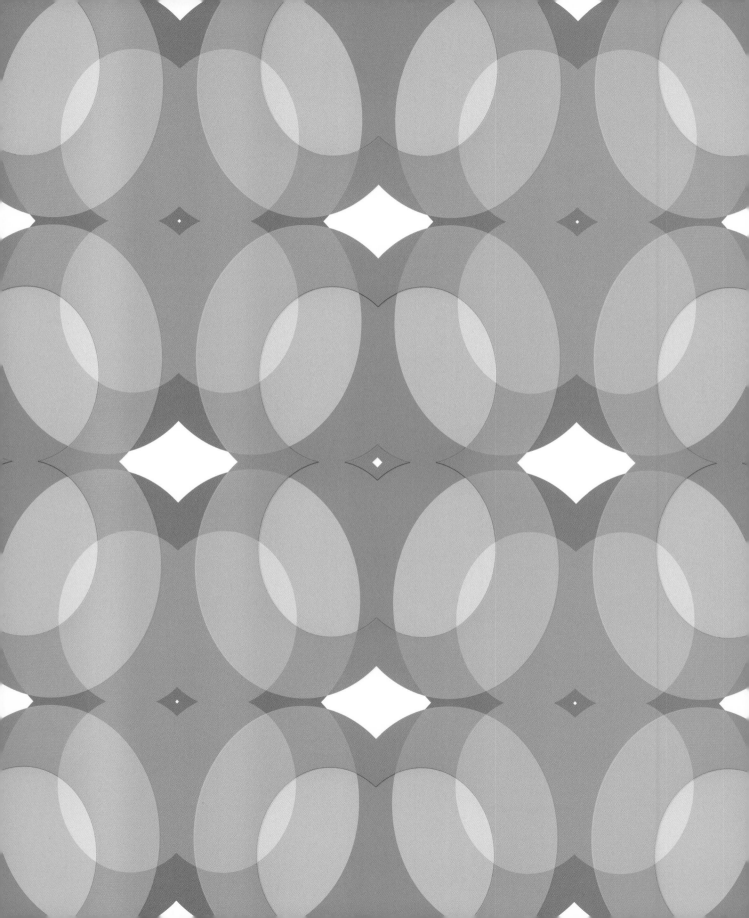

international. Je consomme donc je suis. Si le deuxième terme, Pop, peut sembler apolitique, « Digi » est plus marquant, capable de changer la société, et l'ambiguïté de la technologie numérique influencera la politique et la culture, en affectant ceux mêmes qui la maîtrisent.

La révolution numérique a démantelé nombre de hiérarchies. Traditionnellement, l'art populaire s'est ancré sur une base large. Ce qui signifie qu'il s'est appuyé sur une pyramide culturelle, aplatie — et pour certains discréditée — par le poids des arts plus « nobles » au-dessus. Cette pyramide est en train de s'écrouler, en partie à cause d'un changement des hiérarchies, mais également parce que l'art populaire moderne, l'art numérique, est doué d'une ubiquité qui est, en soi, un phénomène complètement nouveau. Grâce aux communications numériques, tout peut être partout, et immédiatement. Ce qui est nouveau aujourd'hui à Tokyo, l'est aussi aujourd'hui à Berlin, à Londres, et à New York. Il n'y a désormais plus de primauté de lieu. Le temps de distribution, aujourd'hui, c'est la vitesse du téléchargement.

L'ubiquité, en matière de lieu et de temps, n'est qu'une explication partielle. Celle du format est l'autre révolution numérique. Autrefois, le contenu était inclus dans la forme — le motif se trouvait dans le tapis, les coups de pinceau sur la toile, la lumière fixée par les sels argentiques. Mais une image numérique peut avoir différents prolongements — sous forme d'une impression, d'un tissu, d'un transparent ou de jeux de lumières —, alors qu'une image analogique doit être recréée pour chacune des plate-formes. Le contenu numérique se traduit dans tous les médiums, réunissant la surface, la lumière et le son, ainsi que, entre eux, les 2-d et 3-d. Voilà ce qui bouleverse la culture design.

Prenons les mouvements, actions et sons d'un clip vidéo musical : ils n'ont aucun contenu formel, sinon l'émotion, aucun contenu narratif, sinon le motif. Ils sont du bruit sans information externe. Ils sont à la fois inquiétants et innocents, des drames sans conclusion, sans solution. Le Digipop a la même urgence, pose le même défi à une langue que chacun parle, mais qui a pour chacun des significations différentes. Prenons les motifs inventifs qui habitent l'œuvre de Karim Rashid, ou la forme de certains de ses objets. Ce ne sont ni des décorations, ni des symboles insignifiants. Pas plus qu'ils ne sont simplement de l'art abstrait ou des gestes accomplis par l'artiste pour satisfaire ses démons. Il s'agit plutôt d'une sorte de langage sans signification explicite, d'un dialogue entre designer et utilisateur — et entre utilisateur et utilisateur —, dans lequel l'interprétation est une série de significations individuelles, et non collectives. Un langage non linéaire, non normatif, mais opportuniste, et donc, en action. Et contrairement aux symbolismes codés et introvertis des graffitis et des argots des rues, ce langage n'est pas conçu pour exclure les non-initiés.

Ce que ces images Digipop nous invitent à interroger, c'est l'autre monde des symboles que nous sommes forcés d'habiter, l'espace autour de nous, tracé par les symboles et les logos de marques. Le logo affirme l'éthique marchande, et le pouvoir de cette éthique apparaît dans la façon dont même des organismes tels que les institutions caritatives et les O.N.G. cherchent aujourd'hui à marquer leur territoire avec leurs propres logos. L'œuvre de Karim Rashid subvertit l'utilisation capitaliste de l'espace. Pour ce faire, il utilise la technologie du capitalisme. Il s'agit d'un exercice provocateur, engagé, mûrement réfléchi, animé d'un objectif sérieux et couronné de résultats.

Le Digipop est la véritable première avant-garde du numérique. C'est une alternative radicale à la manipulation visuelle que vise le logo, une mise en question des plates-formes du design avec codes traditionnels, une façon de responsabiliser l'utilisateur, pas de le limiter. Servez-vous-en, amusez-vous-en, libérez-vous-en. Big Brother vous surveille, mais il ne voit rien.

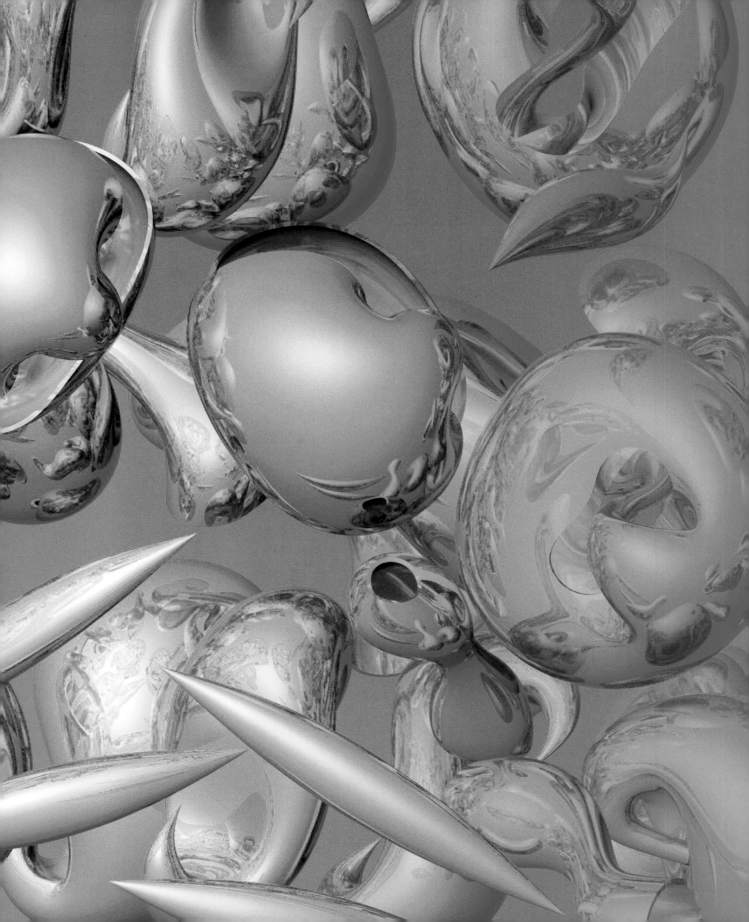

symbolik

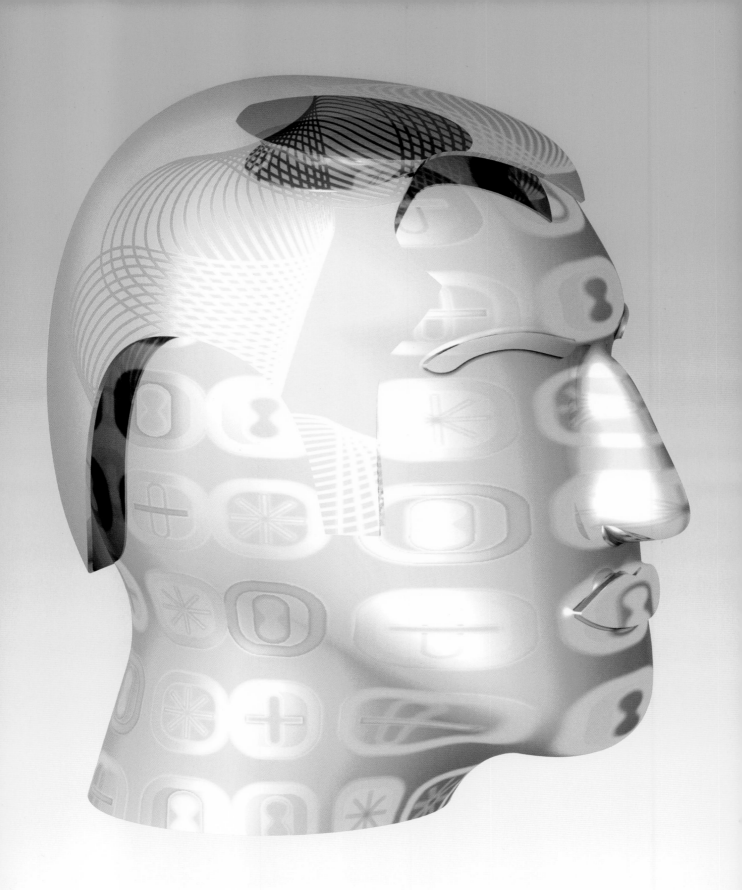

The notion of capturing and documenting the world figuratively and realistically was indicative of the time prior to the advent of photography. Photography obviously changed the tedious process and the need of painting and sculpture to try to emulate a perfect reality. So the contentious ease of silver film caught through the lens was pivotal to the fine and the applied arts. Photography was an incredibly fulgent and exciting phenomenon, and in order for painting to survive it had to become abstract and eventually conceptual. Film documented too well, and art fled from the premise of narrative. But film was, in turn, also distorting reality and not necessarily documenting but becoming painterly in its own right, and hence photography became an art form. Art has moved into very extreme and diverse territory in order to retain a *raison d'être* in the age of ubiquitous imagery. The Polaroid then gave us instant imagery, instant satisfaction, and the immediate capturing of time. It took painting a great deal of time to realize this. Speed is with us in the age of technology, and the digital era has created a sense of immediacy and distortion by factorizing and manipulating imagery. We can now morph a new world and realize our extreme thoughts and dreams. The digital image, which really has no original, and is a construct of binary notation, is data that can go on forever in its exactitude. The printing of the image in a certain form or material or place creates the potent moment of originality and time that signifies and documents the period in which it is made public. In the last 12 years I have developed digital images with a wide variety of programs to create three dimensional realism in projects ranging from products to space to architectural surfaces. In the process, I have seen such incredible beauty in the way one can surface, map, light, morph, and change materials almost instantly on screen. It would be a great rave new world to see these surface changes and this ongoing diverse imagery out there on walls, facades, and even on our bodies. With nano-mechanics and new technologies we will eventually be able to fire up imagery on our bodies like smartattooing. Already if you go to Times Square, you will see a new billboard architecture of motion, movement, video, voxels, and light. The LED signage world, LCD glass technologies, color kinetics, it is all here and contributing to a dynamic architecture. Our windows can become video screens, our wallpaper can become our computer interface, and our rugs can change colors constantly. I try to work with these technologies, or at least to communicate this changing world of images and video. I have developed body parts that are emblazoned with Smarttoos in some of my digital paintings, self-portraits, abstractions, furniture, fonts, icons, blobjects, and various ephemeral forms that speak about a digital utopia—an ever-changing, ever-evolving technorganic world. I could develop forms that had never been produced before and I could animate them and forever vary their properties, surfaces, finishes and colors. For me, these compositions became forms for communicating in a two-dimensional way, of mapping my dreams and fantasies, from the body parts series to the mutablobs I exhibited at the Sandra Gering Gallery in 2002. I believe that we are really only at the abecedarian stage of firing up imagery on our own bodies and on any surface, from smart wallpapers to automobile bodies to entire building facades. Our world will be illustriously visual, seductive, and forever variable.

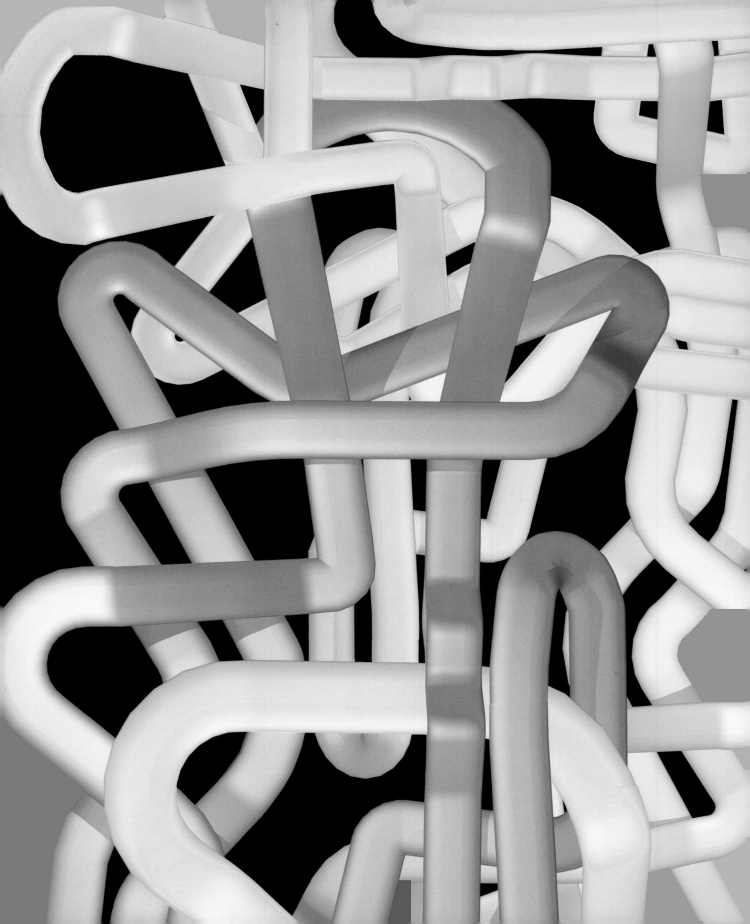

Schon vor der Erfindung der Fotografie war es ein Ziel, die Welt bildlich und wirklichkeitstreu wiederzugeben und zu dokumentieren. Mit der Fotografie änderte sich natürlich der langwierige Prozess, und es bestand kein Bedarf mehr an einer Malerei und Bildhauerei, die danach strebte, die Realität perfekt nachzubilden. Die umstrittene Erleichterung, die Welt durch die Linse einzufangen, war also ein Wendepunkt für die reine und angewandte Kunst. Die Fotografie war ein unglaublich strahlendes und aufregendes Phänomen, und wenn die Malerei überleben wollte, musste sie abstrakt und irgendwann konzeptuell werden. Ihr Film dokumentierte zu gut, und die Kunst überließ ihm kampflos das Gebiet der Wirklichkeitsschilderung. Aber im Gegenzug verzerrte der Film auch die Realität und dokumentierte sie nicht mehr unbedingt, sondern wurde selbst zu einer Art Malerei, wodurch die Fotografie zur Kunstform wurde. Die Kunst ist in sehr extreme und unterschiedliche Gebiete vorgestoßen, um sich im Zeitalter der allgegenwärtigen Bilderflut ihre Daseinsberechtigung zu bewahren. Das Polaroid bescherte uns dann das Sofortbild, die sofortige Bedienung unserer Wünsche und unmittelbar festgehaltene Zeit. Die Malerei brauchte lange, um dies zu verstehen. Im technologischen Zeitalter ist die Geschwindigkeit unser ständiger Begleiter, und das Digitalzeitalter erzeugt durch die Manipulation und Faktorisierung von Bildmaterial ein Gefühl von Aktualität und Verzerrung. Wir können uns nun eine neue Welt morphen und unsere extremsten Ideen und Träume verwirklichen. Das digitale Bild, das tatsächlich kein Original hat, ist ein Konstrukt binärer Notation, besteht aus Daten, die in ihrer ganzen Genauigkeit unverändert weiter bestehen können. Das Ausdrucken dieses Bildes in einer bestimmten Form, auf einem bestimmten Material oder an eine bestimmte Stelle ergibt den aussagefähigen Moment von Originalität und Zeitlichkeit, der die Periode, in der es publiziert wird, kennzeichnet und dokumentiert. Ich habe in den letzten zwölf Jahren mit sehr vielen Programmen digitale Bilder entwickelt, um die unterschiedlichsten Projekte wie Produktdesign, Räume oder Architekturoberflächen plastisch dreidimensional darzustellen. Im Verlauf dieser Arbeit begegnete mir so viel Wunderschönes darin, wie man Materialien am Bildschirm praktisch in Sekundenschnelle strukturieren und glätten, detailliert ausarbeiten, erhellen, morphen und verändern kann. Es wäre eine Rave New World nach meinem Herzen, diese Oberflächenveränderungen und sich ständig abwechselnden Bilder auf den Außenwänden, Fassaden, ja sogar auf unseren Körpern zu sehen. Dank Nano- und anderen neuen Technologien werden wir irgendwann in der Lage sein, Bildzeichen wie Smarttattooing auf unseren Körpern zu aktivieren. Schon jetzt sieht man am Times Square eine neue Billboard-Architektur, zu der Bewegung und Beweglichkeit, Video, Voxels und Licht gehören. Die Welt der LED-Zeichen, der Plasmabildschirme, die Farbkinetik, alle kommen hier zusammen und tragen zu dynamischer Architektur bei. Unsere Fenster können zu Videobildschirmen werden, unsere Tapete kann zu unserer Computerschnittstelle werden, Fußmatten können unablässig ihre Farbe wechseln. Ich versuche mit diesen Technologien zu arbeiten oder zumindest diese sich verändernde Welt von Bild und Video zu vermitteln. Ich habe bei einigen meiner digitalen Malereien mit Smarttoos gezierte Körperteile entwickelt, für Selbstporträts, Abstraktionen, Möbel, Schriften, Icons, Blobjects und andere ephemere Formen, die von einem digitalen Utopia sprechen – einer sich ständig verändernden, ständig entwickelnden techno-organischen Welt. Ich konnte Formen entwickeln, die nie zuvor produziert worden sind, und ich konnte sie animieren und ihre Eigenschaften, Oberflächen, Finishs und Farben unendlich oft variieren. Diese Kompositionen sind meine zweidimensionalen Möglichkeiten, meine Träume und Fantasien darzustellen und zu kommunizieren, von den Serien mit Körperteilen bis zu den Mutablobs, die ich 2002 in der Sandra Gering Gallery ausstellte. Ich glaube, wir stehen gerade erst am bescheidenen Anfang unserer Möglichkeiten, auf unseren eigenen Körpern – oder auf jeder anderen Oberfläche von intelligenten Tapeten über Autokarosserien bis zu ganzen Gebäudefassaden – Bildelemente zu aktivieren. Unsere Welt wird von illustrer Visualität sein, verführerisch und immer weiter veränderlich.

Saisir et illustrer le monde, de manière figurative et réaliste, telle a été l'une de nos constantes préoccupations, jusqu'à l'arrivée de la photographie. A l'évidence, cette dernière a changé le processus et le besoin de peindre et de sculpter, s'efforçant toujours d'imiter une réalité parfaite. Ainsi, la pratique du film aux sels d'argent, à travers l'objectif, a marqué un tournant dans l'art et les arts appliqués. La photographie a été un phénomène à la fois éblouissant et passionnant et, pour y survivre, la peinture a dû se faire abstraite, puis conceptuelle. Le film étant si informatif, l'art a dû quitter le narratif. Par ailleurs, le film déformant la réalité, sans forcément nous informer, il s'est fait parfois esthétisant. En conséquence, la photographie aussi s'est transformée en forme d'art. L'art a pénétré des territoires très extrêmes, très divers, afin d'affirmer sa « raison d'être » à une époque d'images omniprésentes. Ensuite, le polaroïd nous a offert une mise en images, une satisfaction instantanée, et une saisie immédiate du temps, que la peinture mettait beaucoup de temps à réaliser. La vitesse est nôtre, à l'âge de la technologie, et le numérique engendre une urgence, une déformation, par la prise en compte et la manipulation des images. Nous pouvons désormais façonner un monde nouveau et réaliser nos idées et nos rêves les plus fous. L'image numérique, qui n'a pas vraiment d'antécédent, est une construction binaire dont les données, par leur exactitude, sont infinies. L'impression de l'image, sous une certaine forme ou un certain matériau, ou en un certain lieu, crée le moment de l'originalité et du temps qui porte sens, et nous informe sur la période où elle est offerte au public. J'ai développé des images numériques, ces douze dernières années, avec divers programmes visant à créer un réalisme tridimensionnel de projets allant de produits de consommation, à des espaces ou des surfaces architecturales. Au cours du processus, j'ai découvert une incroyable beauté, dans la façon dont on peut lisser, tracer, éclairer, donner forme, ou changer le matériau,

presque instantanément, sur l'écran. Ce serait un nouveau monde très « rave » que de voir ces changements de surface, et ces images d'une diversité infinie, apparaître sur nos murs, nos façades, et même sur notre corps. Avec l'avènement du nanomonde et des nouvelles technologies, nous pourrons faire surgir l'imaginaire sur notre corps, comme du « smart-tatouage ». Déjà, à Times Square, on peut voir de nouveaux panneau-publicitaires, composés de mouvements, de vidéo, de voxels, et de lumière. Le monde des signes, la technologie des cristaux liquides, la cinétique des couleurs, cela contribue à créer une architecture dynamique. Nos fenêtres peuvent se transformer en écrans visuels, notre papier peint devenir notre interface d'ordinateur, et nos tapis changer de couleurs pour toujours. J'essaye de travailler sur ces technologies, ou du moins de communiquer ce monde changeant des images et de la vidéo. J'ai montré des parties de corps émaillés de « Smartoos » dans certaines de mes peintures numériques, autoportraits, abstractions, meubles, polices de caractères, icônes, « Blob-jects » , et autres formes éphémères qui parlent d'utopie digitale, d'un monde techno-organique, en évolution permanente. Je pourrais développer des formes qui n'ont jamais été produites et les animer, en variant à l'infini leurs propriétés, surfaces, finitions et couleurs. Pour moi, ces compositions sont devenues des formes pour communiquer en 2-d, représenter mes rêves, mon imaginaire, mes séries sur le corps, et même ces « muta-blobs » que j'ai exposés à la galerie de Sandra Gering, en 2002. Je crois que nous en sommes seulement au b-a ba, en ce qui concerne la mise en scène sur nos propres corps, et sur n'importe quelle autre surface, des papiers peints à mémoire, aux carrosseries d'automobile ou aux façades de bâtiments. Notre monde sera « i-lustrement » visuel, séducteur, à tout jamais variable.

symbolik

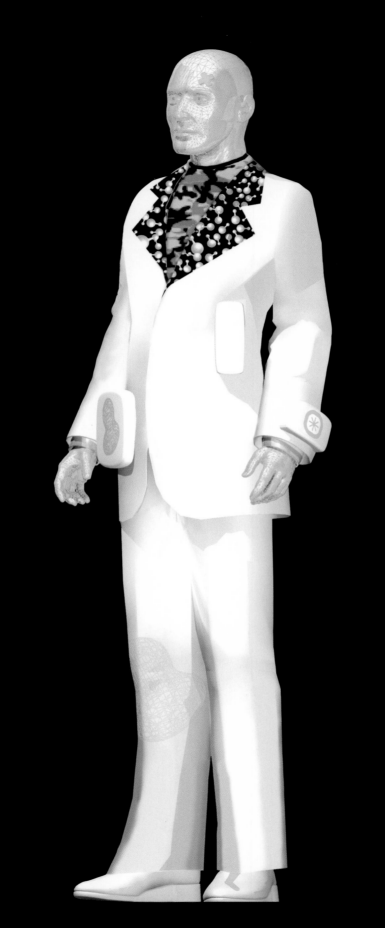

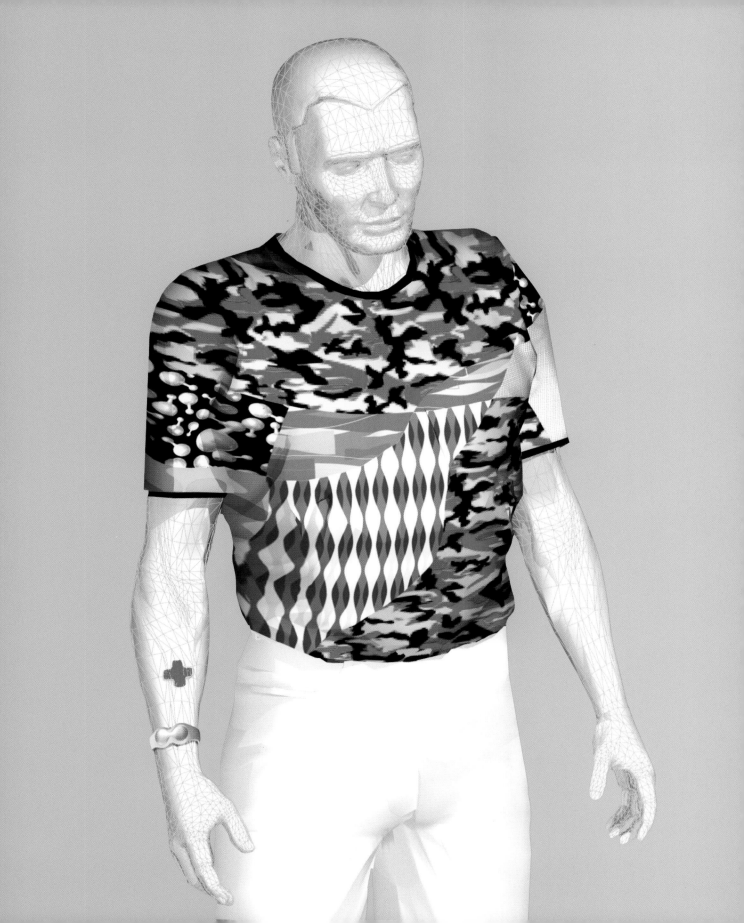

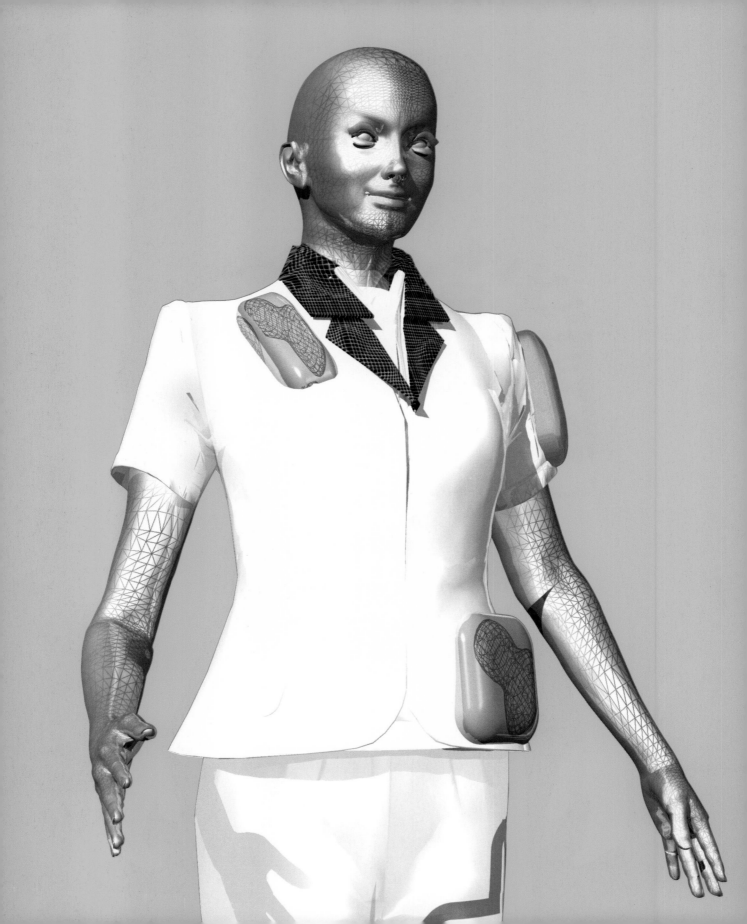

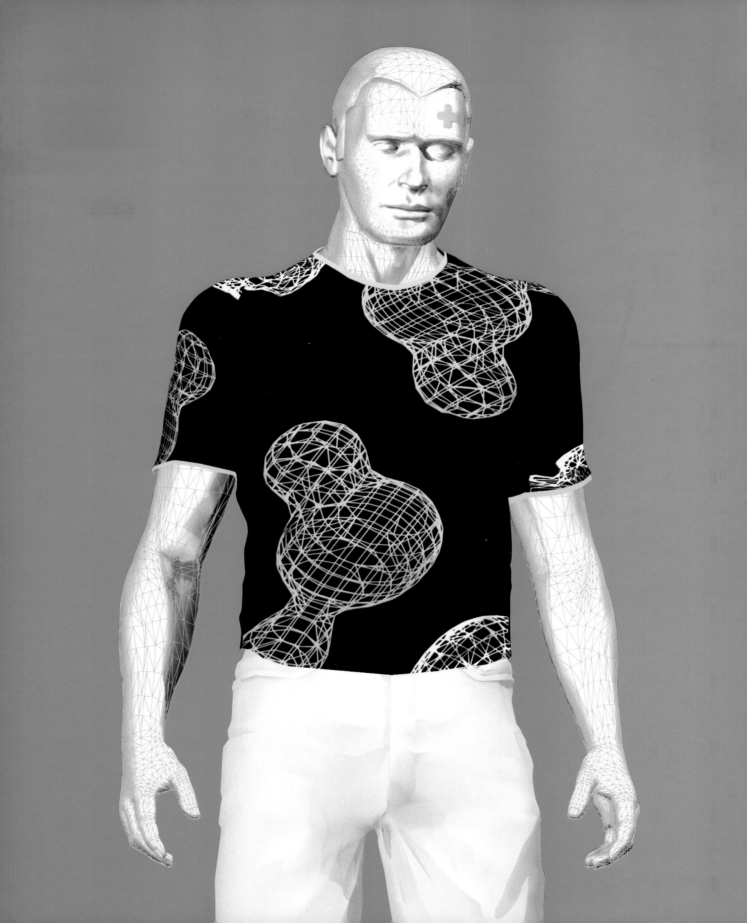

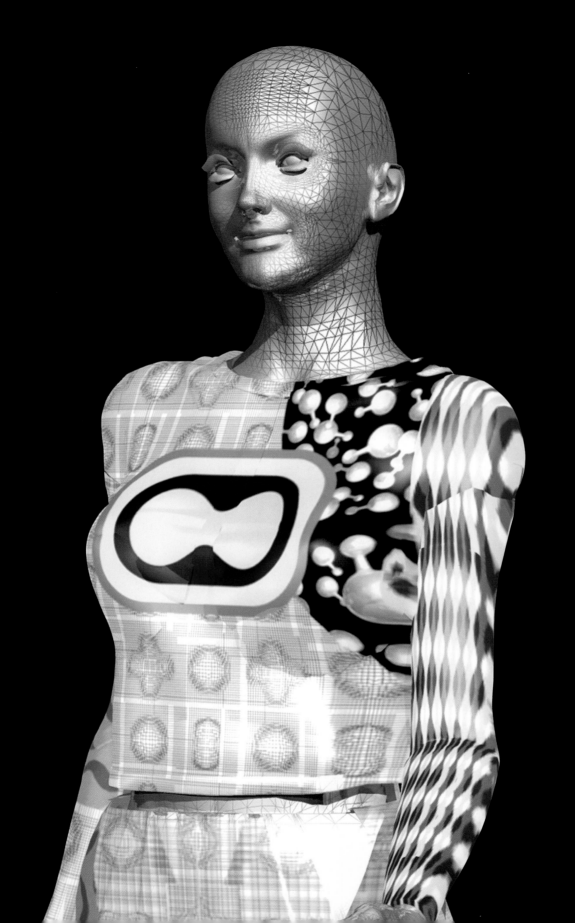

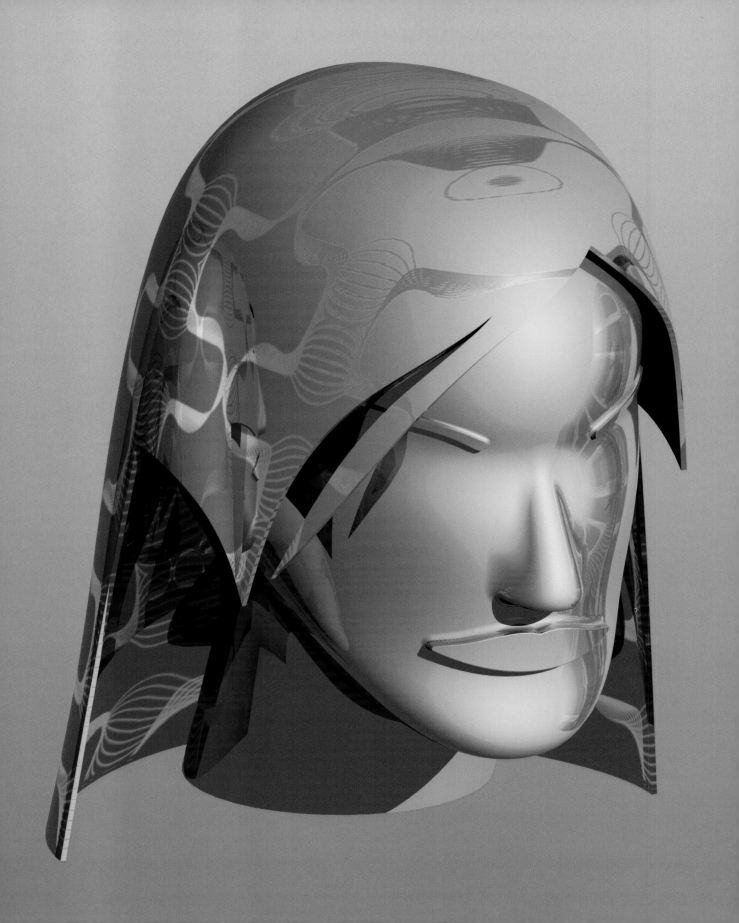

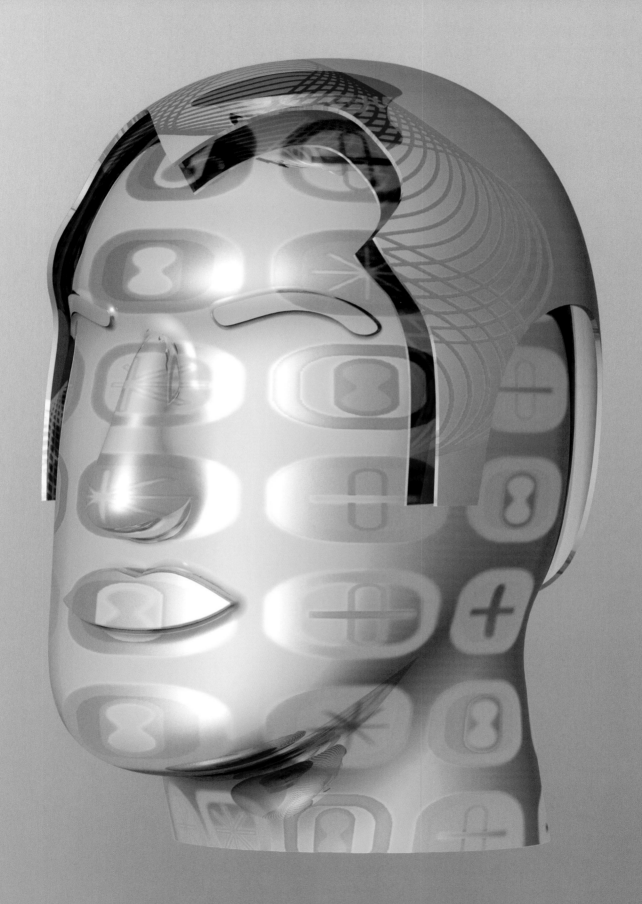

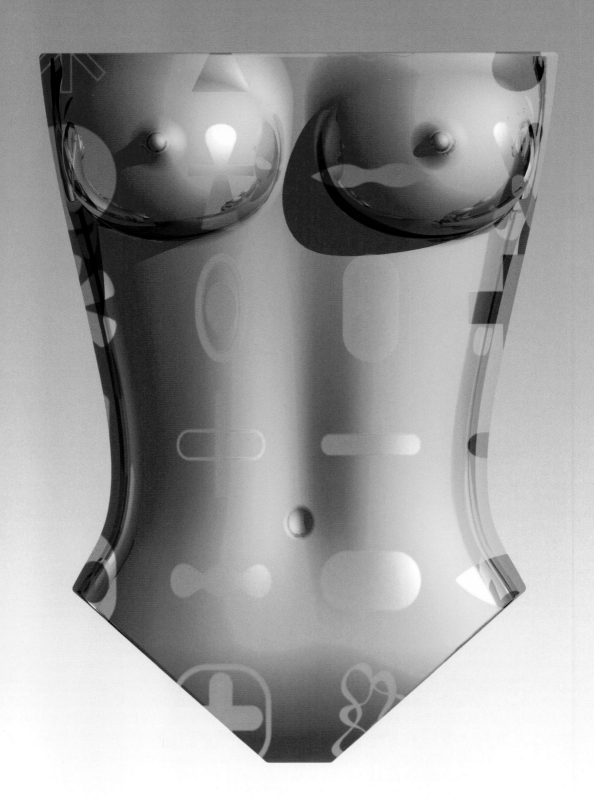

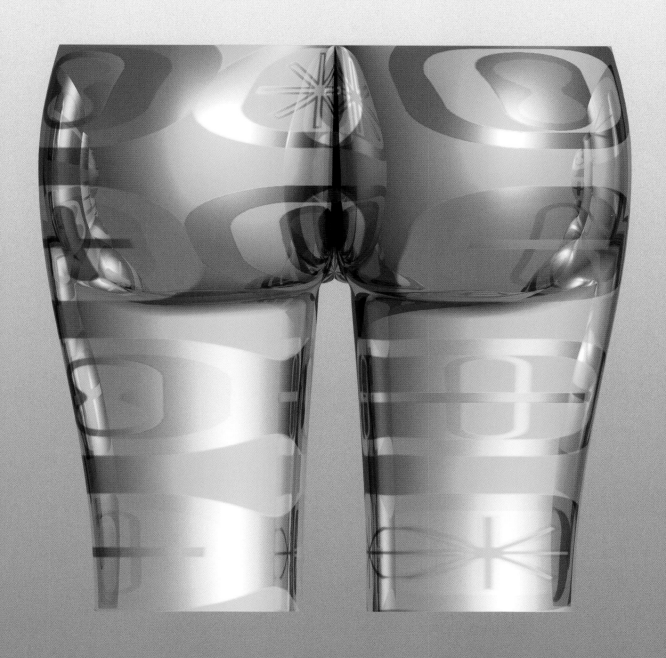

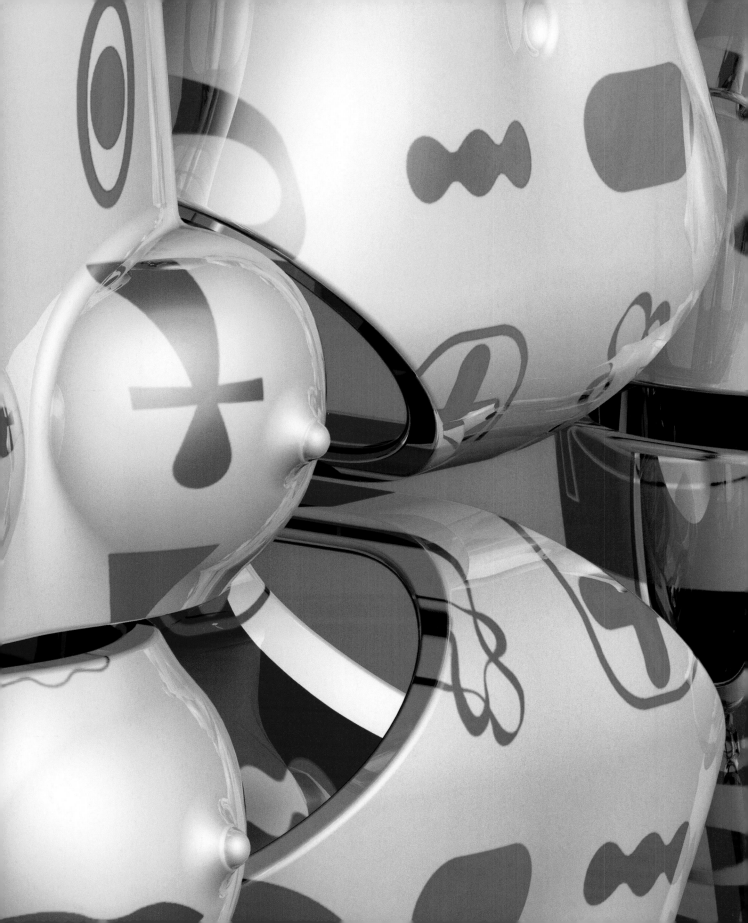

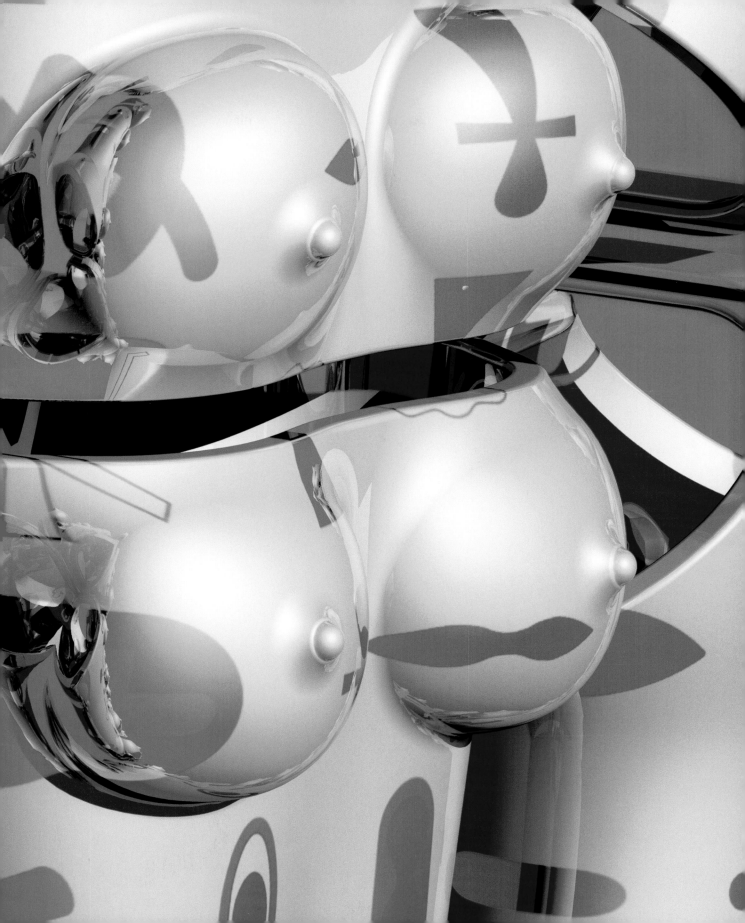

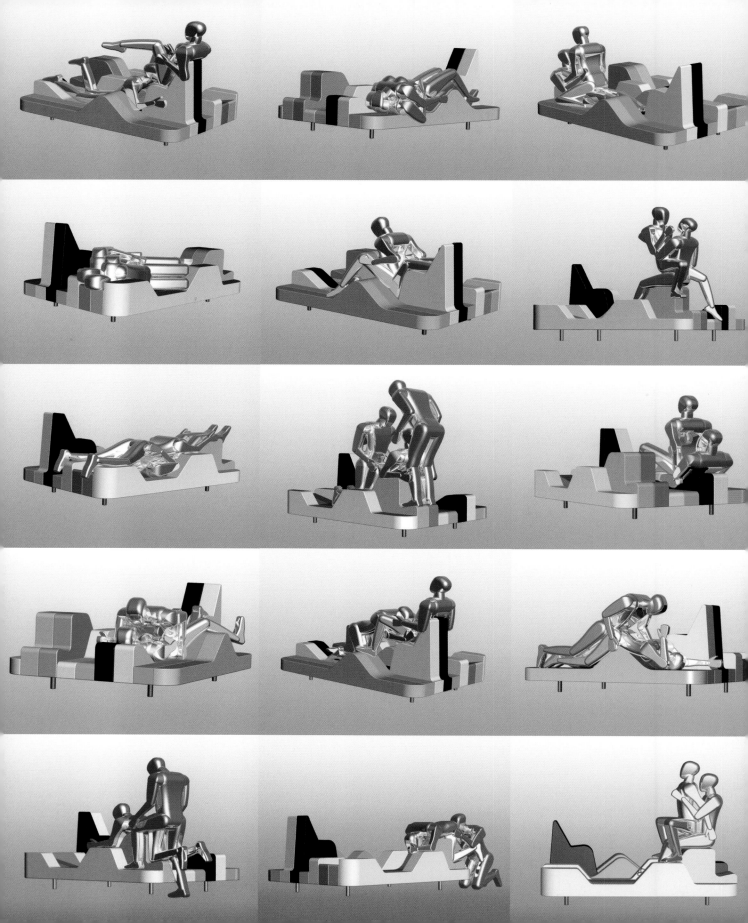

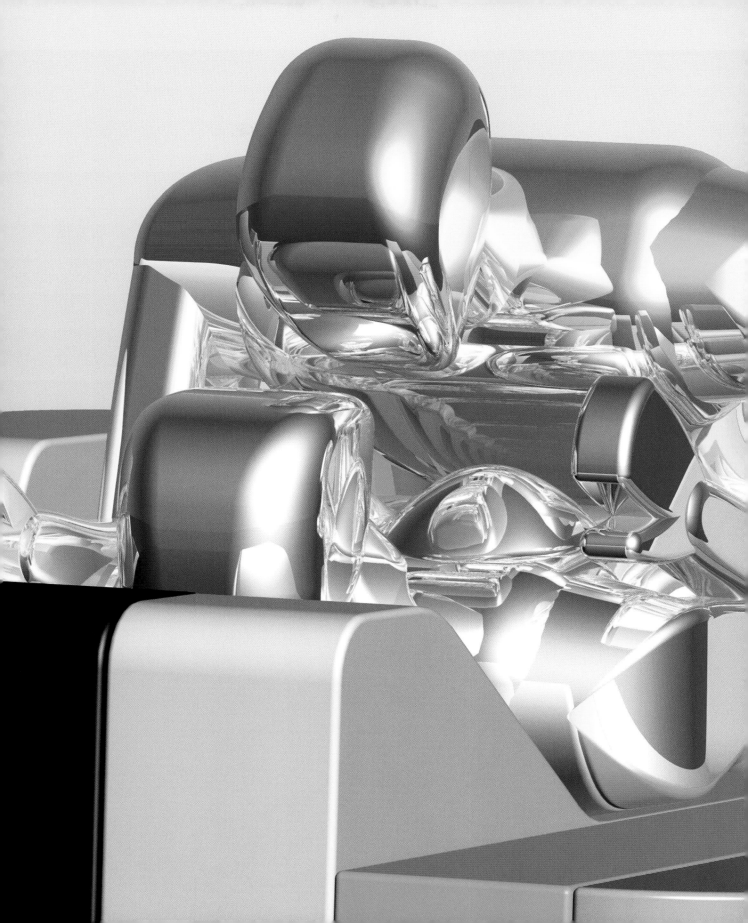

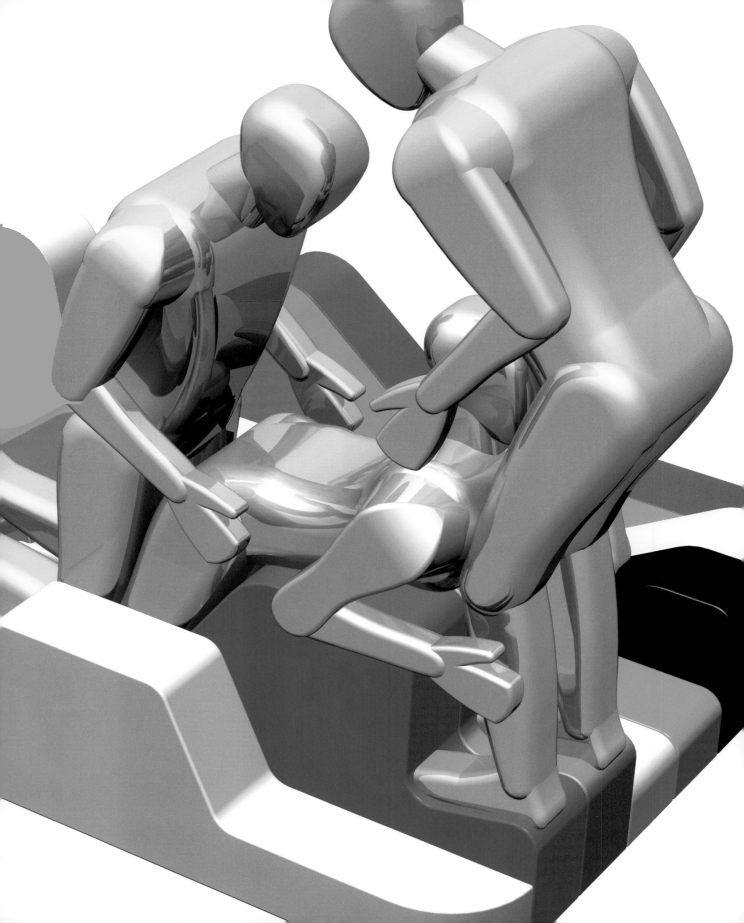

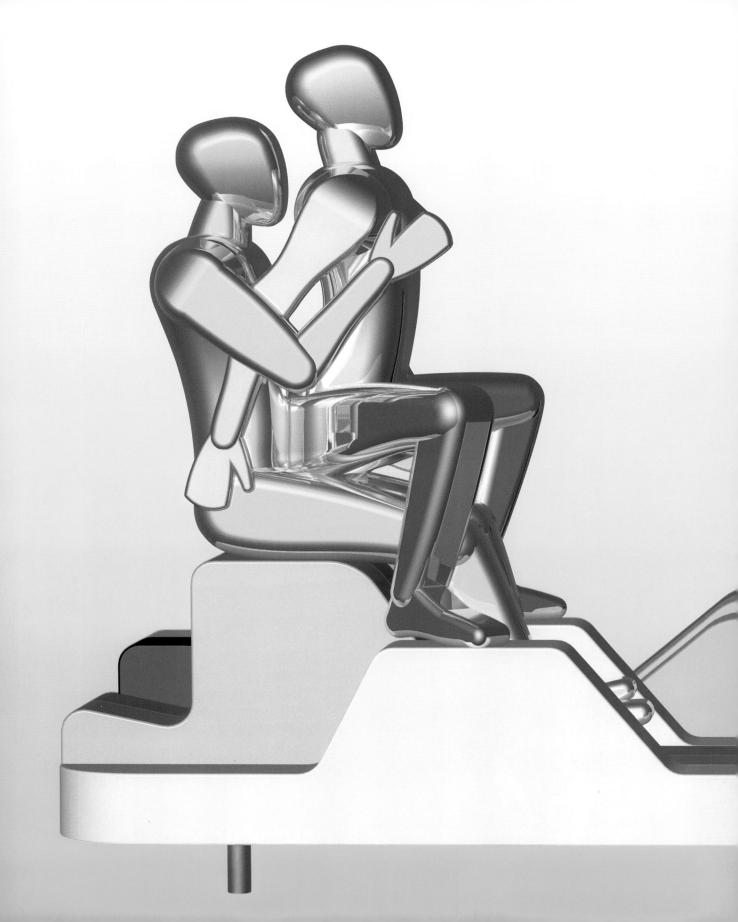

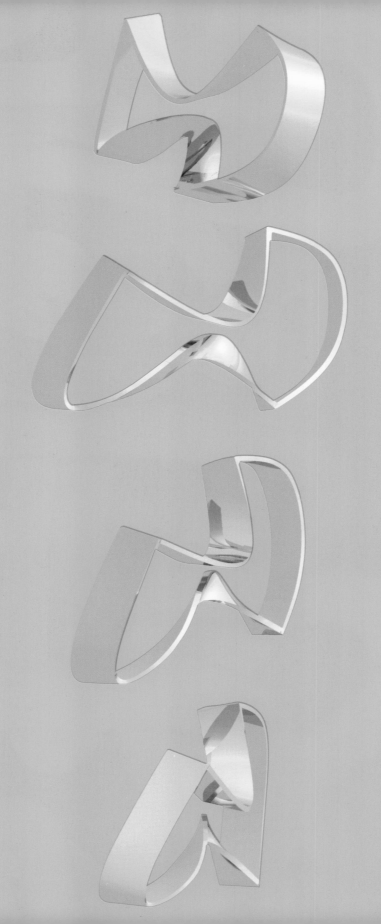

DESIGN OR DIE

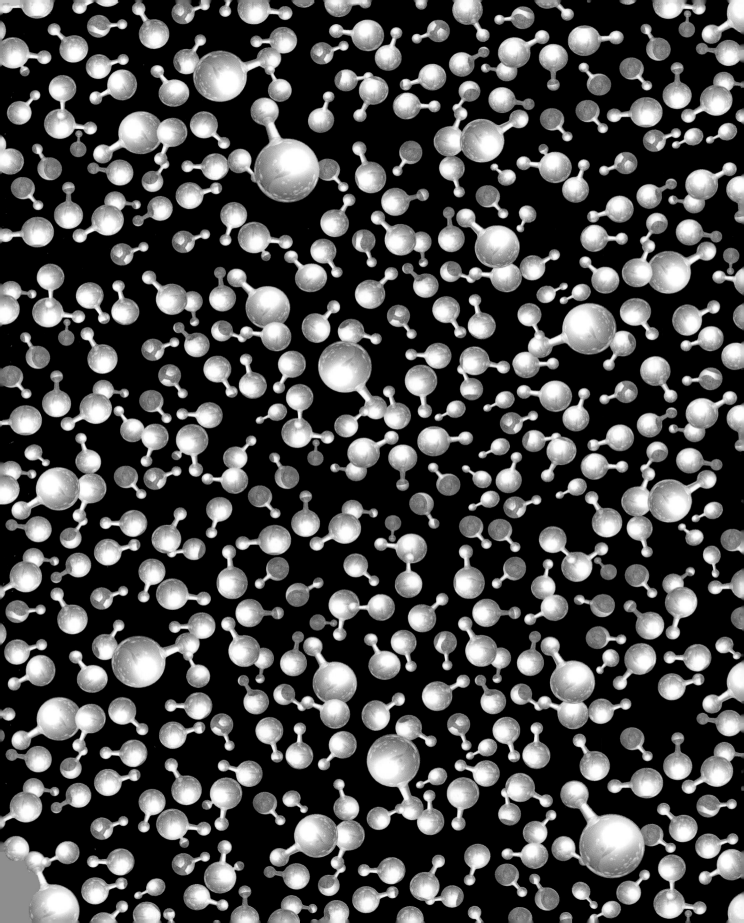

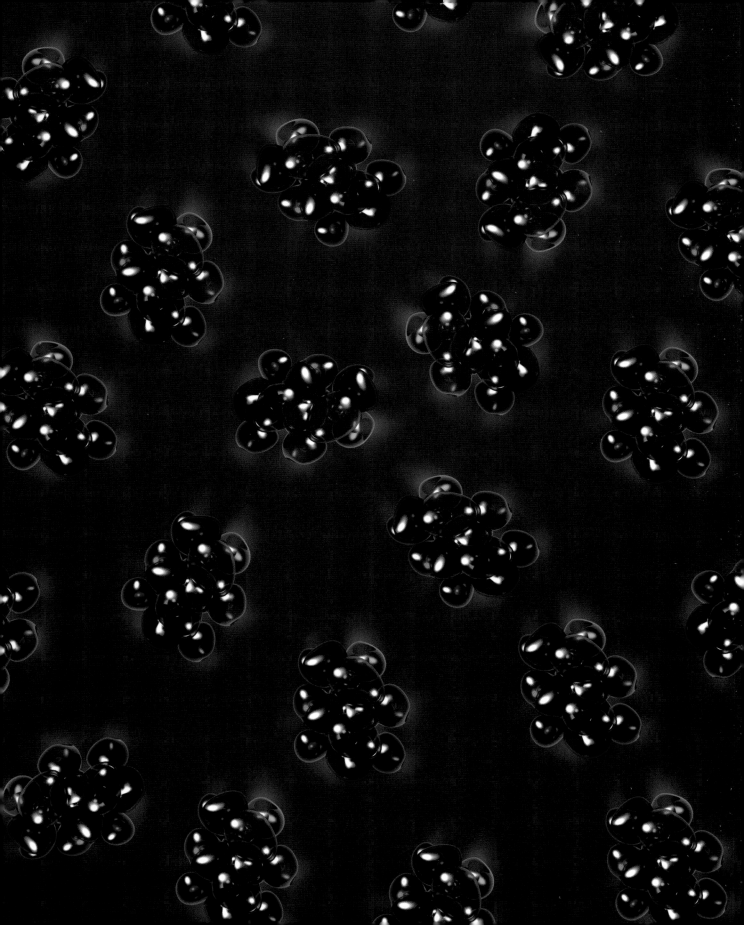

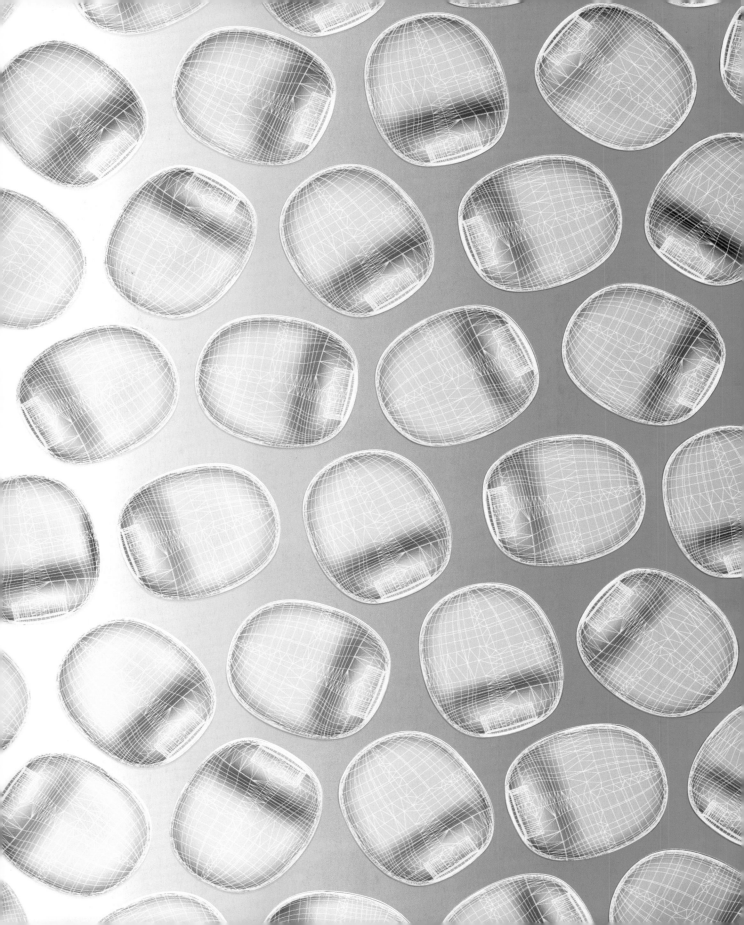

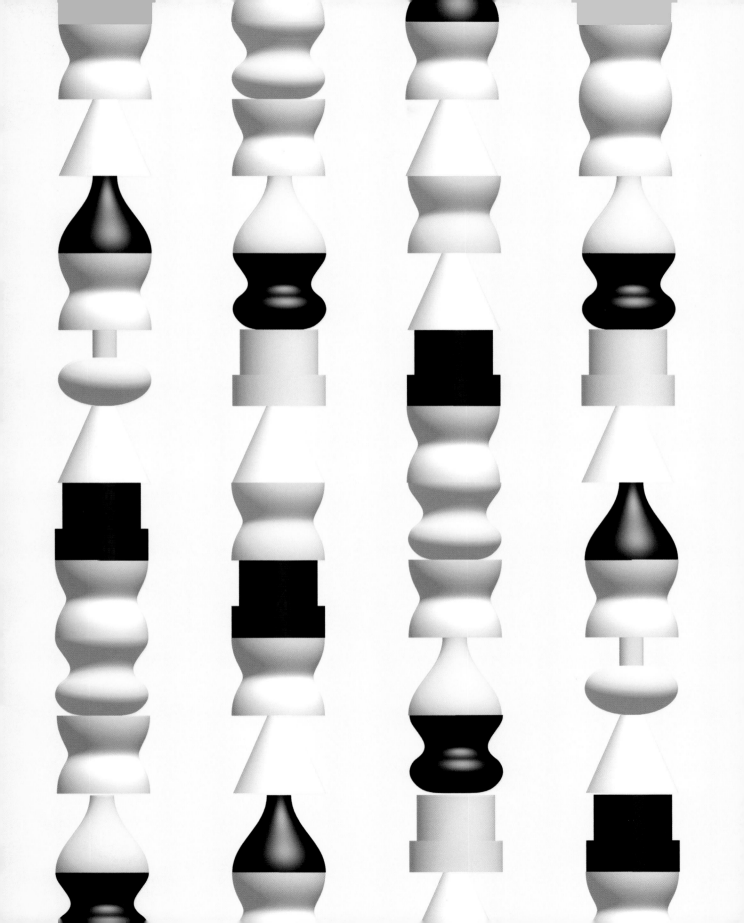

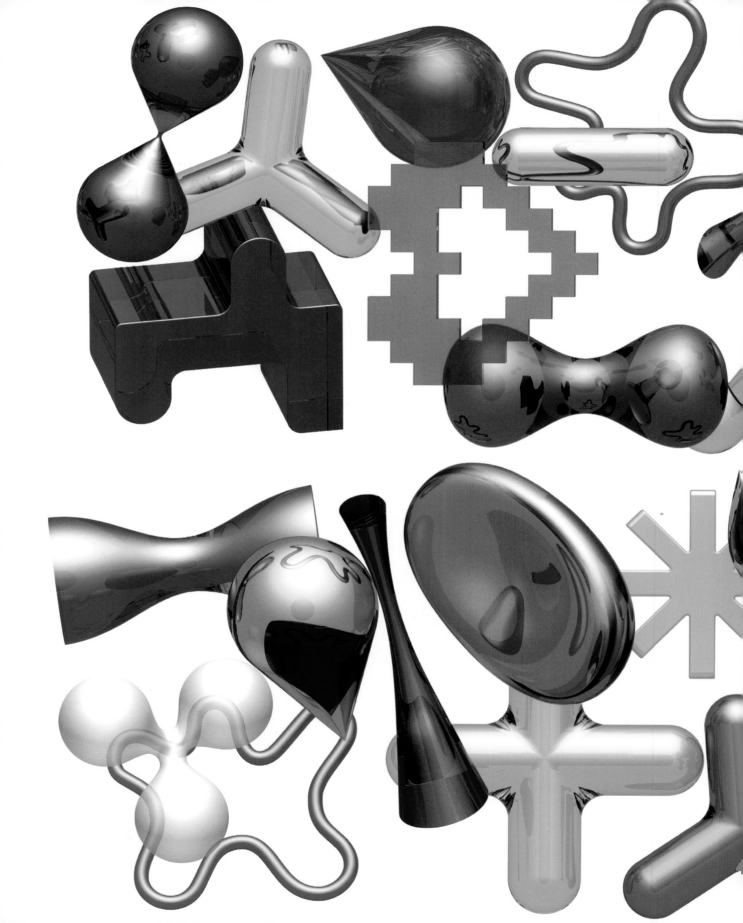

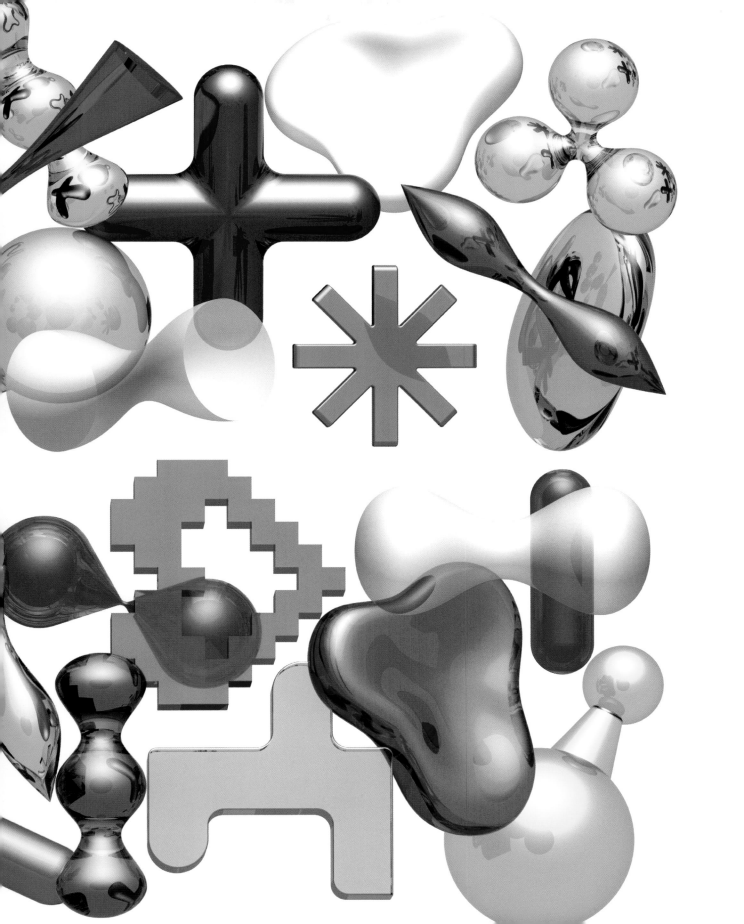

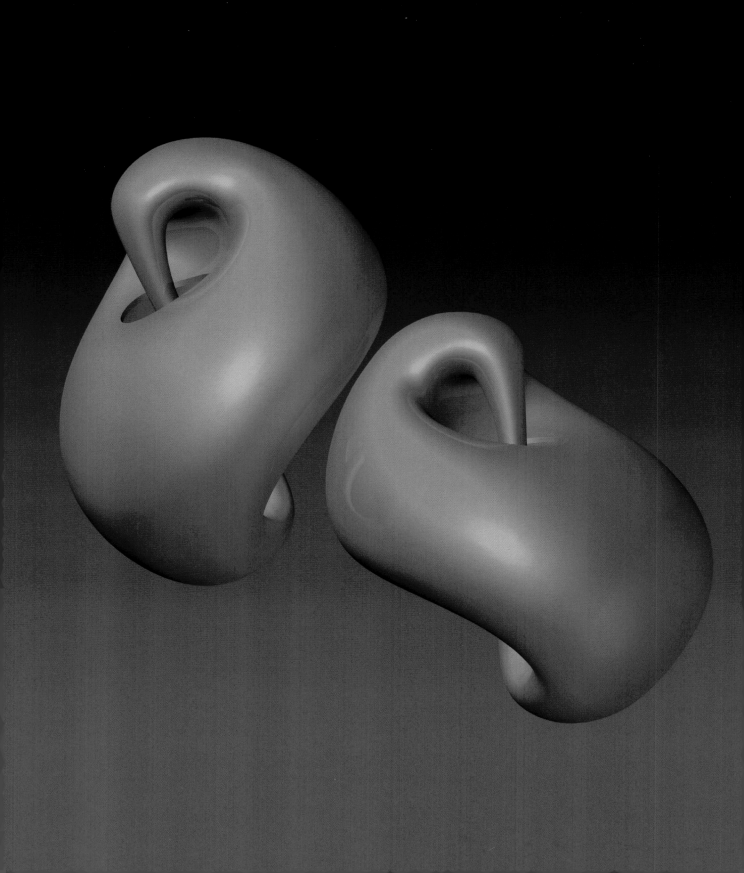

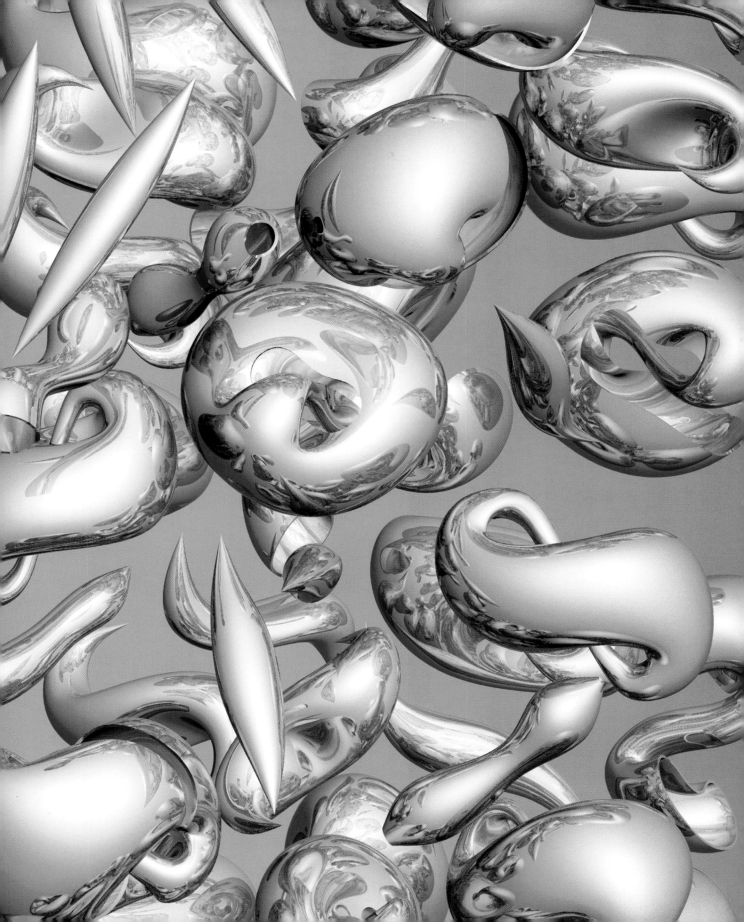

ikons

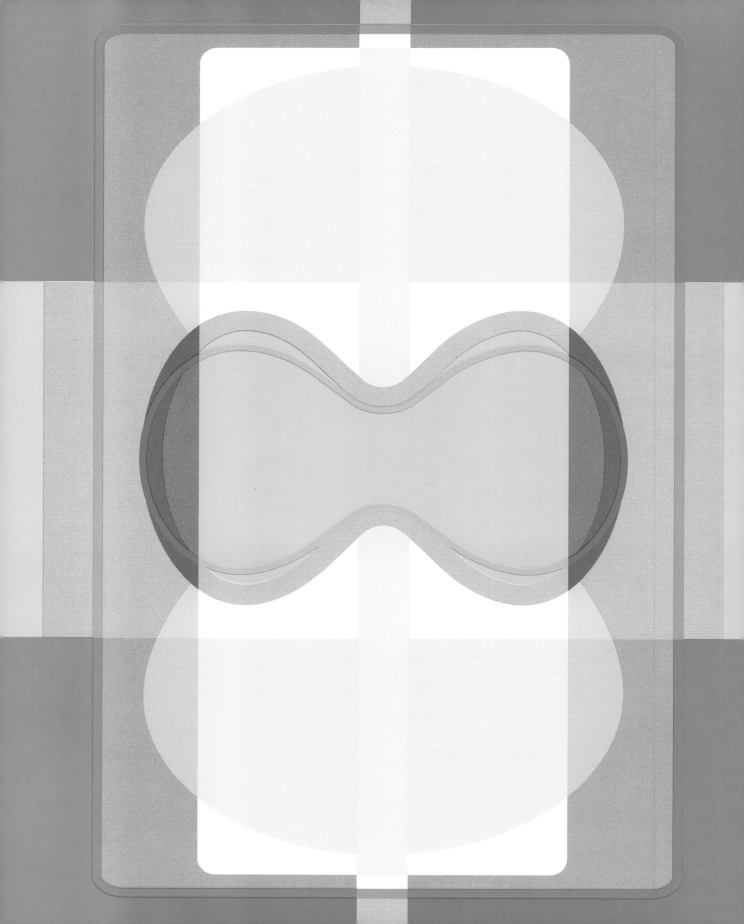

In the mid-1980s I grew increasingly frustrated with designing banal products for corporations that didn't really seem to take design, aesthetics, or beauty very seriously. The problem was—could I really be creative in industrial design? Was there room for poetics, meaning, love, humor, artistic proposal, sculptural notion, or painterly product? After all, commodity is business and design is business, but I believe we are in the business of beauty and cultural shaping. I started marking the products with symbols in order to state that I was the author, and because, unlike Europe, design in North America rarely attached a name to a product. Brands refused this idea since they thought that the designer's name would overshadow the brand name. Also I believed that design was low on the priority list as regards its importance and acknowledgement. Often companies looked on designers as merely engineers. Sadly, we designers are bad engineers. This is still an ongoing issue, although we are now seen as co-branders, in that brands can leverage themselves and open new markets. I needed to 'mark' my products. This was my subversive signature. I would actually draft a symbol into the mold (inside high-tech and mechanical products such as a laptop or an electric kettle or a drill—these were the projects I was working on in the 1980s at KAN industrial design in Toronto). I remember at Bonetto's office in Milan I designed a TV for Brionvega and put a cross in the interior molding, like when people carve their initials on a park bench. I had some perverse idea that many years later I would find the product at a flea market and see my 'tag' on it. I also started a clothing line called Babel with some architect friends, and the symbols became a new hieroglyphic code on buttons, pockets, and details. The line was based on my belief in a universal 'one-world.' The symbols were non-lingual, therefore not biased, and anyone and everyone could interpret them as they saw fit. The beauty of abstraction will always be self-interpretation and higher spiritual meaning. Words are precise and forms are vague. I have continued to work and develop these symbols over these last 20 years and they have started to become an integral part of my life, even to the point of tattooing myself twice a year with them, each symbol done in a different city to continue my quest for and belief in a global oneness. I choose cities that I feel proactive in, and I choose each symbol as a reflection of that specific place. Subconsciously, the symbols keep creeping into my work—sometimes inadvertently. Then companies and the public started to see my graphic symbols all over the place, like random tags of graffiti. In 1997 I decided to make a collection of mouse pads with the symbols, and this project was so successful globally that companies started to approach me with 2-D projects like carpet designs, wallpapers, gift-wrap, tiles, laminates, floorings, textiles, and inevitably paintings. I have never understood why the graphic world didn't take up this concept—it seemed so obvious. I started to show my 'digital' art in art galleries. My wife, Megan Lang, was also doing so much digital art that we inspired each other—her art touched my product landscape and my product world touched her art. We religiously read *Artbyte*, *Wired* and *Mondo* every month and dreamt of a digital nutopia—a multi-dimensional, colorful, energetic, hypnotic, kaleidoscopic world. My icons are a personal language, a contemporary hieroglyphic, and a way of messaging the world.

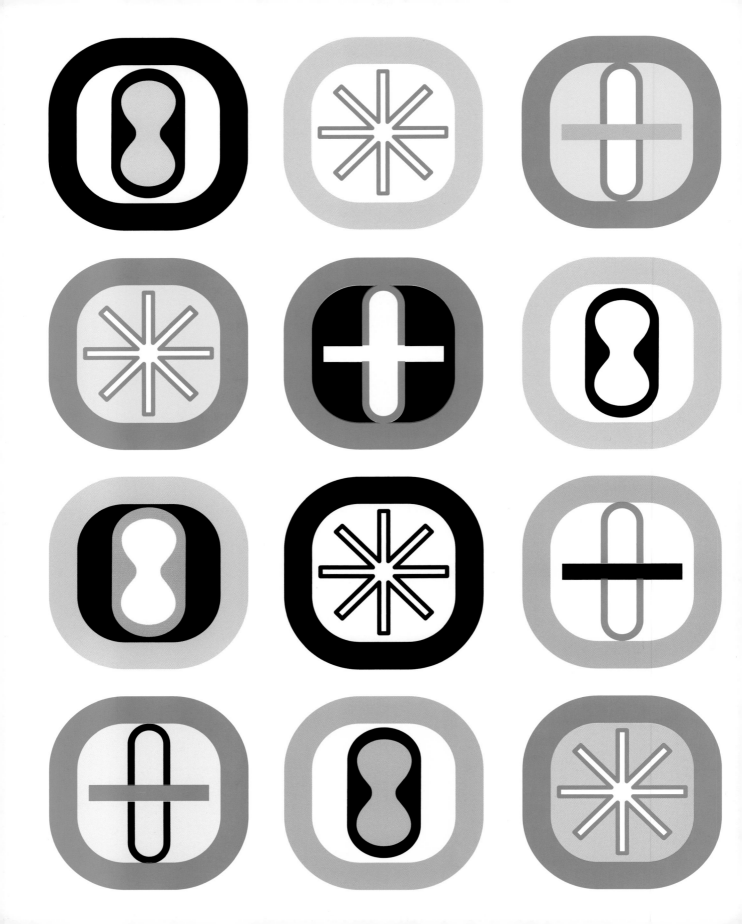

Mitte der 1980er Jahre frustrierte es mich zunehmend, banale Produkte für Firmen zu entwerfen, die Design, Ästhetik oder Schönheit überhaupt nicht ernst zu nehmen schienen. Das Problem war – konnte ich im Industriedesign tatsächlich meine Kreativität ausleben? War dort Raum für Poesie, Bedeutung, Liebe, Humor, künstlerische Vorschläge, bildhauerische Ideen oder malerische Produkte? Schließlich ist die Herstellung von Gebrauchsgegenständen ein Geschäft, und auch Design ist ein Geschäft – nur finde ich, unser Geschäft ist Schönheit und Einflussnahme auf die Kultur. Ich begann, meine Produkte mit Symbolen zu kennzeichnen, um meine Urheberschaft zu dokumentieren, weil man in Nordamerika, anders als in Europa, selten ein Produkt mit einem Namen etikettiert. Den großen Firmen war diese Vorstellung immer suspekt, weil sie glaubten, der Name des Designers würde den Markennamen in den Hintergrund drängen. Außerdem glaube ich, dass Design auf ihrer Prioritätenliste ziemlich weit unten stand und wenig Respekt genoss. Die Firmen betrachteten ihre Designer oft als reine Ingenieure. Traurigerweise sind wir Designer schlechte Techniker. Das ist manchmal immer noch so, obwohl wir heute schon manchmal als Unter-Marke wahrgenommen werden, wenn Firmen sich neue Märkte zu erschließen hoffen. Ich musste meinen Produkten ein „Markenzeichen" verpassen, meine subversive Signatur. Ich fügte ein kleines Symbol in das Gehäuse ein (an der Innenseite von High-Tech- und mechanischen Produkten wie einem Laptop, einem Elektrokocher oder einem Bohrer – die Projekte, an denen ich in den 1980ern bei KAN Industrial Design in Toronto arbeitete). Ich erinnere mich, dass ich, als ich in Bonettos Designbüro in Mailand beschäftigt war, einen Fernseher für Brionvega designte und ein Kreuz in das Gehäuse machte, so wie man seine Initialen in eine Parkbank ritzt. Ich hatte die leicht perverse Vorstellung, ich würde viele Jahre später das Produkt auf einem Flohmarkt wiedersehen und mein „Tag" darauf erkennen. Ich entwarf auch mit einigen befreundeten Architekten eine Modelinie, die ich Babel nannte, und die Symbole wurden zu einem neuen

hieroglyphischen Code auf Knöpfen, Taschen und Details. Die Linie entsprach meiner Überzeugung von einer universellen „One World". Die Symbole waren nonverbal, daher bedeuteten sie jedem gleich viel oder wenig, und jeder konnte sie interpretieren, wie er es für passend erachtete. Die Schönheit der Abstraktion wird immer in der Eigeninterpretation und der übergeordneten spirituellen Bedeutung liegen. Ich habe die Arbeit an diesen Symbolen über die letzten 20 Jahre immer wieder aufgenommen und sie weiterentwickelt, bis sie zu einem integralen Bestandteil meines Lebens wurden, was sogar so weit ging, dass ich sie mir zweimal im Jahr eintätowierte, jedes Symbol in einer anderen Stadt, um meine Auffassung von globaler Einheit zu unterstreichen. Ich suchte mir Städte aus, die Initiative in mir wecken, und ordnete jeder ein Symbol zu, das für mich diesen speziellen Ort am besten wiedergibt. Die Symbole schleichen sich über das Unterbewusstsein immer wieder in meine Arbeit ein – manchmal ganz unabsichtlich. Irgendwann begannen dann der Industrie und dem Publikum meine grafischen Symbole überall ins Auge zu springen wie zufällige Graffiti-Tags. 1997 beschloss ich, eine Serie von Mousepads mit den Symbolen herauszubringen, und das Projekt war weltweit so erfolgreich, dass diese Firmen mit 2-D-Projekten wie Teppichdesigns, Tapeten, Geschenkpapier, Fliesen, Laminaten, Bodenbelägen, Textilien und natürlich auch Gemälden auf mich zukommen. Ich habe nie verstanden, warum die Grafikwelt dieses Konzept nie aufgegriffen hat – es erschien mir so nahe liegend. Ich begann, meine „digitale" Kunst in Galerien auszustellen. Meine Frau Megan Lang machte ebenfalls so viel digitale Kunst, dass wir uns gegenseitig inspirierten – ihre Kunst berührte meine Produktlandschaft, und meine Produktwelt berührte ihre Kunst. Wir lasen jeden Monat mit religiösem Eifer *Artbyte*, *Wired* und *Mondo* und träumten von einem digitalen Spinnerparadies – einer multidimensionalen, bunten, energetischen, hypnotischen, kaleidoskopischen Welt. Meine Icons sind eine persönliche Sprache, sind zeitgenössische Hieroglyphen, ein Weg, der Welt eine Nachricht zu übermitteln.

ikons

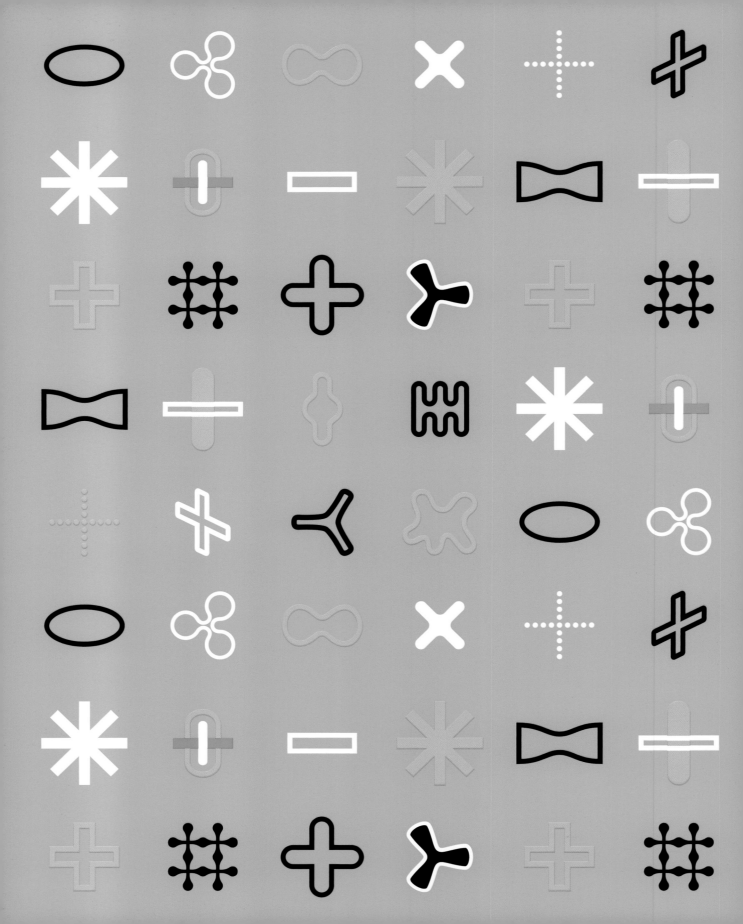

Au milieu des années 80, je me suis senti de plus en plus frustré de devoir concevoir des produits banals, pour des sociétés qui ne semblaient pas prendre au sérieux le design, l'esthétique, ou le beau. La question était de savoir si je pouvais vraiment être créatif dans le design industriel. S'il y avait là de la place pour le poétique, le sens, l'amour, l'humour, l'artistique, le sculptural, ou l'esthétique ? Après tout, le produit doit se vendre, et le design aussi, même si je pense que nous appartenons davantage au domaine de la beauté et de la culture. Je me suis mis à fabriquer des produits en leur accolant des symboles, afin de dire que j'en étais l'auteur, et parce que, à la différence de l'Europe, le design, en Amérique du Nord, attache rarement un nom à un produit. Les marques ont toujours refusé cette idée, craignant que le nom des designers n'éclipse celui de la marque. En outre, je crois que le design était en bas de la liste des priorités, en matière d'importance ou de respect. Nombre de compagnies considéraient les designers comme des sortes de petits ingénieurs. Malheureusement, nous sommes de mauvais ingénieurs. C'est parfois encore le cas, bien que nous soyons maintenant considérés comme attachés à la marque, dans le sens où celles-ci peuvent gagner et ouvrir de nouveaux marchés. J'ai donc eu besoin de « marquer » mes produits. Ainsi ma signature s'est faite subversive. Je suis allé jusqu'à inscrire un symbole dans le moule (à l'intérieur de produits high-tech ou mécaniques, tels qu'un ordinateur portable, une bouilloire électrique ou une perceuse – projets sur lesquels je travaillais dans les années 80, chez KAN à Toronto). Je me souviens de Bonetto à Milan, où j'ai conçu un téléviseur pour Brionvega, et inscrit une croix à l'intérieur du moule, comme quand on grave ses initiales dans le banc d'un parc. J'entretenais l'idée perverse que, des années plus tard, j'allais retrouver le produit sur un marché aux puces et y verrais mon « tag ». J'ai également – avec quelques amis architectes – lancé une ligne de vêtements, appelée Babel, et les symboles se

sont transformés en un code hiéroglyphique sur les boutons, les poches et autres détails. De fait, je pense que nous vivons dans un « monde unique » et universel. Les symboles étaient verbaux, donc abstraits, et chacun pouvait les interpréter à sa guise. La beauté de l'abstraction sera toujours du domaine de l'interprétation individuelle et la signification hautement spirituelle. Les mots sont précis, mais les formes sont vagues. J'ai continué à travailler et développer ces symboles au cours de ces vingt dernières années, et ils ont fini par faire partie intégrante de ma vie, au point que je me tatoue moi-même, deux fois, par an, chaque symbole confectionné dans une ville différente, pour poursuivre ma quête et ma foi en une unité globale. J'ai choisi des villes où je me sens plein d'initiative, et j'ai choisi chaque symbole en reflet d'un lieu spécifique. Inconsciemment, les symboles continuent à s'infiltrer dans mon travail – parfois sans intention. Alors les compagnies et le public ont vu apparaître mes symboles graphiques, comme des sortes de graffitis. En 1997, j'ai décidé de faire une collection de tapis pour souris d'ordinateur, avec ces symboles, et ce projet a connu un tel succès mondial, que les compagnies se sont mises à me commander des projets en 2-d, pour des tapis, du papier peint, du papier-cadeau, du carrelage, du stratifié, des planchers, des textiles, et bien sûr des peintures. Je n'ai jamais compris pourquoi le monde graphique n'a pas adopté un concept aussi évident. J'ai commencé à montrer, dans des galeries, mon art « numérique ». Mon épouse Megan Lang s'est aussi tellement investie là-dedans, que nous nous sommes mutuellement inspirés : son art a touché mes produits et mes produits ont touché son art. Nous avons lu religieusement, chaque mois, *Artbyte, Wired* et *Mondo*, et nous avons rêvé d'un monde utopique numérique, qui serait multidimensionnel, énergétique, hypnotique, kaléidoscopique. Mes icônes constituent un langage personnel, une écriture de hiéroglyphiques contemporains, donc une manière de transmettre le monde.

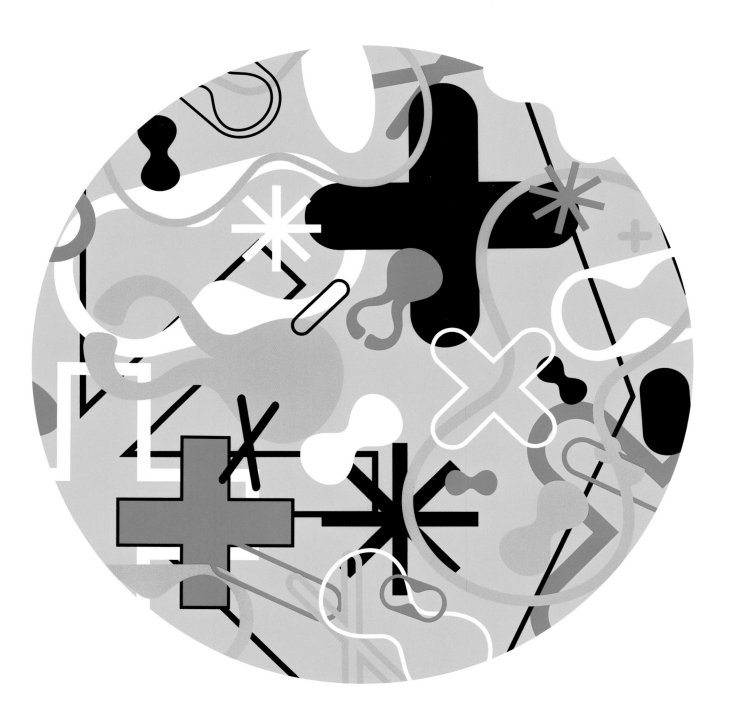

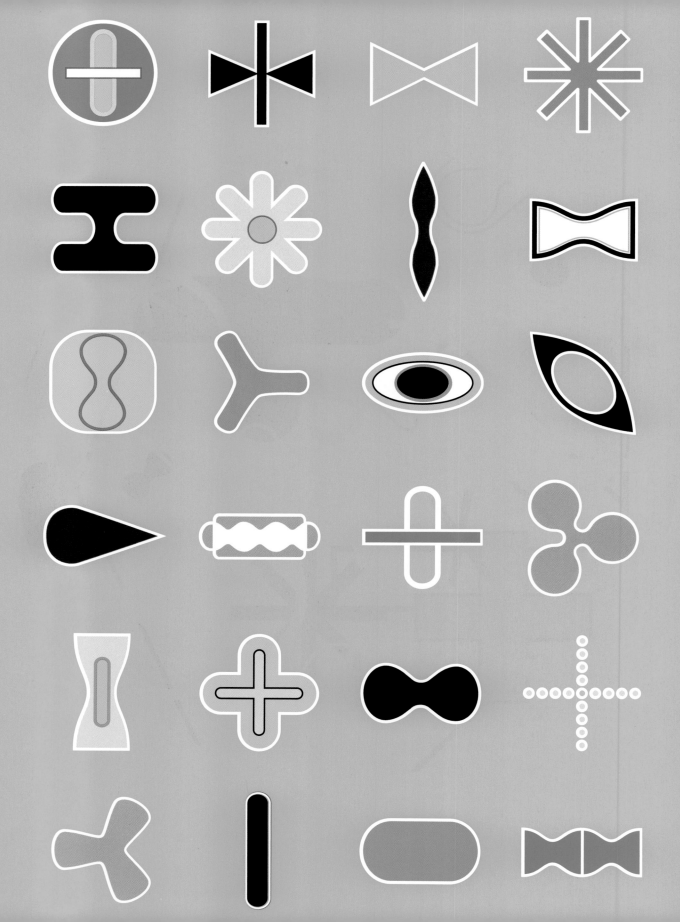

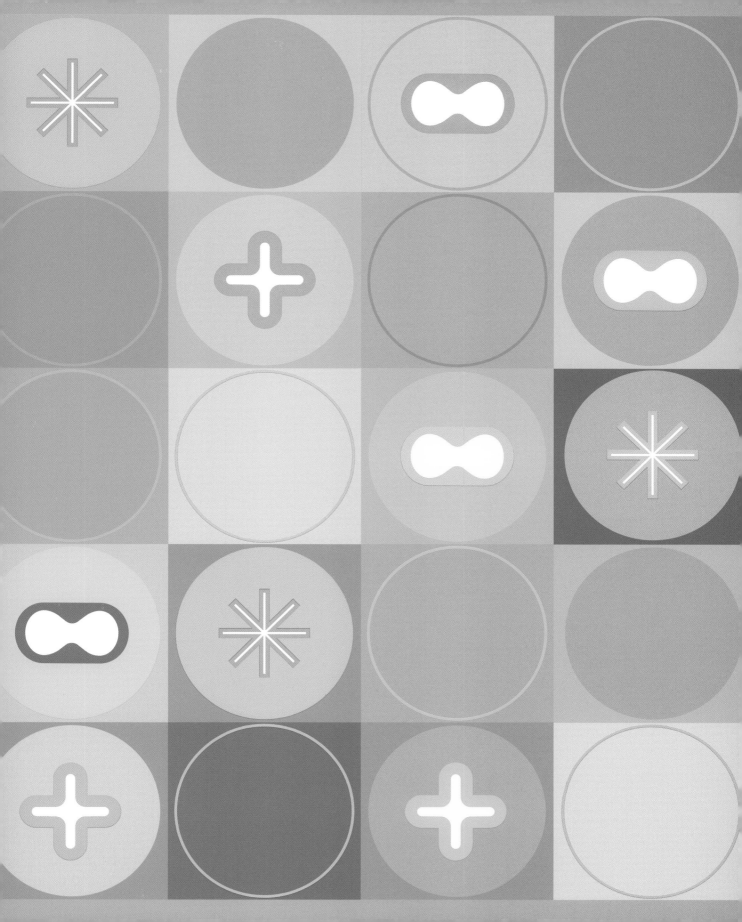

SEMIRAMIS

iOiSHii

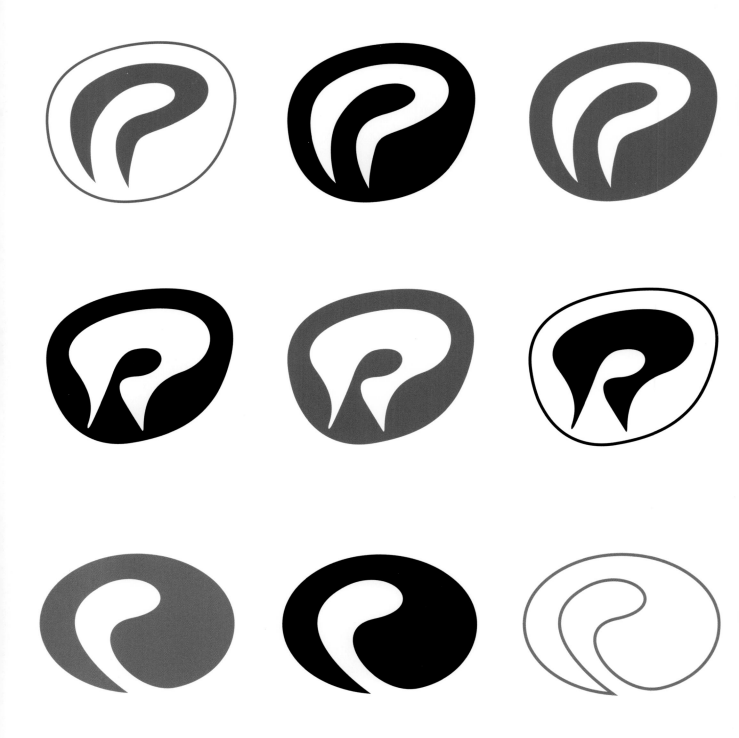

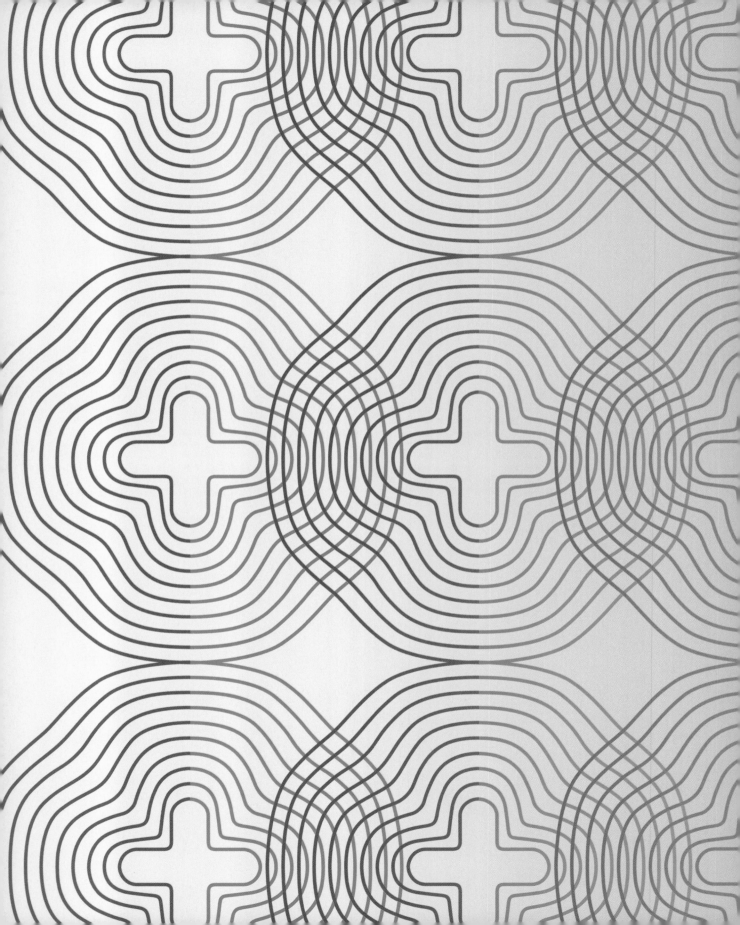

graphiks

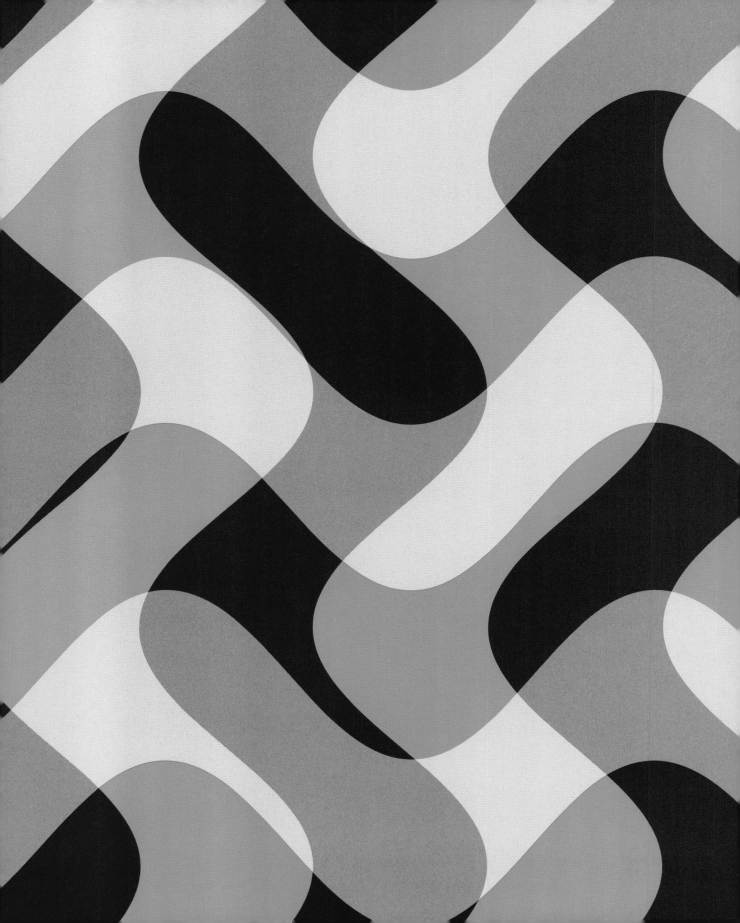

Early in my career I questioned industrial design firms' involvement with graphics. It seemed the graphic industry was being continually trodden upon by others. I felt that specialization in graphic communications should be left to the fontizers and the typo-stylists, the masters of the flat surface. Gradually, I noticed the merging of graphic and product design—graphics becoming more 3-D and products becoming more 2-D. One minute we were reading glossies and the next we were hypertextualizing on the Web. The graphic industries' hand-crafted type, perfection of subtle kerning, and progressive exactitude seem almost irrelevant today, as the computer can do the job for us more efficiently. Do we need this precision or care? Are text and image flippant, omnipresent, and exhaustive? Information has hyper-saturated our world. Visual and moving images seem to flash by us without any real knowledge or consideration (on our part) of the complexities of the software, creativity, and diligence that went into them. We are now so used to the cleverness of imagery that we can't distinguish real from unreal—a complete and, I would add, beautiful blur.

My real interest in the graphic world started as a child, during the hypergraphic sixties. At 18, I got my first design job doing telephones for Mitel in Canada, and at that time the painful process was ink, rub-on Letraset, and vellum on a drafting table. I remember thinking of simple hierarchies for lettering the keys on the board, choosing a palette of baby blue, lime, and orange for certain keys floating against a matt black computer to describe the separation between numeric, QWERTY, and operational. I chose Universe, Futura, and Metro fonts—which spoke (to me) of the future, of precision, of sharpness. The logos had names like Superset and numbers like XS2000; I did not realize then that the year 2000 would have so much excess or access—it seemed so far away. I thought we were entering an incredibly hypertrophic computer age, where we would be living in something far beyond films like *2001* or *THX 1138*. I modified the fonts on those

logos and created continuous marks by rounding, joining, and personalizing the letters, like NASA's or CN's marks. In 1984, at Bonetto's office in Italy, I was asked to design the LaCimbali logo. Remembering Raymond Loewy's argument about subtle, almost unnoticeable transitioning, I updated the fonts with an italic slant and exaggerated those pointed non-serifs, connecting all the letters to communicate progress and movement, virtually leaning into the future. Loewy believed in 'evolving' the logo so as not to disturb the memorable 'brand' signifiers, thereby moving consumers slowly but surely into the next generation of the brand. Ironically, we are now so steeped in this concept that years are spent on changes so subtle that one must question whether it really matters and who really cares. I think the entire notion of mark—image and logo—as static and perfect sacred form is irrelevant now. The mark should change continually and speak of our new multi-dimensional world. For me, design should communicate the present, which in turn affects the future.

For an industrial designer, graphics can be a form of survival, thanks to the immediacy and abundance of work available in that field. Years ago in England, as manufacturing dissipated, many prominent designers turned to graphics, and a plethora of major changes in graphics affected the way we process and utilize type and image. But overall, the desktop-publishing phenomenon changed the industry more, because we can all do it (even if we do it badly). The excrescence of imagery is such that we take for granted the talent that has been prevalent in even the most banal and everyday graphics up to this point.

graphiks

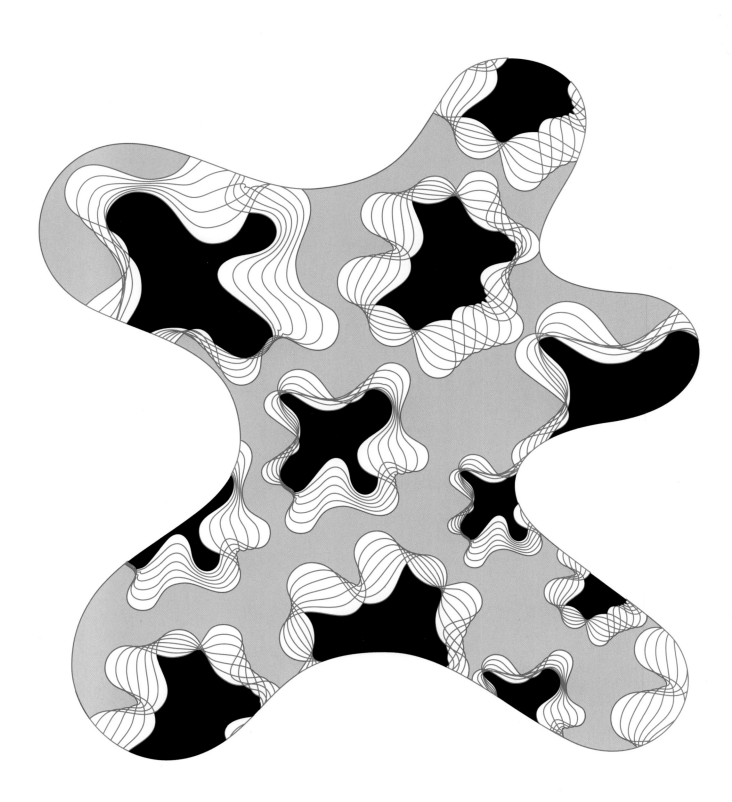

Dass sich Firmen für Industriedesign mit Grafik befassen, habe ich schon früh in meiner Berufslaufbahn als fragwürdig empfunden. Es kam mir so vor, als würde die grafische Industrie von den anderen ständig untergebuttert. Ich fand, die Spezialisierung auf grafische Kommunikation sollte den Schriftentwicklern und Typostylisten überlassen bleiben, den Meistern der ebenen Fläche. Nach und nach bemerkte ich dann, wie die Übergänge zwischen Grafik- und Produktdesign zunehmend fließender wurden – die Grafiken wurden dreidimensionaler und die Produkte zweidimensionaler. In der einen Minute blätterten wir ein Hochglanzmagazin durch, in der nächsten hypertextualisierten wir schon im Web. Die von Hand gefertigte Type der grafischen Industrie, die Perfektionierung der subtilen Unterschneidung, des penibel festgelegten Zeilenabstands erscheint heute beinahe irrelevant, da der Computer diese Arbeit viel effizienter für uns tun kann. Brauchen wir Präzision und Sorgfalt noch? Sind Text und Bild beliebig, omnipräsent und umfassend? Unsere Welt ist mit Information übersättigt. Visuelle und bewegte Bilder scheinen an uns vorbeizuflitzen, ohne dass wir die komplexen Zusammenhänge von Softwarekenntnissen, Kreativität und Sorgfalt, die darin Eingang gefunden haben, überhaupt ahnen oder zu würdigen wissen. Wir sind an den cleveren Einsatz von Bildern mittlerweile so gewöhnt, dass wir Reales und Irreales nicht auseinander halten können – eine vollkommene und, wie ich hinzufügen möchte, wunderschöne Trübung des Blicks.

Mein eigentliches Interesse an der Grafikwelt erwachte während meiner Kindheit in den hypergrafischen Sixties. Mit 18 bekam ich meinen ersten Designerjob, Telefone für Mitel in Kanada, und der schmerzvolle Prozess umfasste damals Tusche, Rubbelbuchstaben von Letraset und Pergamentpapier auf einem Zeichentisch. Ich erinnere mich, dass ich mir für die Beschriftung der Tasten simple Hierarchien ausdachte und dass ich, um die numerische, alphabetische und die Funktionstastenbelegung zu unterscheiden, für bestimmte Tasten eine Palette von Babyblau, Limonengrün und Orange wählte,

die sich von dem mattschwarzen Gehäuse abhoben. Als Schrift-Fonts wählte ich Universe, Futura und Metro, die (für mich) für Zukunft, Präzision und Eleganz standen. Die Logos trugen Namen wie Superset und Nummern wie XS2000; damals war mir nicht bewusst, dass das Jahr 2000 uns so viel Exzess bzw. Access bringen würde – es war noch so weit weg. Ich dachte, wir stünden am Beginn eines unglaublich hypertrophen Computerzeitalters, wo unsere Lebensbedingungen das, was man aus Filmen wie *2001* oder *THX 1138* kannte, bei weitem hinter sich lassen würden. Ich modifizierte die Schriftarten auf diesen Logos und kreierte durchgehende Zeichen, indem ich die Buchstaben rundete, verband und individuell anpasste, wie bei den Zeichen von NASA oder CN. 1984 wurde ich in Bonettos Büro in Italien mit dem Design des LaCimbali-Logos betraut. Eingedenk Raymond Loewys Plädoyer für eine subtile, fast unmerkliche Umformung aktualisierte ich die Schriften mit einer leichten Kursivierung und verstärkte die spitzen Non-Serifen, wobei ich alle Buchstaben aneinander stoßen ließ, um den Eindruck von Fortschritt und Bewegung zu vermitteln, indem sie sich buchstäblich in die Zukunft neigten. Loewy war dafür, das Logo zu „entwickeln", um den Wiedererkennungswert der „Marken"-Kennzeichen nicht zu gefährden und damit den Verbraucher langsam, aber sicher in die Zukunft der Marke zu geleiten. Es entbehrt nicht einer gewissen Ironie, aber wir haben dieses Konzept mittlerweile so verinnerlicht, dass Jahre in Änderungen investiert werden, die so subtil sind, dass man sich fragen muss, ob es darauf wirklich ankommt oder sich überhaupt jemand darum kümmert. Ich glaube, die ganze Vorstellung von „Markenzeichen" und Logo als statisch und absolut sakrosankt hat sich mittlerweile überlebt. Das Markenzeichen sollte sich kontinuierlich verändern und von unserer neuen, multidimensionalen Welt sprechen. Für mich sollte Design die Gegenwart wiedergeben, was wiederum Einfluss auf die Zukunft nimmt.

graphiks

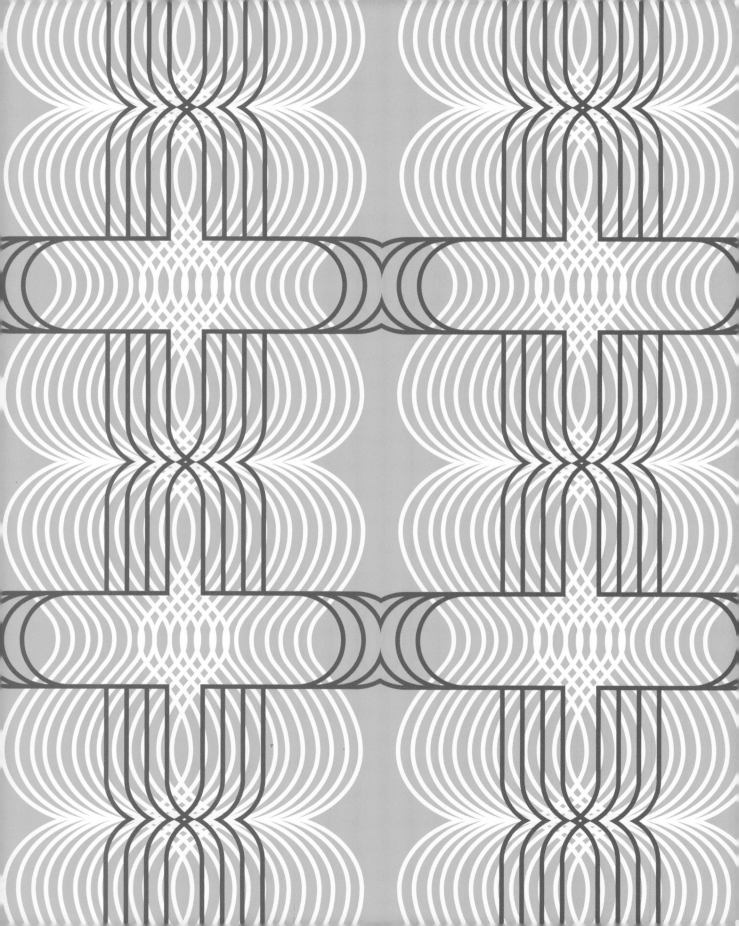

Tôt dans ma carrière, je me suis interrogé sur le rôle que jouaient les sociétés de design industriel, en matière de graphisme. Il me semblait que ce secteur était continuellement écrasé par les autres. Je pensais donc qu'il conviendrait de le confier aux typographes et aux typo-stylistes, ces maîtres de la surface plane. Peu à peu, j'ai noté la fusion entre graphisme et design – le premier s'opérant davantage en 3-d, le second en 2-d. Tantôt on lisait des magazines de luxe, tantôt on se livrait à l'hyper-textualisation, sur la Toile. Les industries graphiques de type artisanal, avec la perfection et l'exactitude subtile de leurs polices de caractères, semblent presque complète-ment dépassées, aujourd'hui où l'ordinateur peut faire ce travail de manière bien plus efficace. Avons-nous besoin de cette précision ou de ce soin ? Le texte et l'image sont-ils désinvoltes, omniprésents, et exhaustifs ? Notre monde est hyper saturé d'informations. Les images visuelles et mobiles semblent clignoter autour de nous, sans transmettre de véritable connaissance, ni de com-préhension (de notre part) pour la complexité que repré-sente le savoir des logiciels, la créativité et l'application qui les ont engendrés. Aujourd'hui, nous sommes tant habitués à l'intelligence des images que nous sommes incapables de discerner le réel de l'irréel, lesquels se fon-dent totalement et magnifiquement l'un dans l'autre.

Mon intérêt pour le monde graphique a commencé quand j'étais enfant, dans les années 60, années hyper-graphiques. A 18 ans, j'ai décroché mon premier boulot de designer pour Mitel, au Canada. A l'époque, le travail s'effectuait encore à l'encre, avec Letraset et vélin, sur une table à dessin. Je me revois en train d'organiser des hiérarchies pour placer les lettres sur le clavier, de choisir une palette de bleu ciel, vert et orange pour certaines lettres, sur un ordinateur noir mat, pour marquer la diffé-rence entre les touches portant les chiffres, les lettres et les commandes. J'avais choisi les polices Univers, Futura, et Métro qui (pour moi) annonçaient l'avenir et la préci-sion du trait. Les logos avaient pour nom Superset et des nombres comme XS2000. Je ne me suis pas rendu compte, à l'époque, que l'année 2000 serait la marque

de tant d'excès ou d'accès : elle me semblait alors si loin-taine. Je pensais que nous entrions dans une ère d'ordi-nateurs, incroyablement hypertrophique, où nous vivrions dans quelque chose bien au-delà de films comme 2001 ou THX 1138. J'ai modifié la police de ces logos et créé des lignes continues en arrondissant, reliant et personna-lisant les lettres, comme pour la NASA ou CN. En 1984, l'agence italienne Bonetto m'a invité à concevoir le logo de LaCimbali. Me souvenant de l'argument de Raymond Loewy quant à une transition subtile, passant presque inaperçue, j'ai actualisé les polices avec une pente d'ita-lique, exagéré les linéales, relié entre elles toutes les lettres, pour exprimer le progrès et le mouvement qui, vir-tuellement, se penchaient vers l'avenir. Loewey pensait qu'il fallait « faire évoluer le logo » mais sans déranger le « signifiant » de la marque, donc bousculer le consomma-teur, lentement mais sûrement, pour l'amener vers la pro-chaine génération de la marque. Ironiquement, nous sommes aujourd'hui tellement engagés dans ce concept, que des années s'écoulent sur des changements si sub-tils, qu'on en vient à douter de leur efficacité et de leur impact. Je pense que la notion de marque–image et de logo, en tant que forme sacrée et statique, n'est plus per-tinente aujourd'hui. La marque devrait changer continuel-lement, afin d'insister sur notre nouveau monde multidi-mensionnel. Pour moi, le design doit communiquer le présent, lequel, à son tour, affecte l'avenir.

Pour un designer industriel, le graphisme peut être une forme de survie, grâce à l'urgence et à l'abondance de travail dans ce domaine. Il y a des années en Angle-terre, au moment où la fabrication se tarissait, beaucoup de designers de renom se sont tournés vers le graphis-me. Ainsi, une pléthore de changements majeurs est venue marquer notre manière de traiter et d'utiliser le genre et l'image. De plus, le phénomène d'édition par desktop a totalement transformé l'industrie, car nous pou-vons tous le faire, (même si nous le faisons mal). Le foi-sonnement d'images est tel que nous ne pouvons que saluer le talent qui a réussi à s'exprimer, jusque-là, dans le graphisme le plus banal et le plus quotidien.

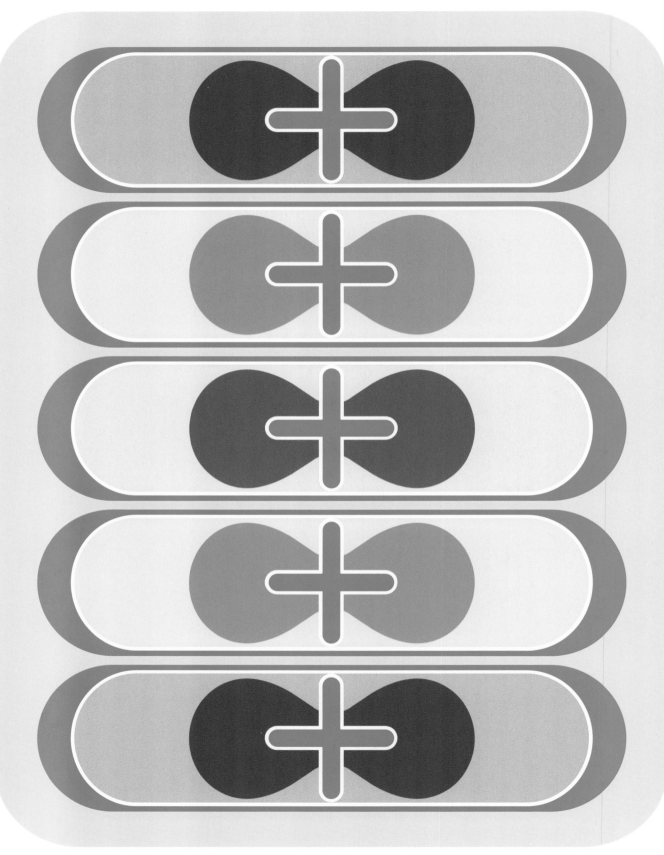

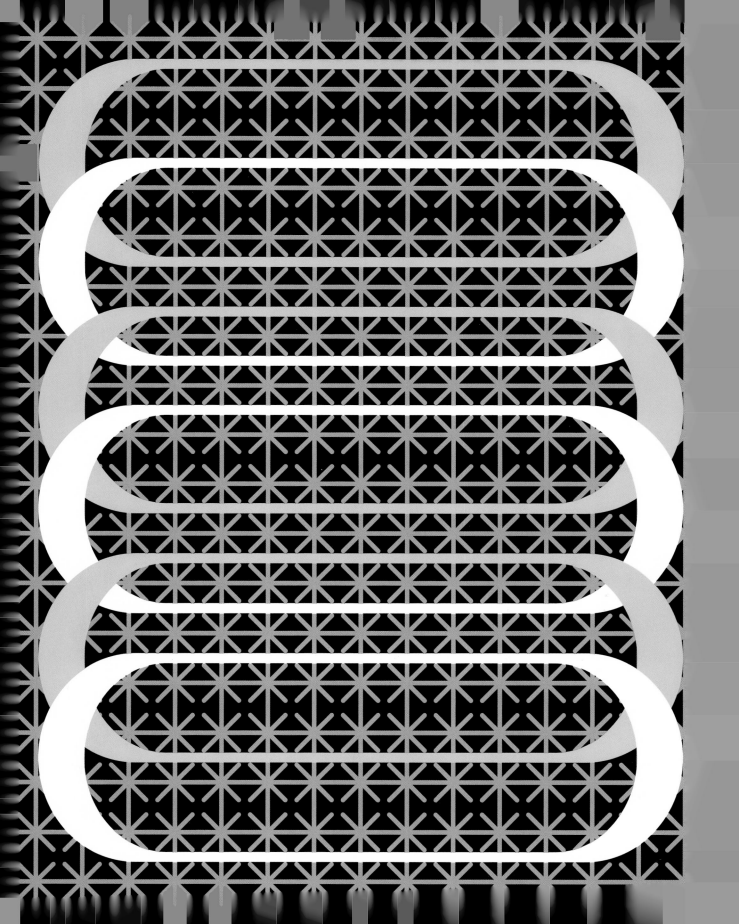

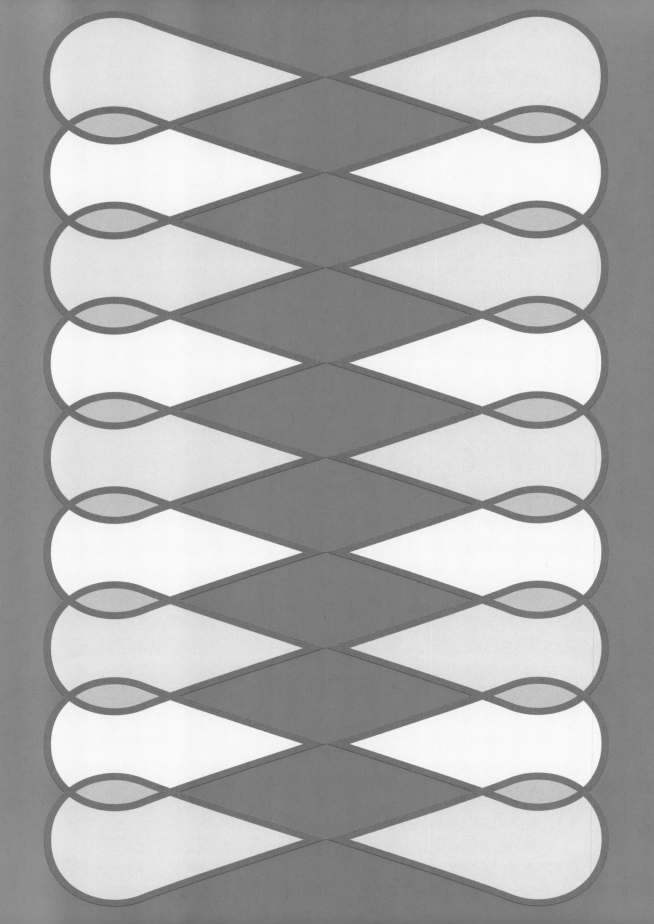

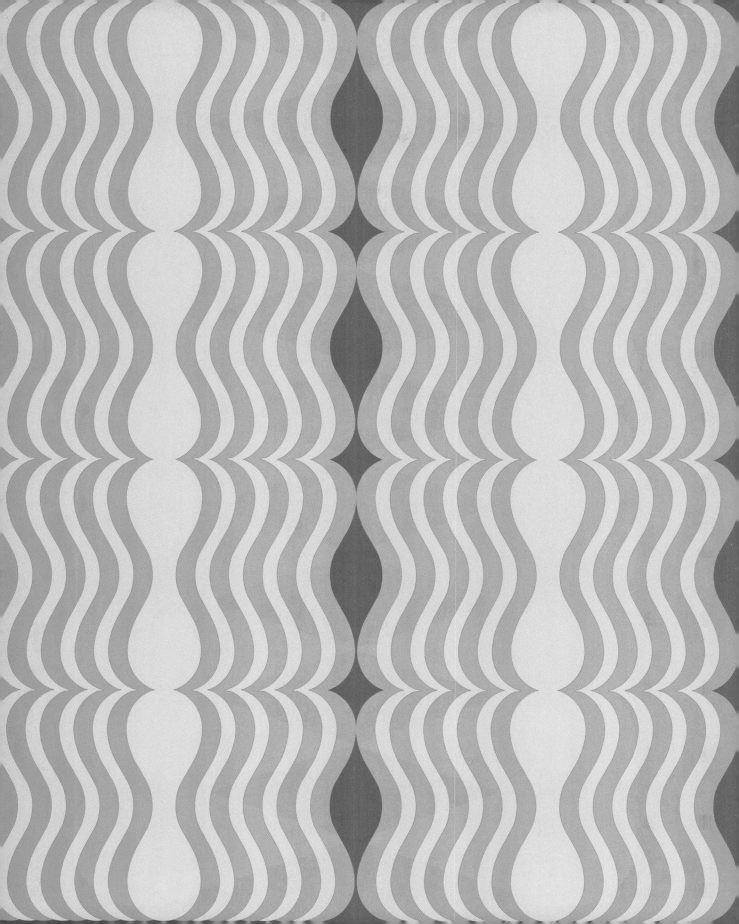

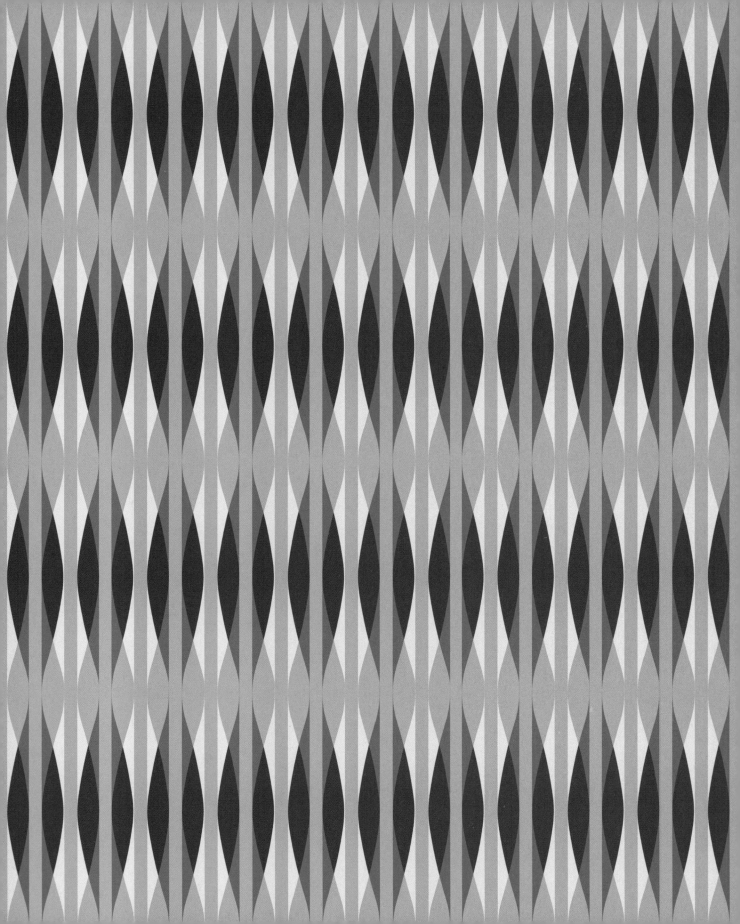

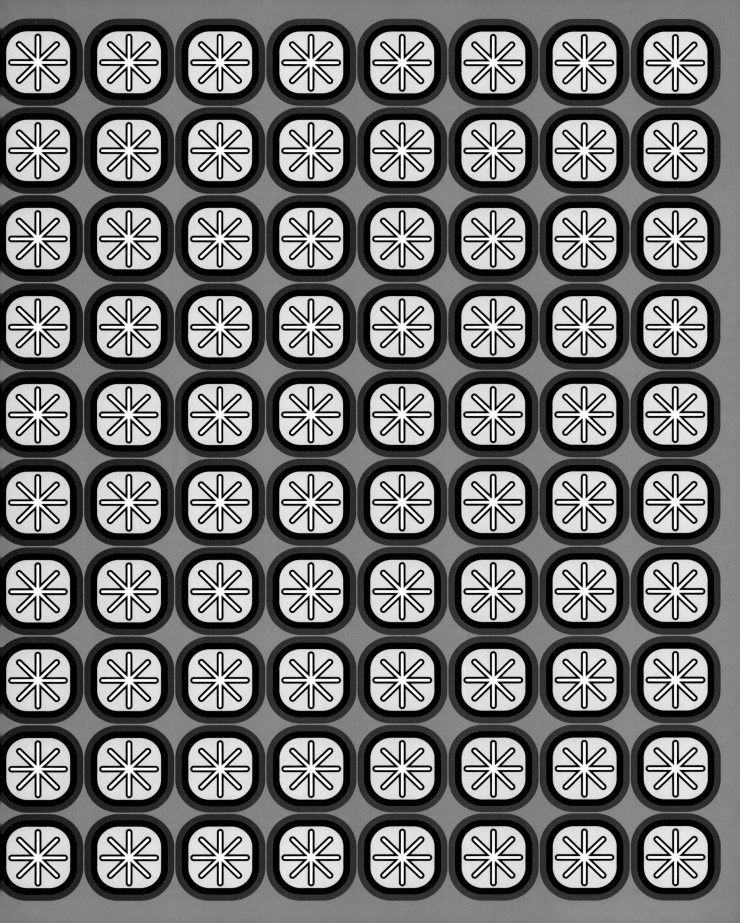

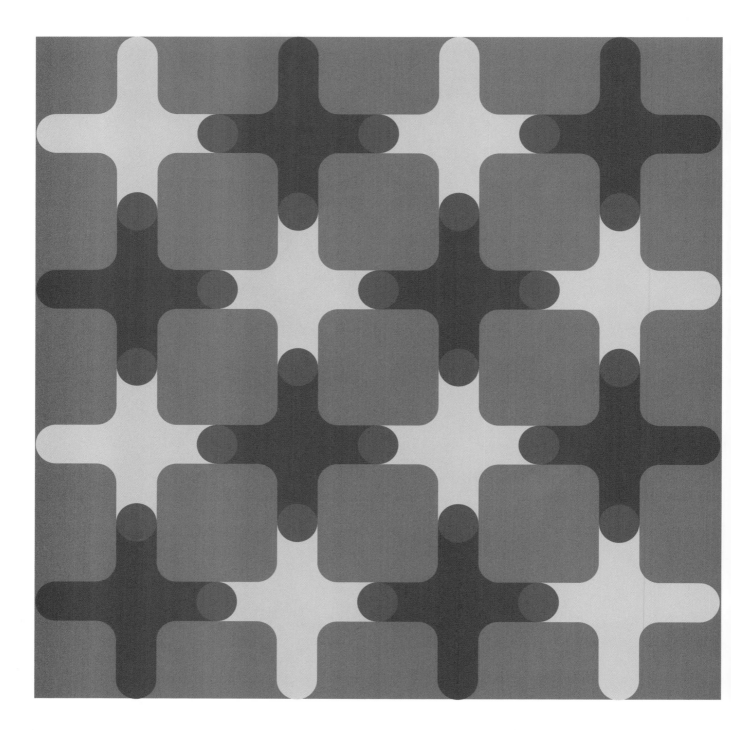

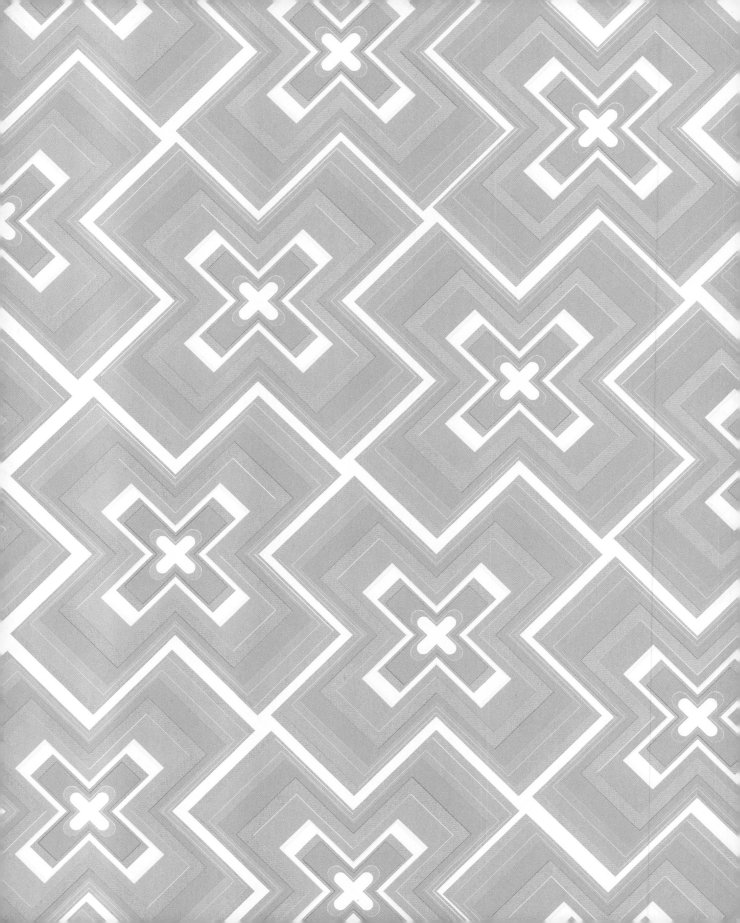

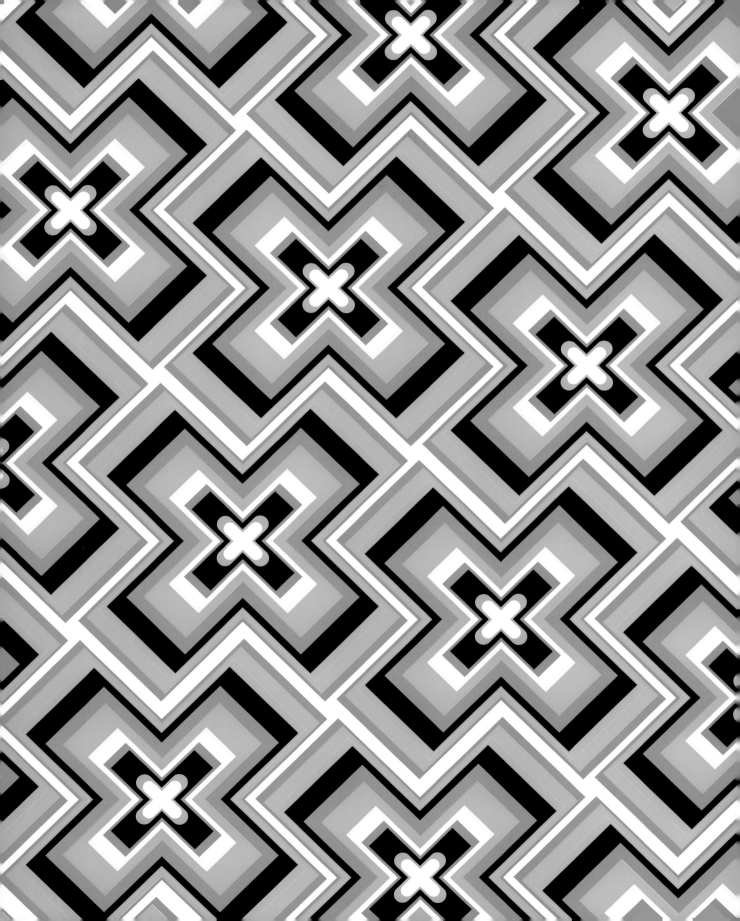

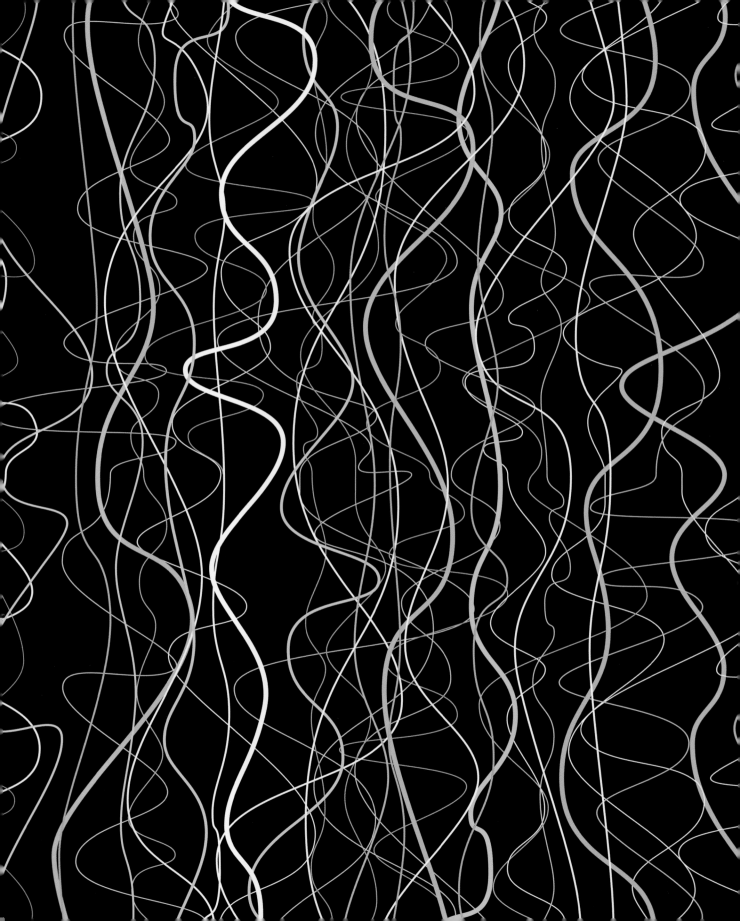

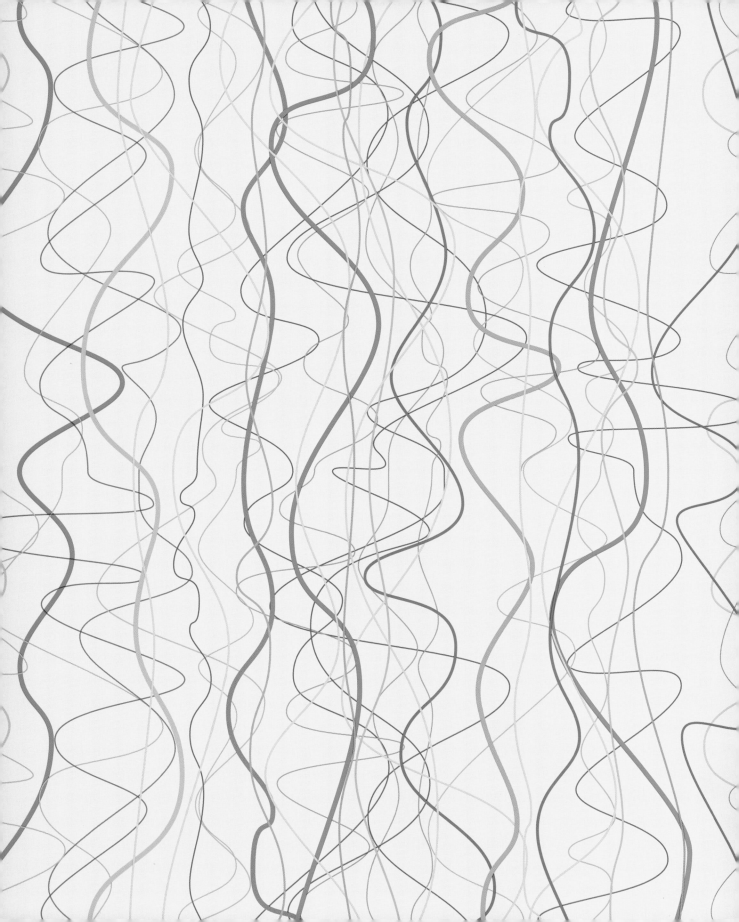

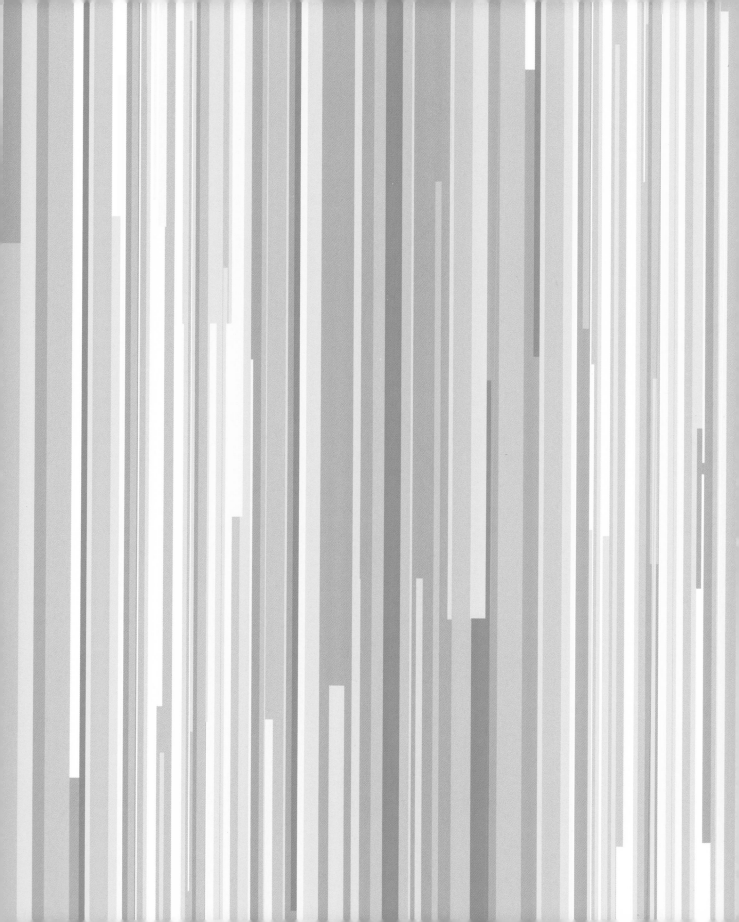

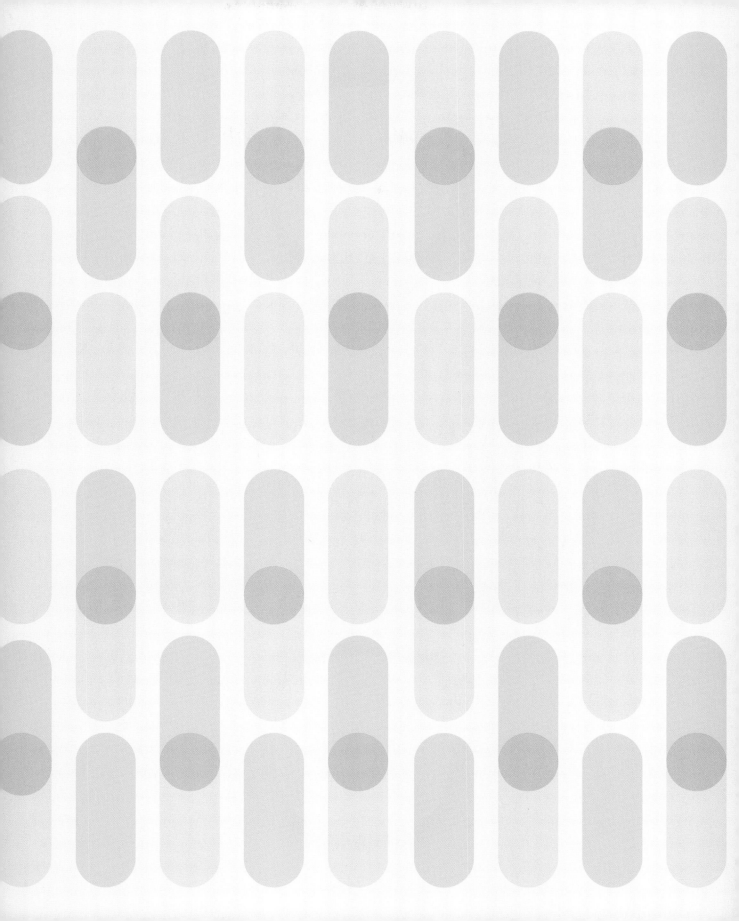

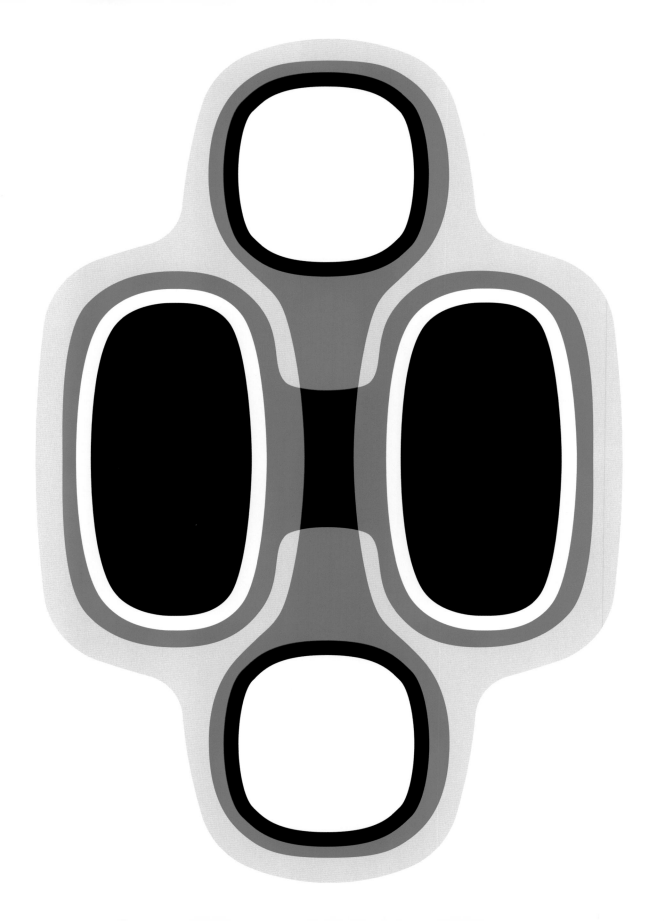

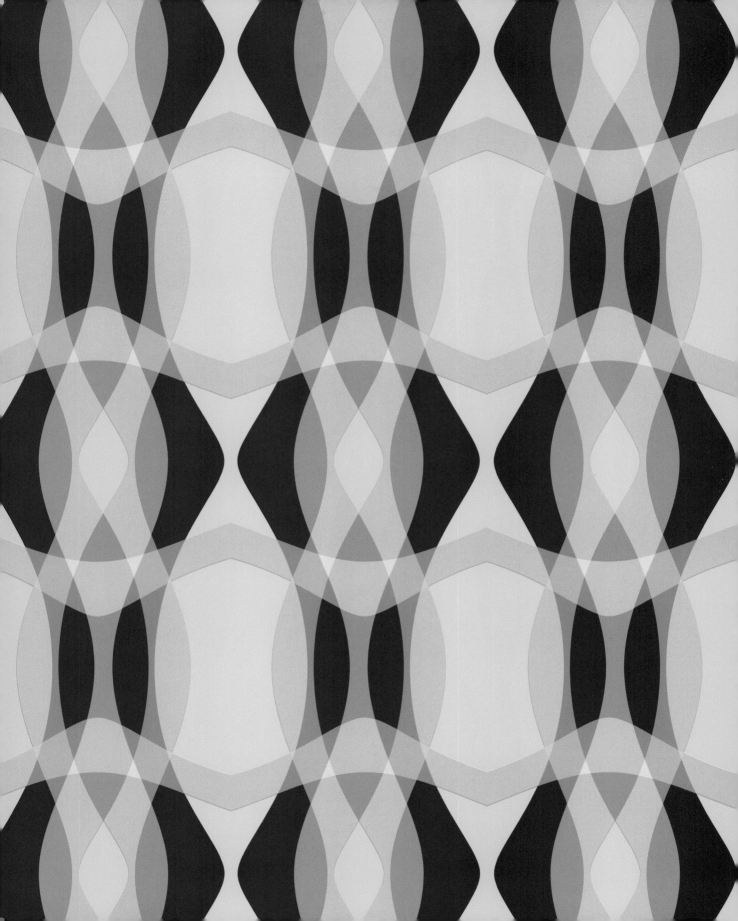

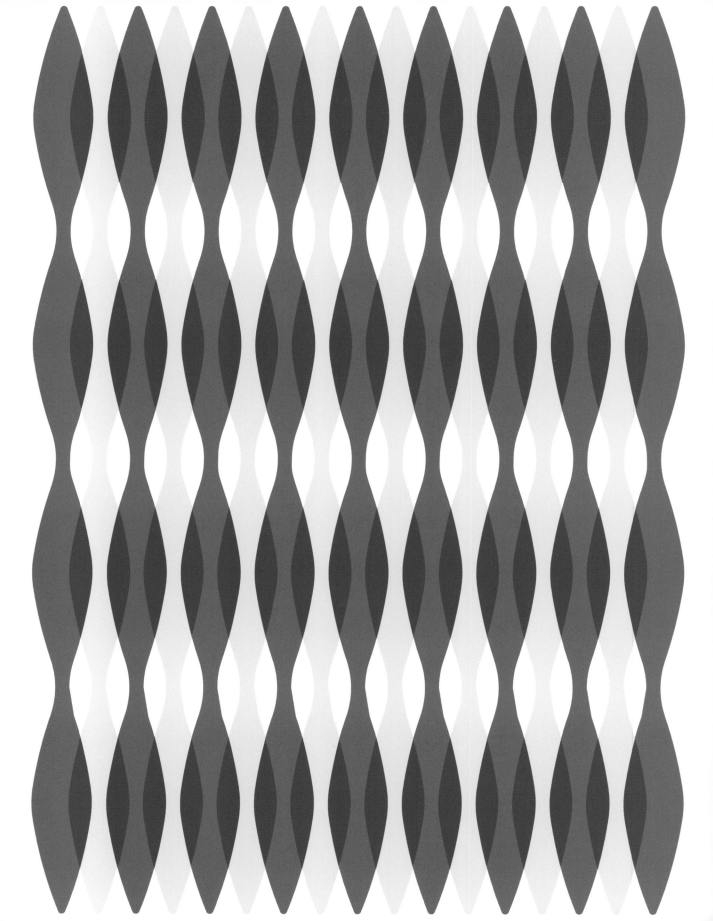

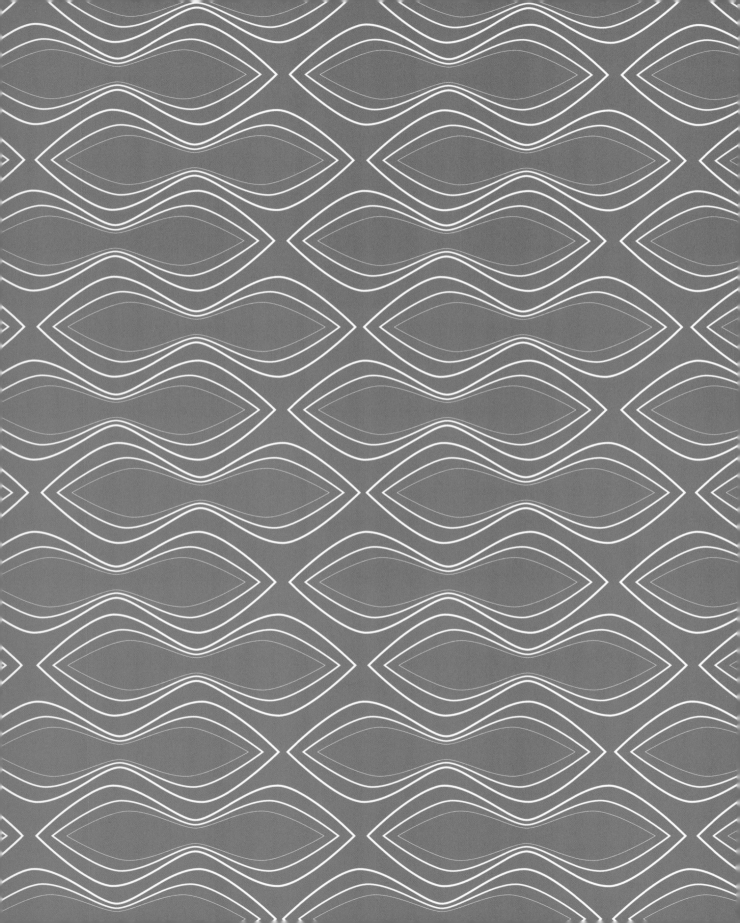

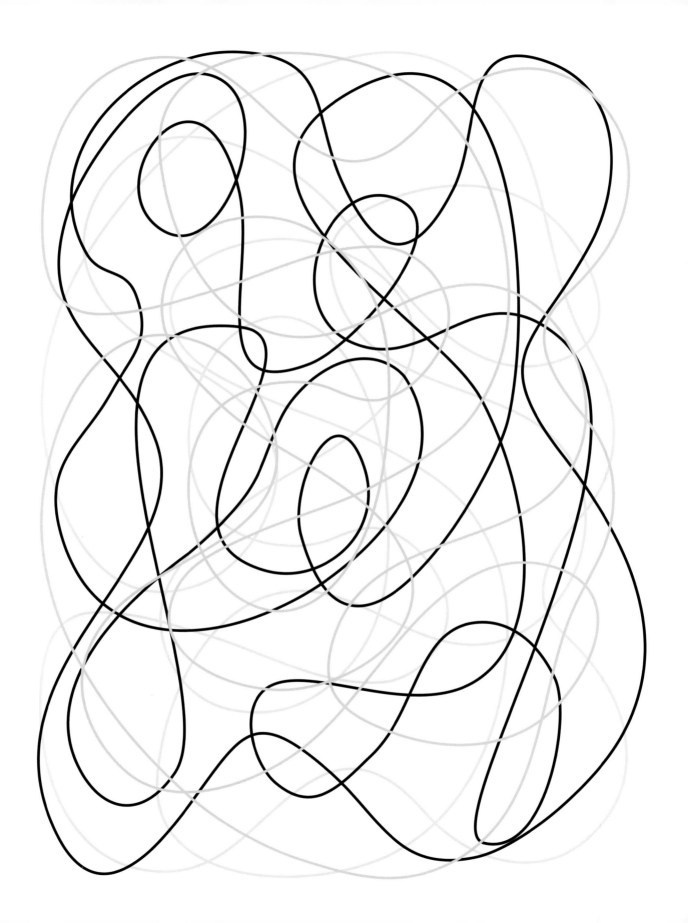

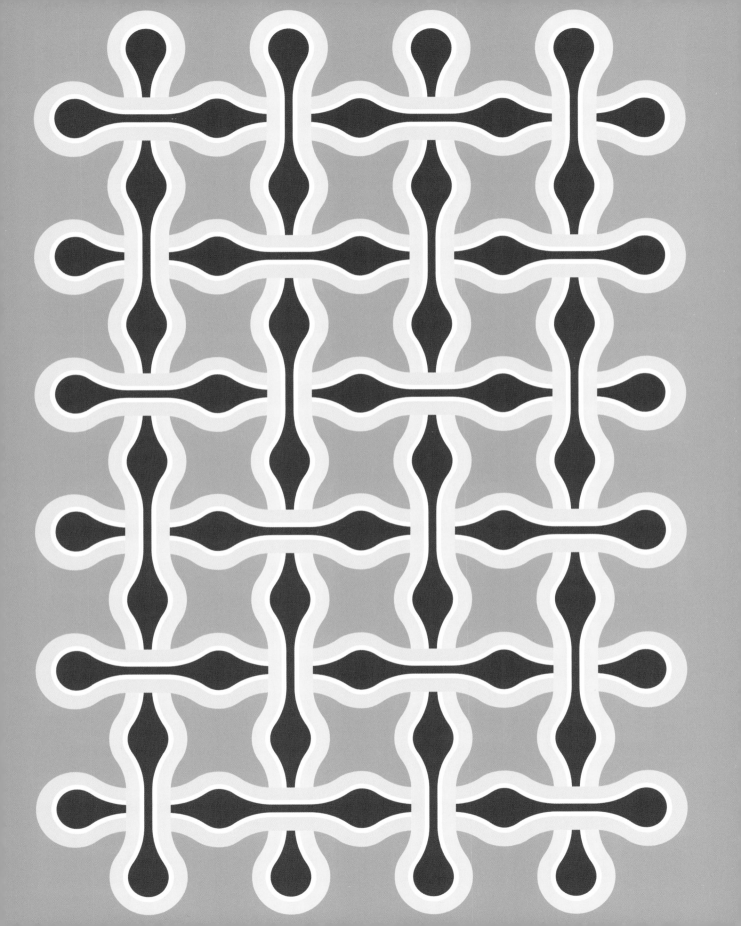

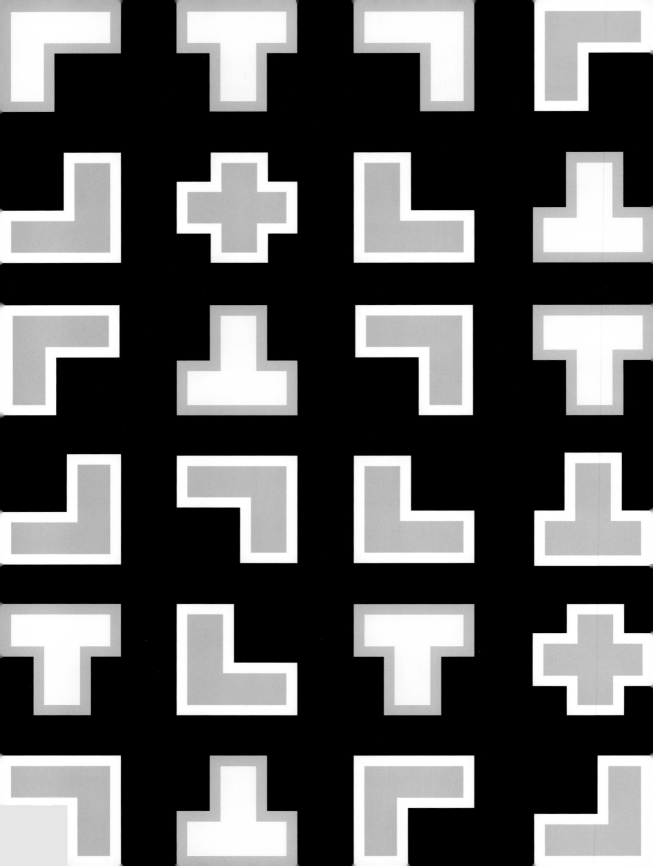

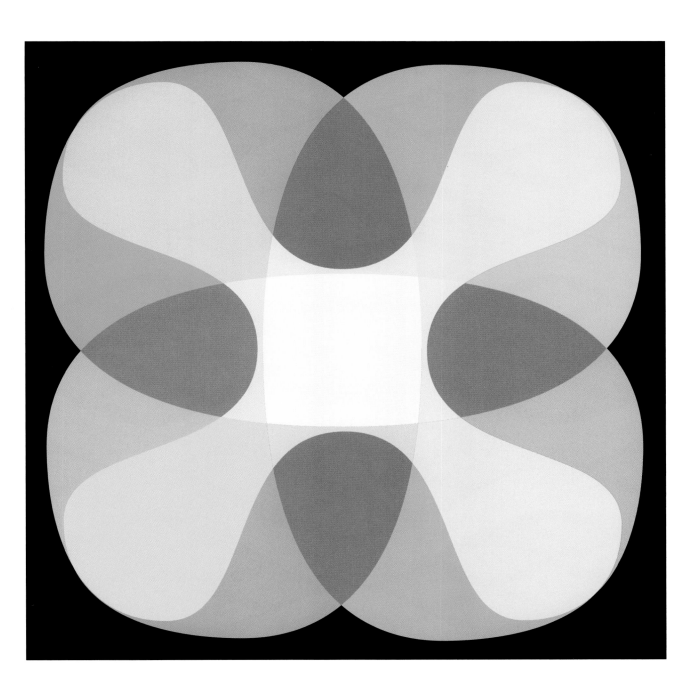

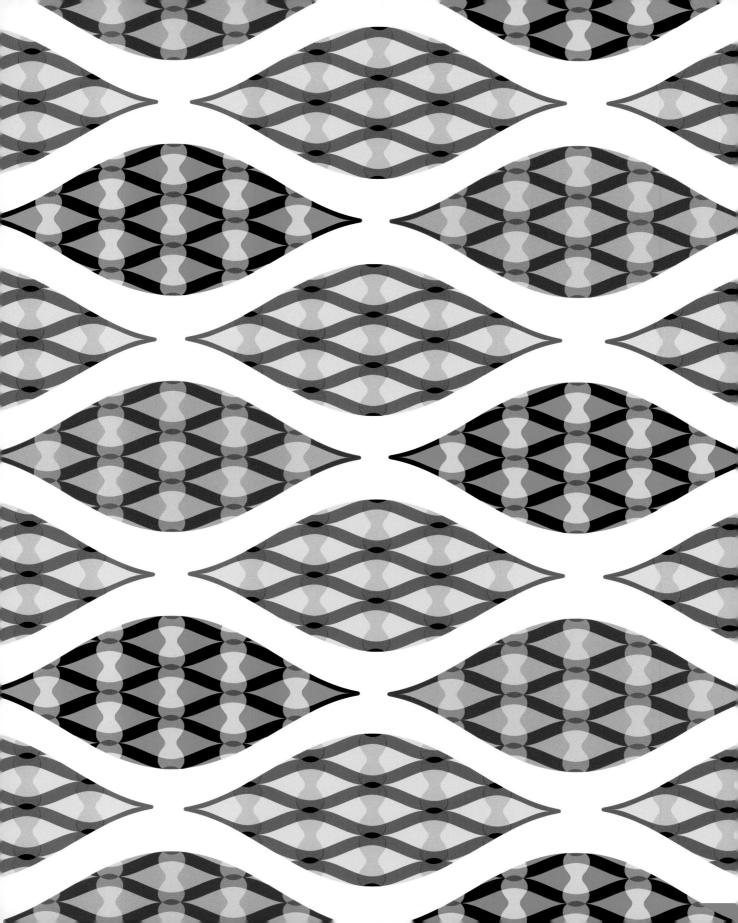

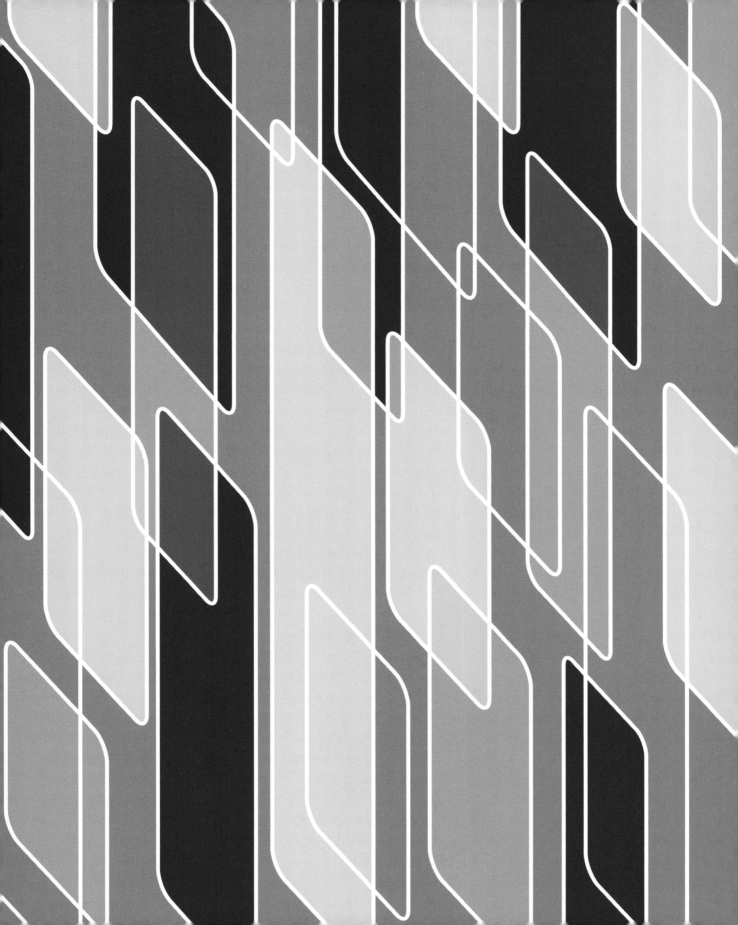

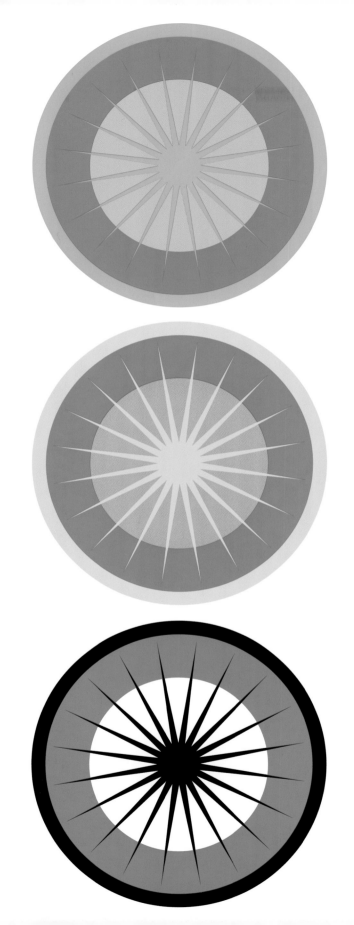

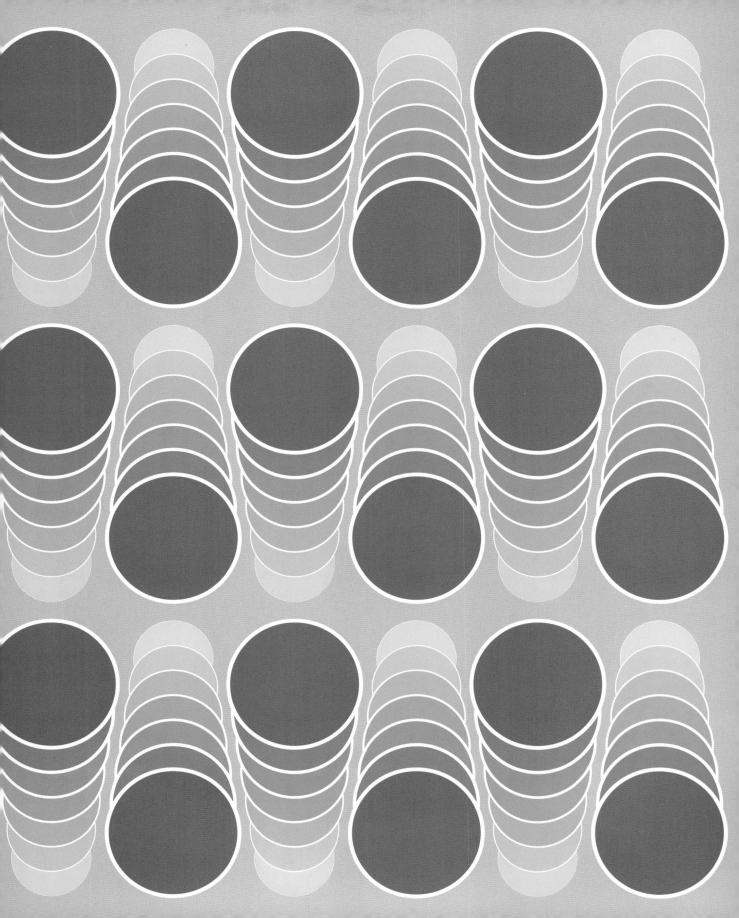

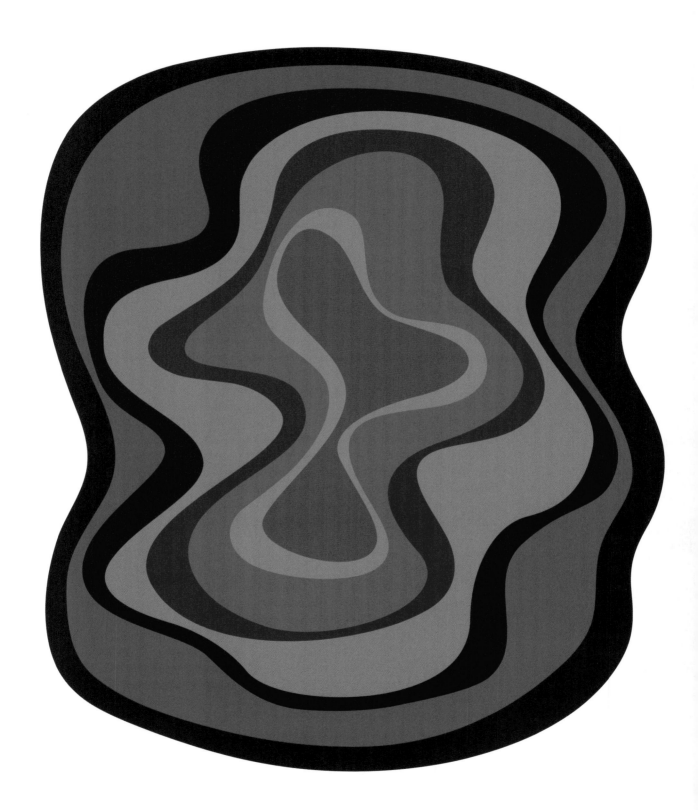

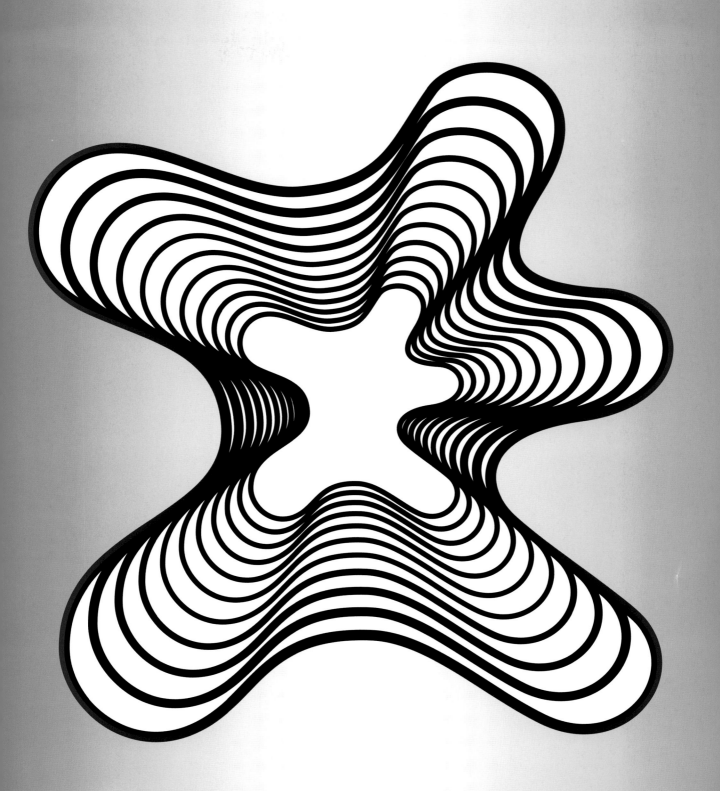

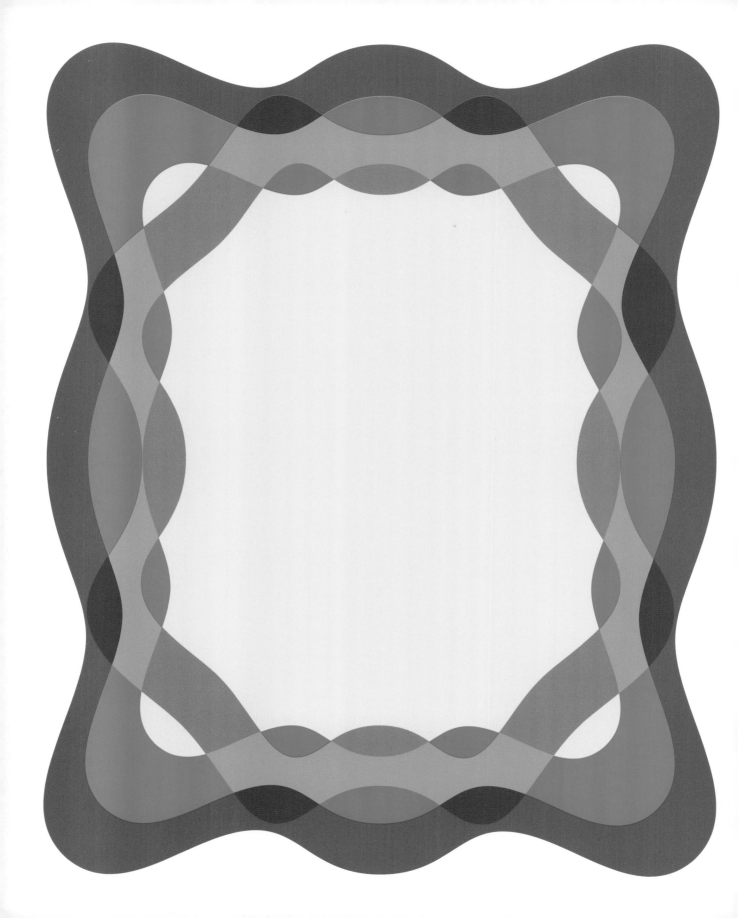

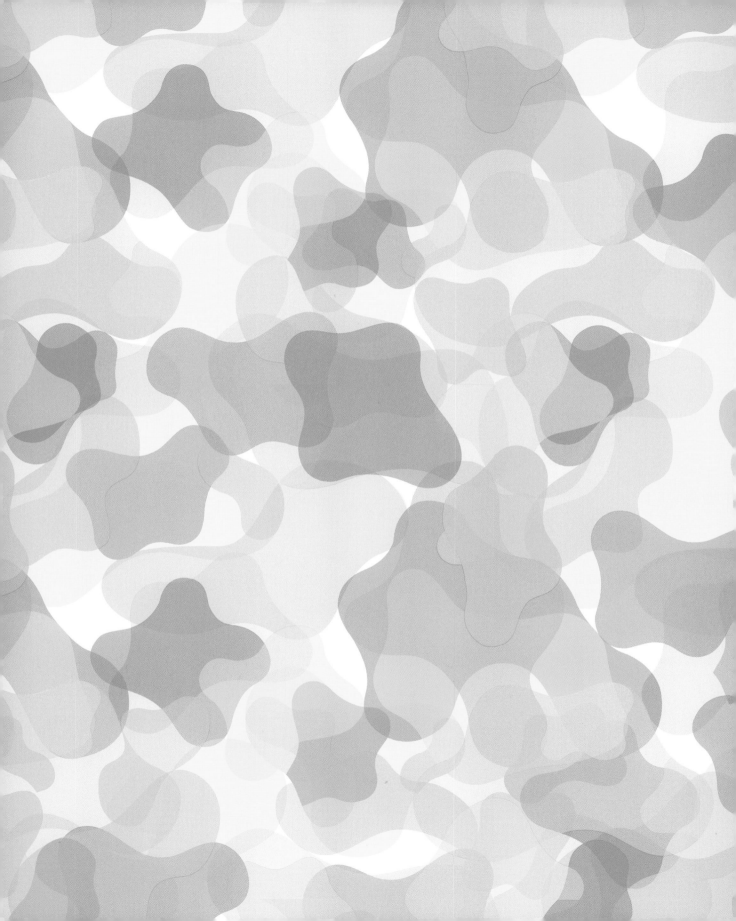

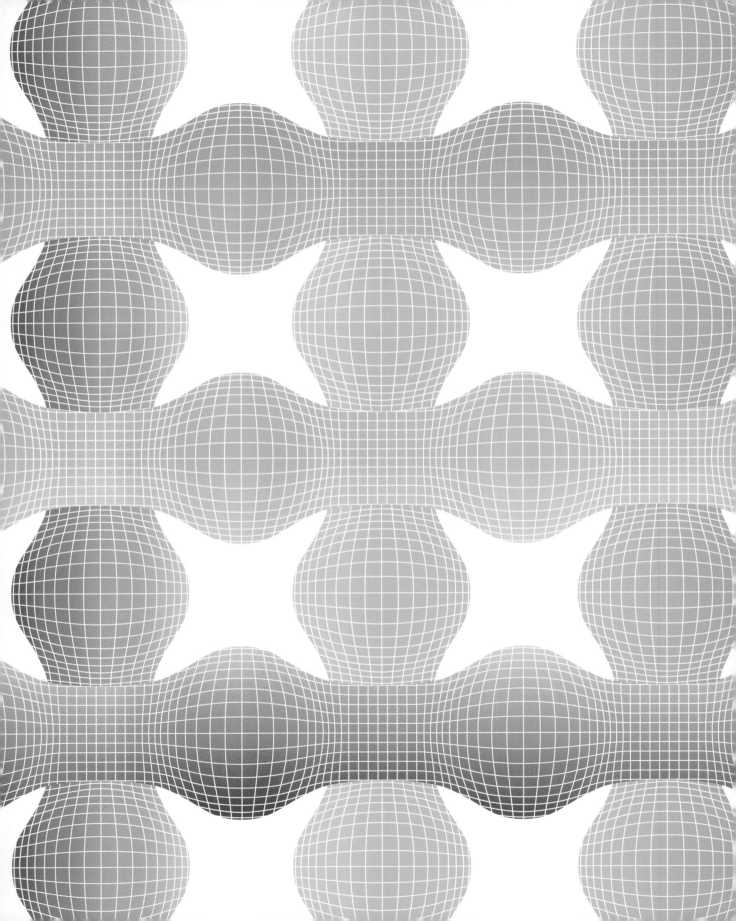

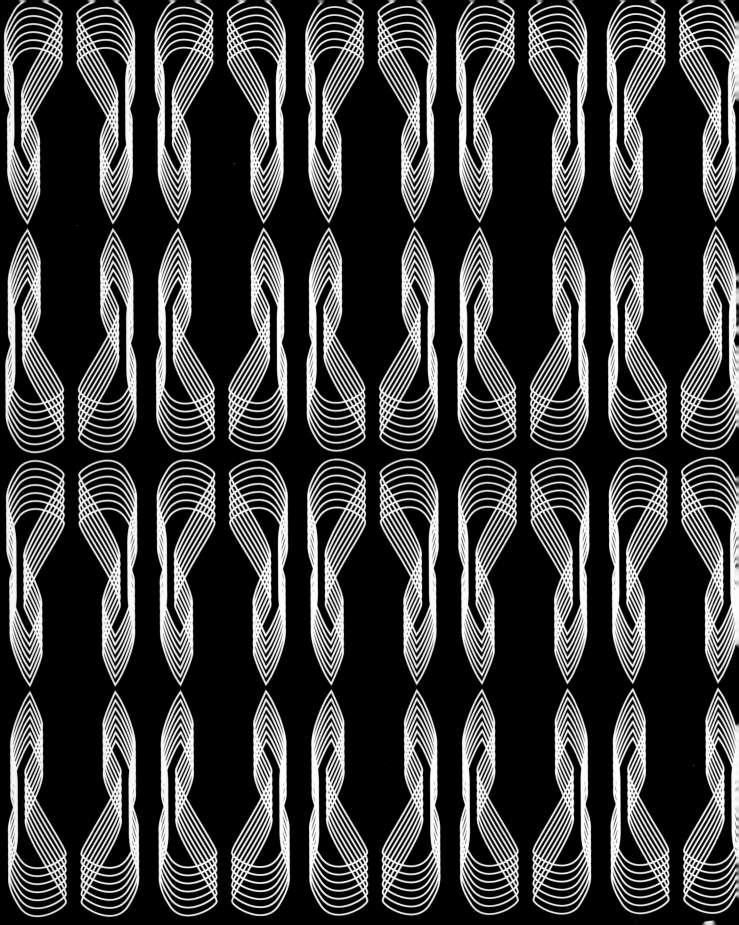

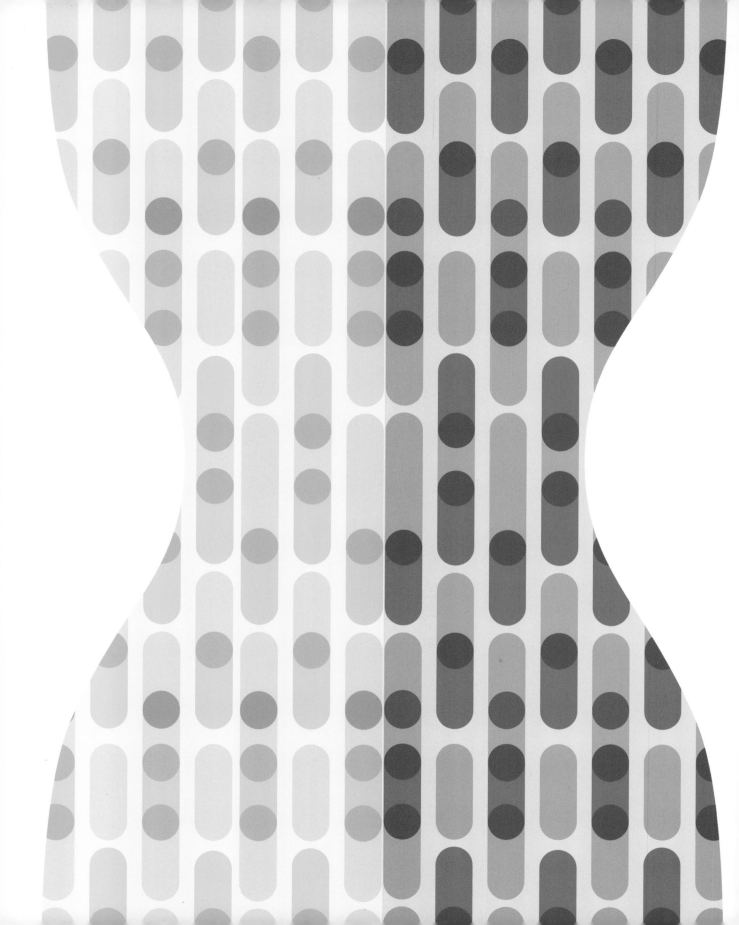

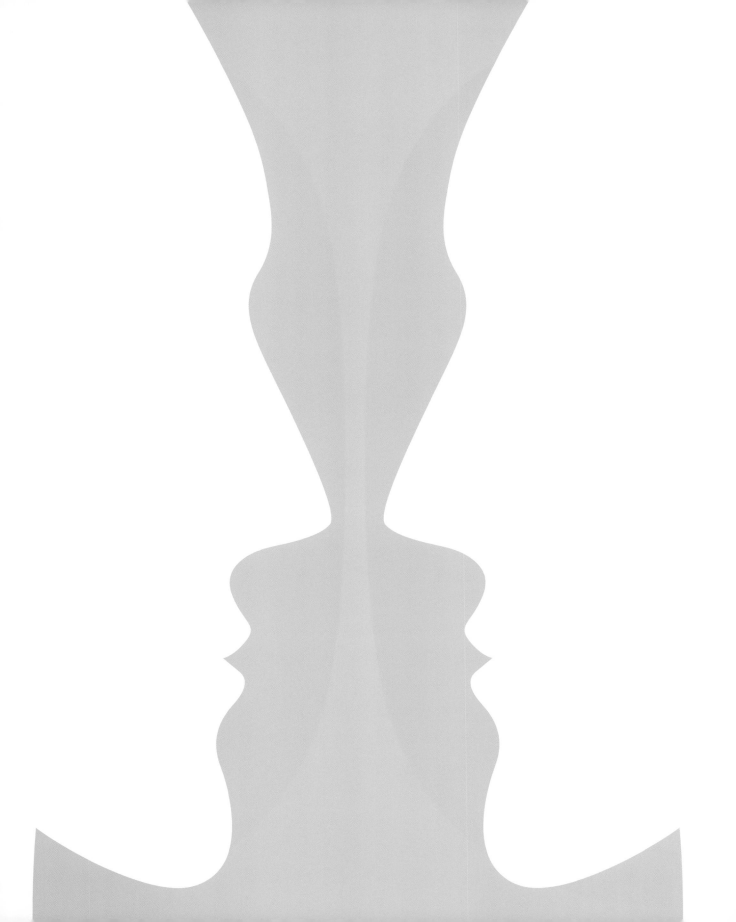

10101010101010101010
12121212121212121212
13131313131313131313
14141414141414141414

01234567890123456 7
89012345678901234 5
67890123456789012 3
45678901234567890 1

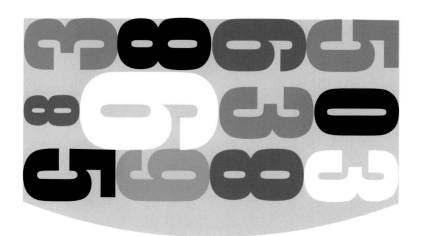

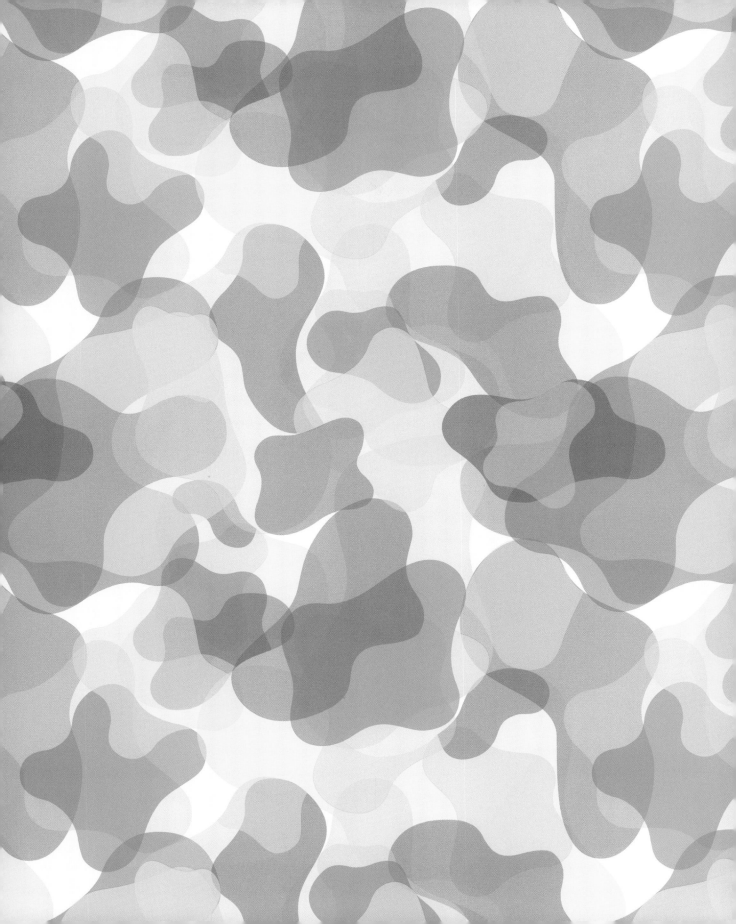

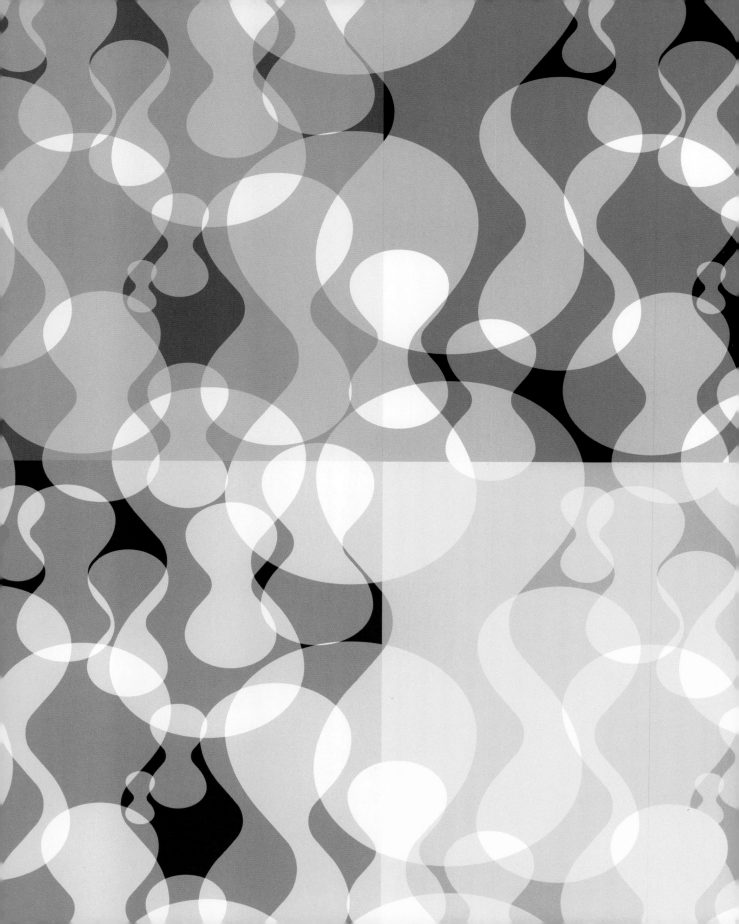

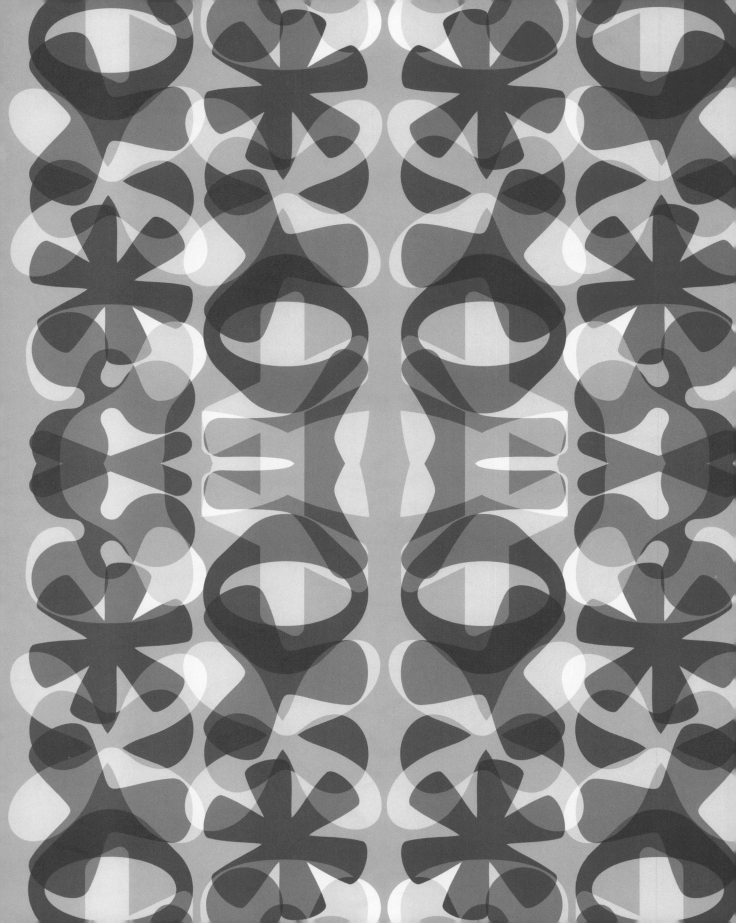

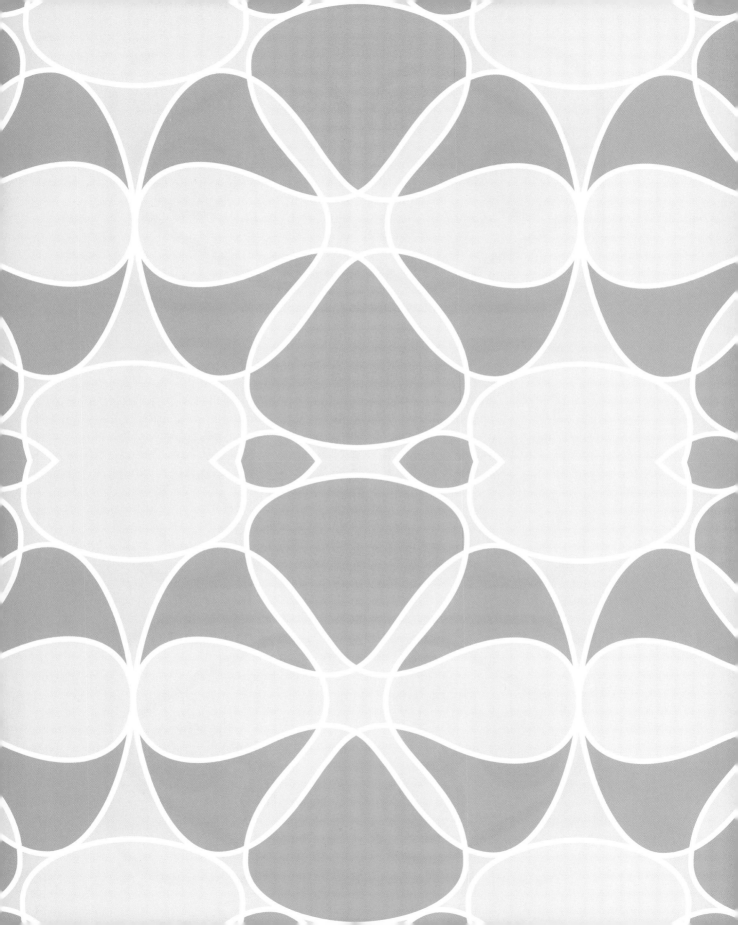

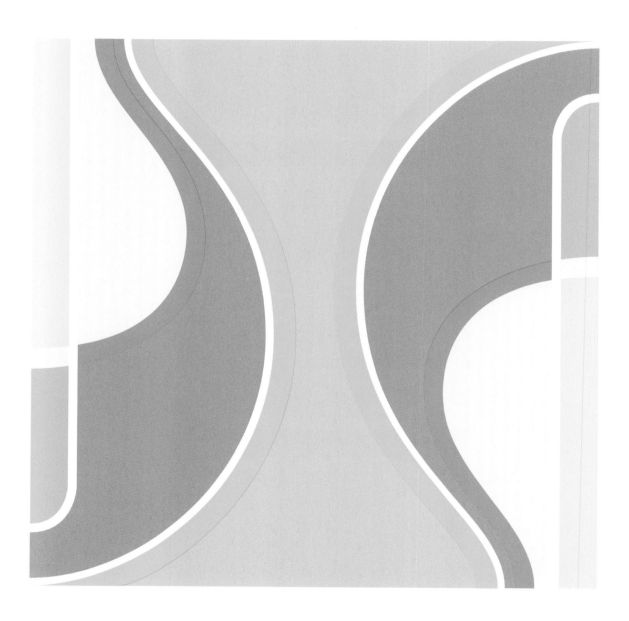

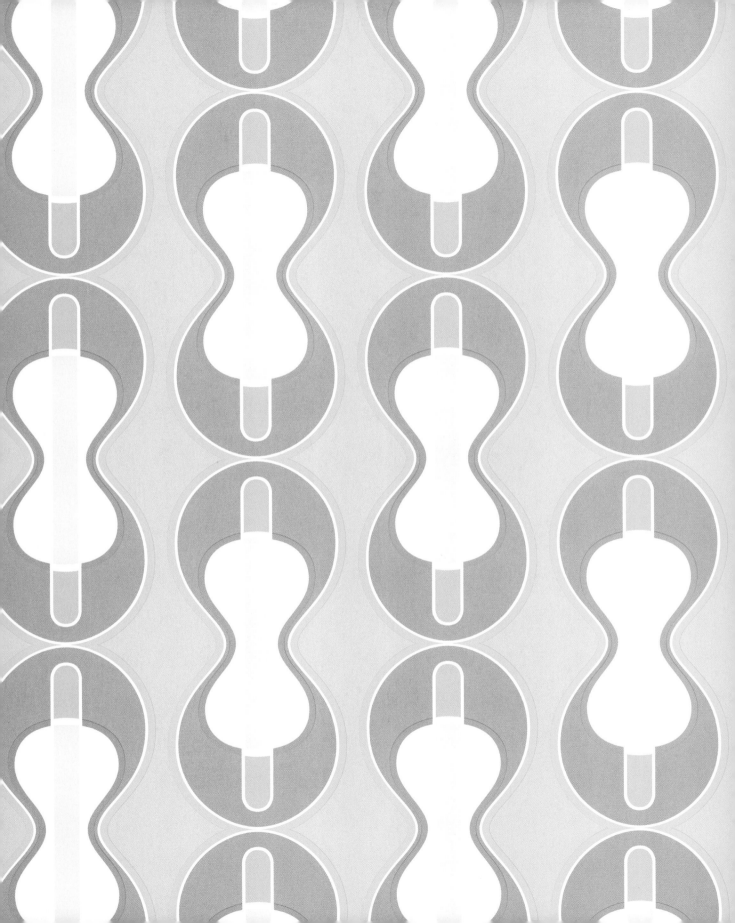

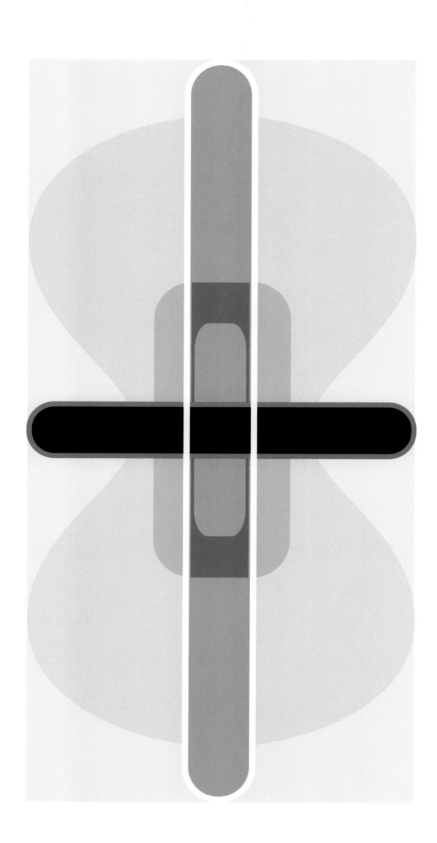

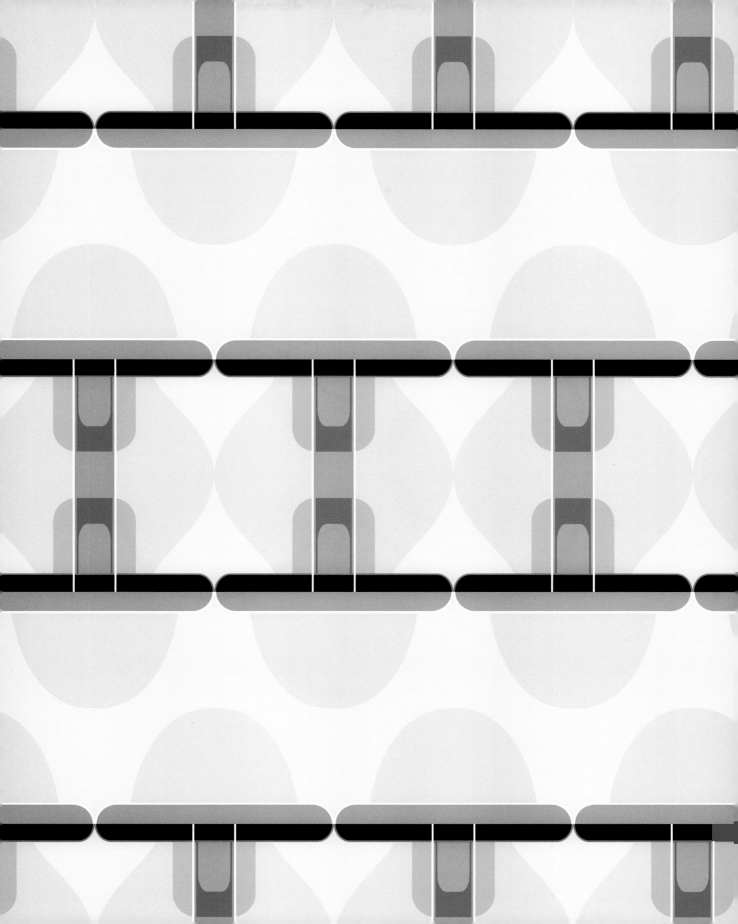

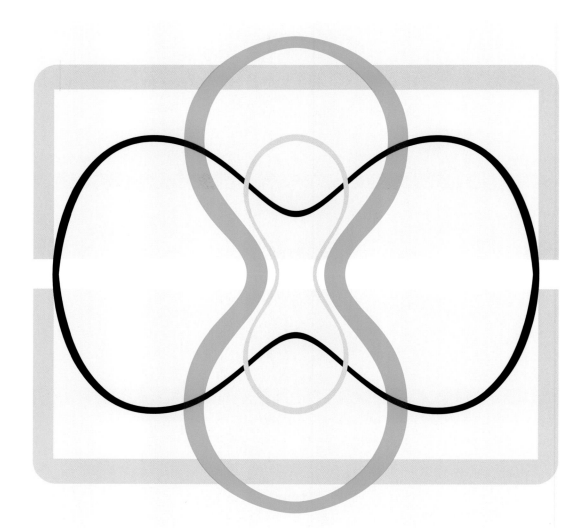

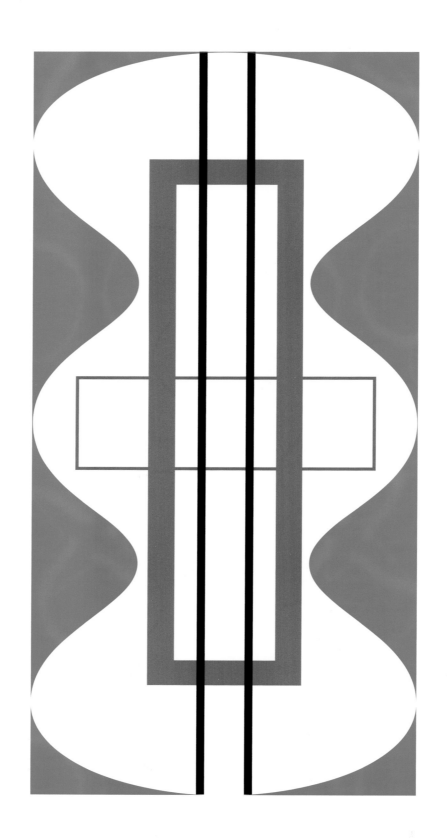

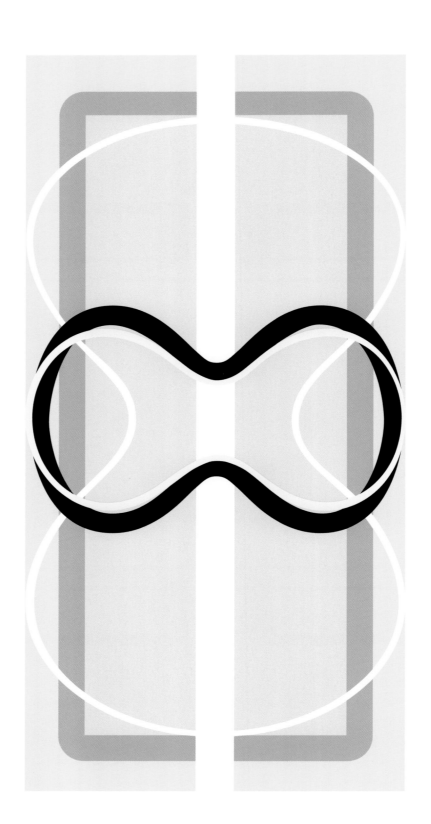

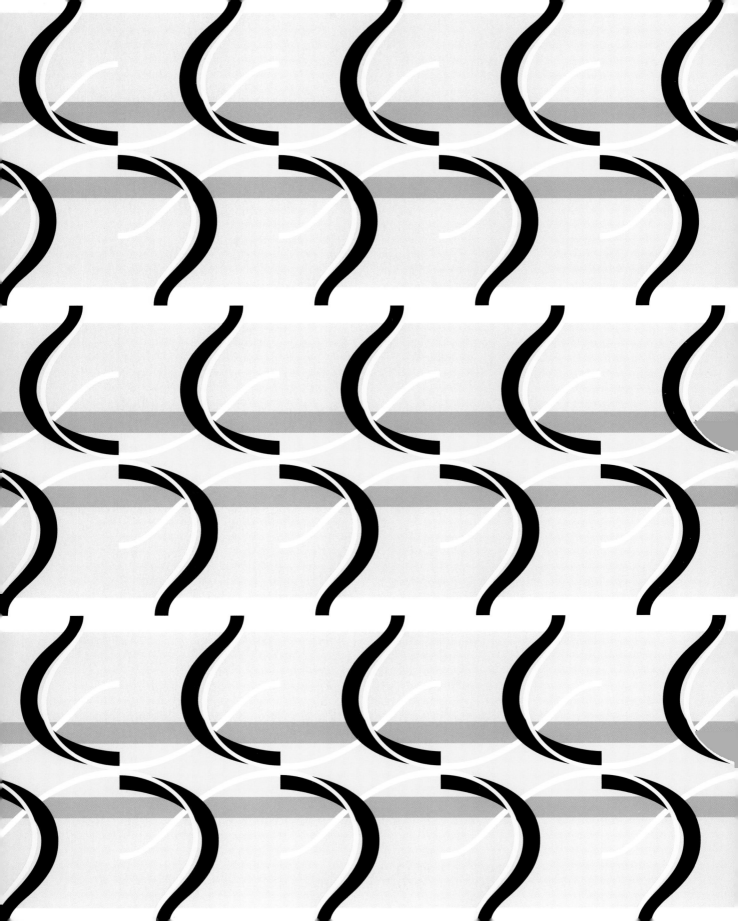

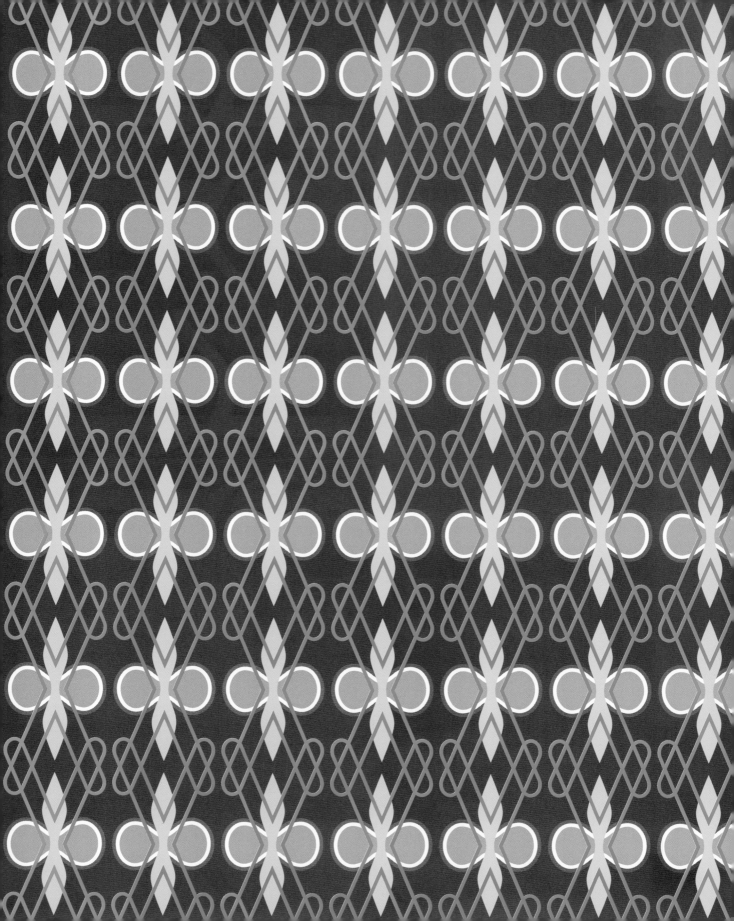

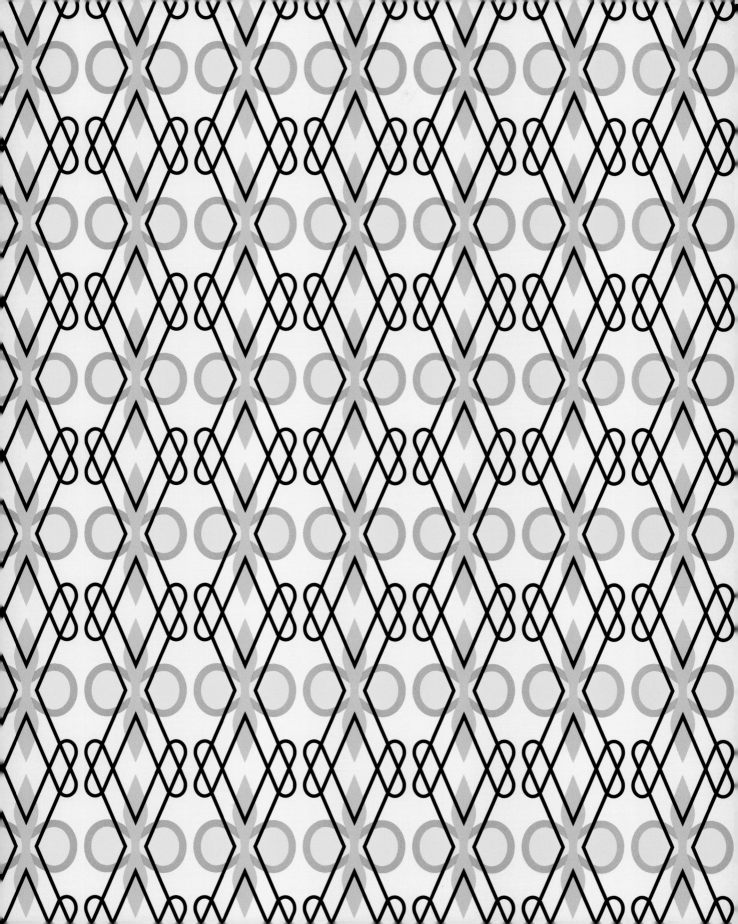

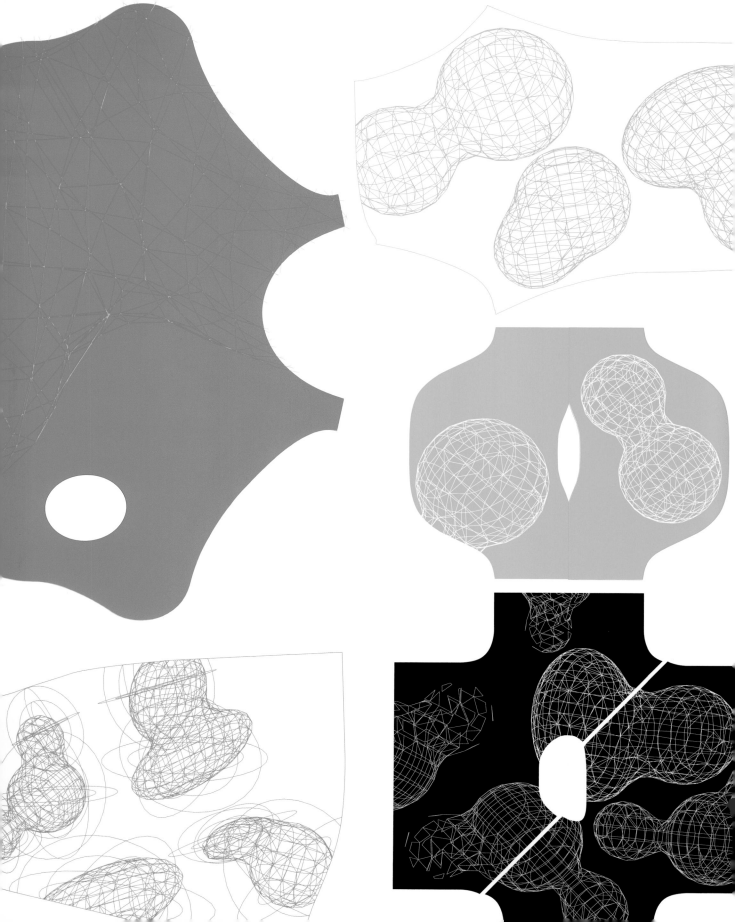

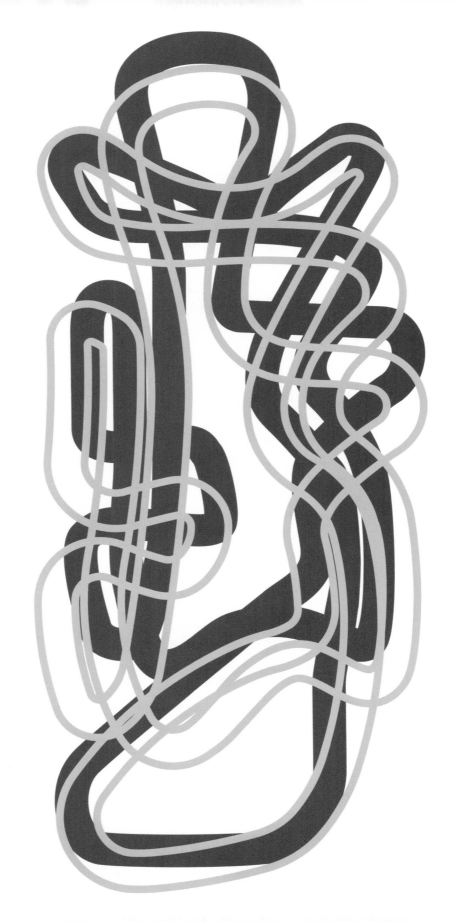

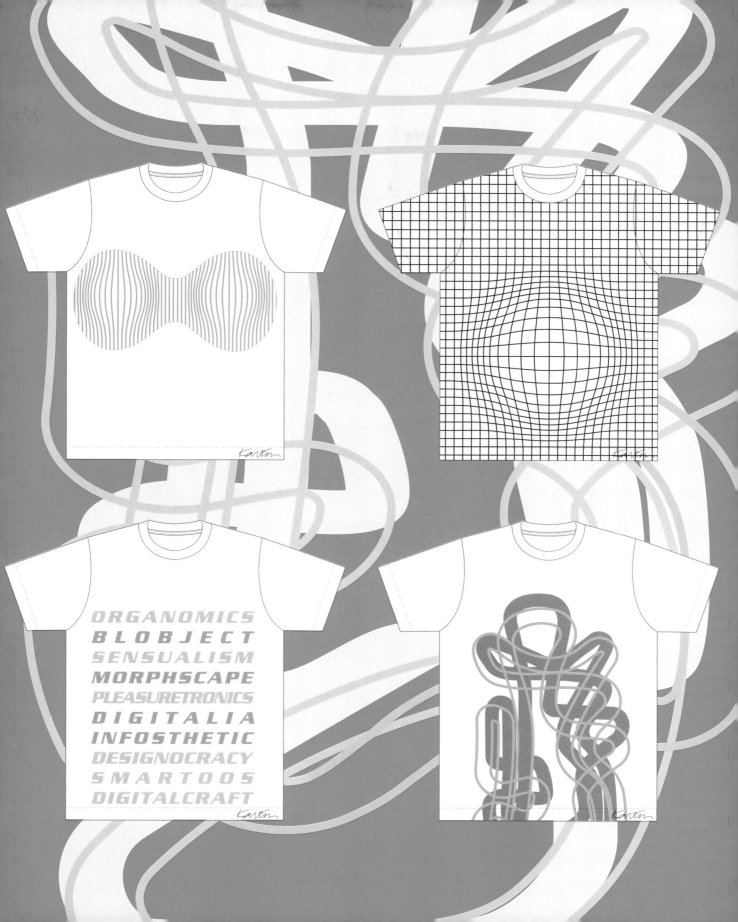

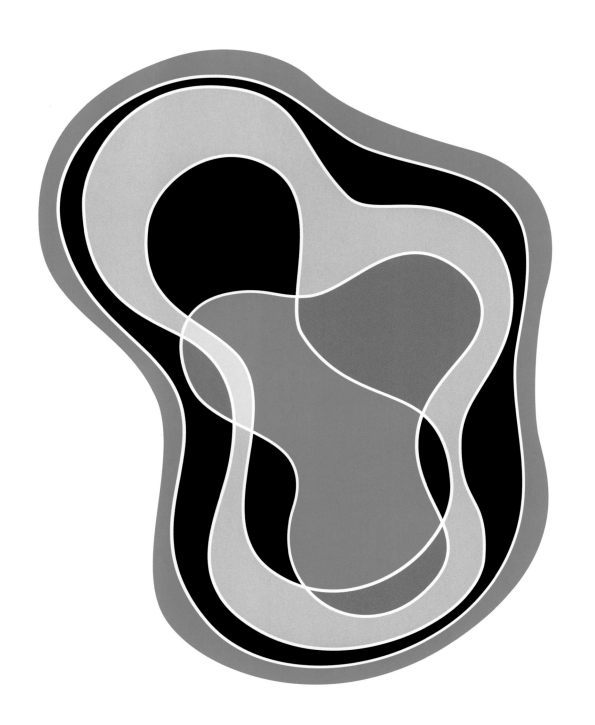

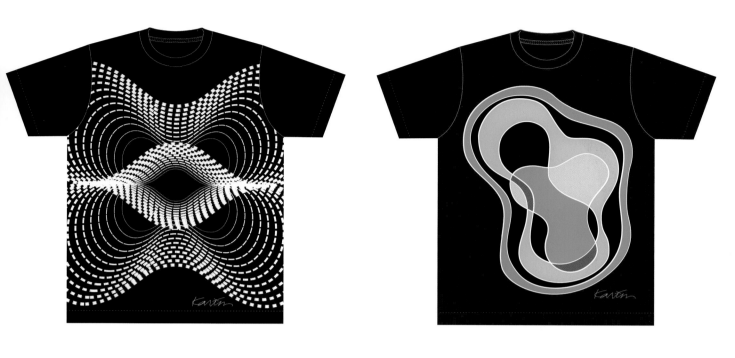
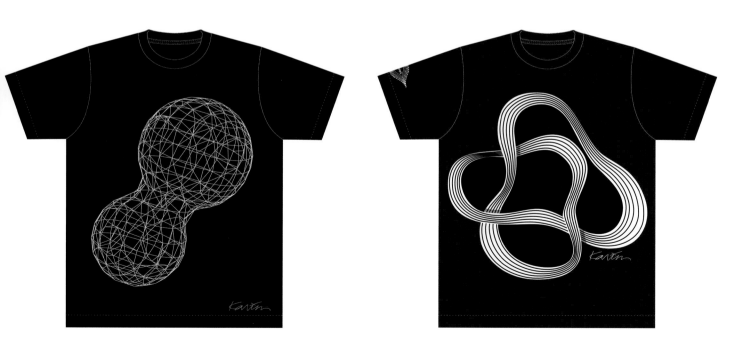

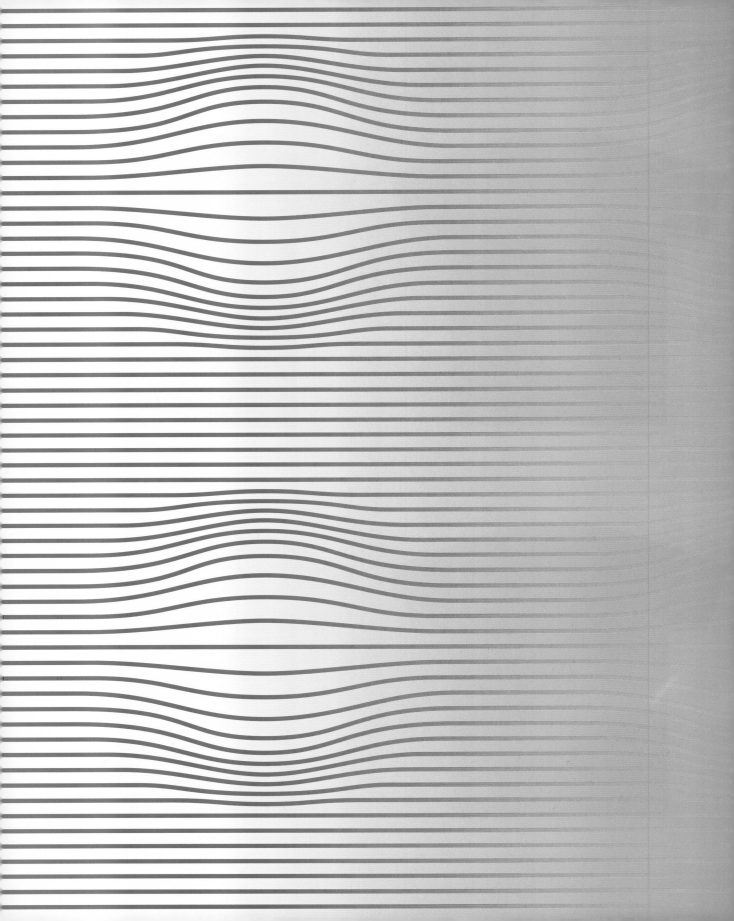

optikal

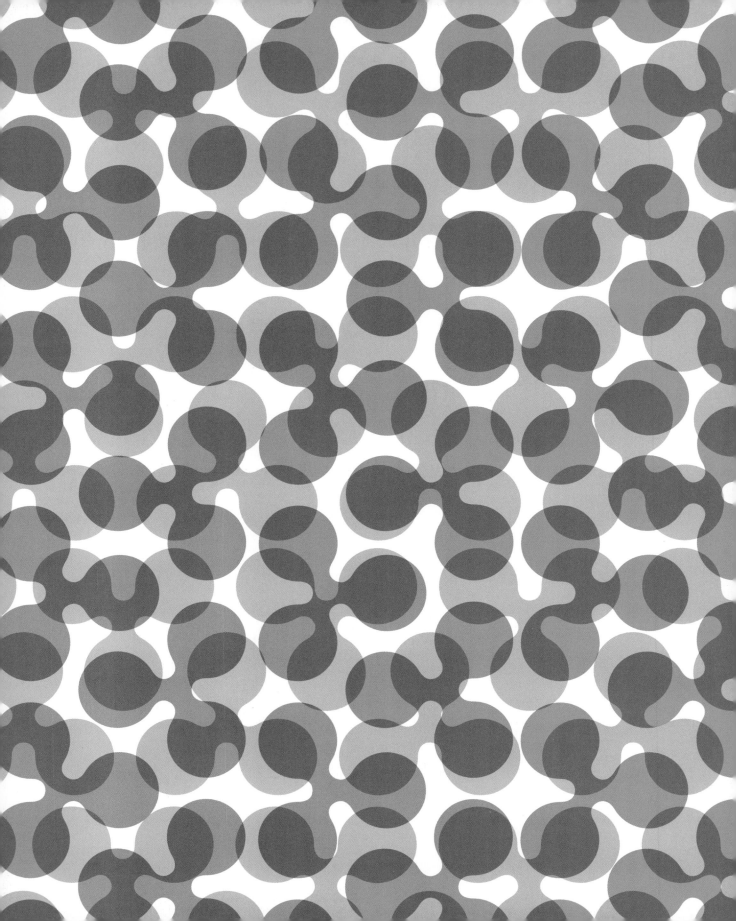

In the 60s, the path was prescribed for optical art—by thinkers and doers such as Bridget Riley, Victor Vasarely, Yaacov Agam, Vassilakis Takis, and many others. The optical movement and geoism had evolved from the foundations laid in early abstraction, from Seurat with Pointillism to Malevich and Rodchenko's mathematical point line and volume studies, to De Stjl with Van Doesburg and Mondrian, and even the Cubist and post-Constructivist archetypes of creating new geometries and compositions based on pure form, on Cartesian constructs, and on modularity and mathematical proportions. The illusion and play of the eye has been an ongoing pursuit to create by simple means—the image, new phenomena that trigger an emotive and metaphysical consciousness. Illusory phenomena, from Jasper Johns' vibrating flag paintings to the surface kinetics and pulsating patterns of Andy Warhol and Kenneth Noland, to the subtler ephemeral wall sculptures of Robert Irwin. Contemporaries such as Yek, Mori, and others, continue in the spirit of ricocheting the eye and the mind. The notion of fooling the eye, of creating dynamic vistas, of kinetic illusion *ad infinitum*, set the scene for what I refer to as exploitation of the conscious flux versus inertia of the mind. The data-driven constructs we saw eventually led to us designing geometries on canvas that began to create and play with illusion, depth, dimension, and movement. Strongly graphic illusory and hypnotic canvases and proposals experimented with creating a 3-D movement from a 2-D surface. Op-Art was born as a movement that, with its vibrating colors, concentric motifs, and infinitely repeated patterns quickly dissipated into the commercial world, into kitsch and banality. But the movement predicted the digital age—the RGB generation and the vector and raster age. From Mark Rothko to Chuck Close to Dan Flavin and Donald Judd, art was doing the groundwork for binary notation, pixels, voxels, nanos, and the advent of digital art. Zipping on to 30 years later, we are now in the thick of the digital age (it will be thin when it is totally wireless and the speed of light), and in this age our tools can create far more accurate data and results that put the hand-calculated neo-geos to shame. I always loved mathematics and geometries and thought as a child that I would become a mathematician, but the need to draw and create was so dominant that I chose to be an artist of sorts. I remember Spiral Graph, a toy with a swinging pendulum that would create beautiful images. It occurred to me at an early age that calculus, geometry, and art are one, because they are actually abstract notions. Then, by the time I went to university, I realized that industrial design—a symbiosis of engineering, art, architecture, humor, and psychology—was a perfect place for me in this world. The result of creating a commodity that allowed me to exploit the 2-D surface has been of great interest, and the notion of illusion and post-pop decoration is a way to speak about the merging and crossover of the irreal and the real, the virtual and the physical.

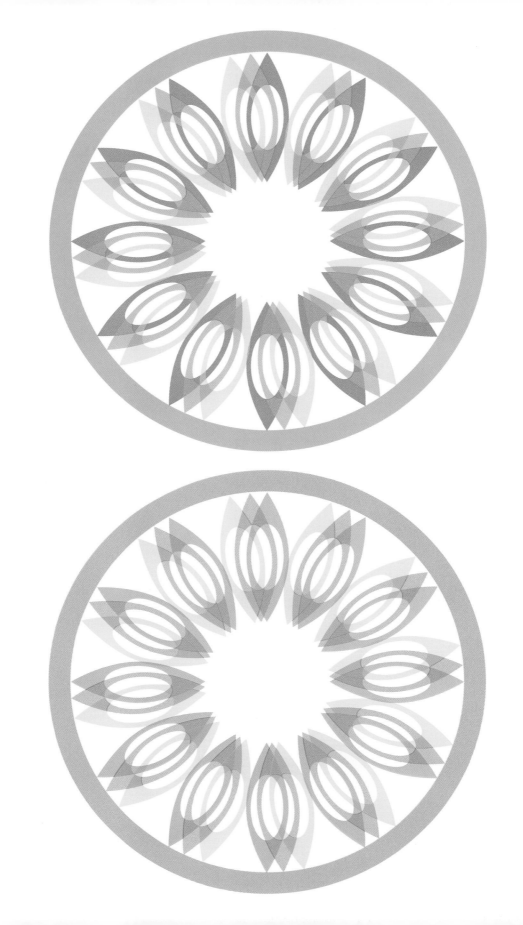

In den 60er Jahren war der Weg frei für Op-Art – mit Denkern und Machern wie Bridget Riley, Victor Vasarely, Yaacov Agam, Vassilakis Takis und vielen anderen. Op-Art und Geoism hatten sich auf den Fundamenten entwickelt, die von den frühen Abstrakten gelegt wurden: von Seurat und dem Pointillismus über Malewitschs und Rodtschenkos Linienkonstruktionen und Volumenstudien zu de Stijl mit Van Doesburg und Mondrian und selbst den kubistischen und postkonstruktivistischen Ansätzen, neue Geometrien und auf reiner Form beruhende Kompositionen zu erschaffen, auf kartesianischen Konstruktionen, auf Modularität und mathematischen Proportionen. Illusion und optische Täuschung erschaffen mit einem einfachen Mittel – dem Bild – neue Phänome und kitzeln eine emotionale und metaphysische Bewusstseinsebene hervor. Die illusionistischen Phänomene von Jasper Johns` vibrierenden gemalten Flaggen und die Oberflächenprozesse und pulsierenden Muster von Andy Warhol und Kenneth Noland sowie die subtileren, ephemeren Wandskulpturen von Robert Irwin, Yek, Mori oder anderen Zeitgenossen führen die Tradition weiter, Auge und Bewusstsein auf eine Achterbahnfahrt zu schicken. Die Idee, das Auge zu täuschen oder dynamische/wechselhafte Perspektiven zu erzeugen, von kinetischer Illusion *ad infinitum*, ist das Vorprogramm zu dem, was ich Nutzbarmachung der Bewusstseinsströme kontra geistige Erstarrung nenne. Wie gesehen, führten die datengetriebenen Konstruktionen dazu, auf der Leinwand Geometrien zu entwerfen, um Illusion, Tiefe, Dimension und Bewegung zu schaffen und spielerisch damit zu arbeiten. Einprägsame grafische illusionistische und hypnotische Malereien und Entwürfe experimentierten damit, aus der zweidimensionalen Oberfläche bewegte 3-D-Effekte herauszuholen. Mit der Op-Art und ihren vibrierenden Farben, konzentrischen Motiven und Endlosmustern wurde eine Bewegung geboren, die sehr schnell auf die kommerzielle Welt durchschlug und in Kitsch und Banalität abrutschte. Aber die Op Art kündigte das digitale Zeitalter an – die RGB-Generation und die Vektor-und-Raster-Ära. Mark Rothko, Chuck Close, Dan Flavin, Donald Judd et al. leisteten die Vorarbeit für binäre Notation, Pixel, Voxel, Nanos und das Kommen der digitalen Kunst. Lächerliche 30 Jahre später stecken wir im dicksten Getümmel des Digitalzeitalters (das sich lichten wird, wenn alles vollkommen drahtlos und in Lichtgeschwindigkeit passiert), und in diesem Zeitalter geben unsere Tools sehr viel präzisere Daten her, und die Resultate stellen auch die mit der Hand bedienten Neo Geos in den Schatten. Ich habe Mathe und Geometrie immer geliebt und dachte als Kind, ich würde später Mathematiker werden, aber das Bedürfnis zu zeichnen und schöpferisch zu sein war so übermächtig, dass ich beschloss, irgendetwas im künstlerischen Bereich zu machen. Ich erinnere mich noch an den Spirographen, ein Spielzeug mit einem frei beweglichen Stift an einem fest stehenden Drehpunkt, mit dem sich wundervolle Bilder erschaffen ließen. Mir ging schon in ziemlich jungen Jahren auf, dass höhere Mathematik, Geometrie und Kunst ein und dasselbe sind, weil sie alle mit Abstraktion zu tun haben. Als ich dann studierte, wurde mir klar, dass Industriedesign, eine Symbiose von Technik, Kunst, Architektur, Humor und Psychologie, für mich das optimale Betätigungsfeld darstellte. Was beim Entwerfen von Gebrauchsgegenständen, das von mir verlangte, zweidimensionale Flächen zu nutzen, herauskam, war hochinteressant, und die Vorstellung von Illusion und Post-Pop-Dekor besteht immer darin, das Fusionieren und den Crossover des Irrealen und Realen, des Virtuellen und Materiellen anzusprechen.

optikal

Dans les années 60, la voie était libre pour l'avènement de l'art l'optique – grâce à des penseurs et des créateurs tels que Bridget Riley, Victor Vasarely, Yaacov Agam, Vassilakis Takis, et beaucoup d'autres. Le mouvement optique et le « geoism » évoluent alors à partir de bases créées, aux débuts de l'abstraction, de Seurat et le pointillisme, à Malevich et Rodchenko – la ligne point mathématique et les études de volume – et jusqu'à De Stjl avec Van Doesburg et Mondrian, et même les archétypes cubistes et post-constructivistes qui cherchent à créer de nouvelles géométries et compositions basées sur la forme pure, les constructions cartésiennes, la modularité et les proportions mathématiques. L'illusion et le jeu du regard n'ont cessé d'être étudiés, afin de créer « l'image », à partir de moyens simples. Car l'image est un phénomène nouveau, capable de déclencher une conscience émotive et métaphysique. Les phénomènes illusoires, des peintures vibrantes des drapeaux de Jasper Johns, à la cinétique extérieure et aux pulsations de Andy Warhol et de Kenneth Noland, aux sculptures murales éphémères, plus subtiles, de Robert Irwin et à des contemporains tels que Yek ou Mori, s'intéressent à la trajectoire en ricochet de l'œil et de la pensée. L'idée de duper le regard, ou de créer des visions dynamiques, des illusions cinétiques à l'infini, se situe à ce que je définirais comme l'exploitation du flux conscient en opposition à l'inertie de l'esprit. La construction de ces données nous a ensuite amenés à composer sur toile des géométries qui se sont mises à jouer avec l'illusion, la profondeur, la dimension et le mouvement. Des toiles fortes, graphiques, hypnotiques et illusoires, ainsi que des expérimentations, ont tendu vers un mouvement en 3-d, à partir d'une surface en 2-d. L'Op art était né, mouvement qui s'est rapidement fondu dans le monde commercial avec ses couleurs vibrantes, ses motifs concentriques, ses modèles répétés à l'infini, et a fini par se réduire au kitsch et au banal. Mais le mouvement annonçait l'arrivée du numérique – la génération RGB (Red-Green-Blue) et le tube cathodique. De Mark Rothko à Chuck Close, Dan Flavin et Donald Judd, l'art s'est préparé à recevoir la notation binaire, les pixels, voxels, et nanos, ainsi que le numérique. Trente ans plus tard, et nous voici au cœur du numérique (bientôt totalement sans fil, et à la vitesse de la lumière) à manier des outils et des données bien plus précis, avec des résultats capables de faire honte aux néo-geos calculés à la main. J'ai toujours adoré les maths et la géométrie et, enfant, je pensais devenir mathématicien. Mais le besoin de dessiner et de créer était si fort, que j'ai choisi de devenir une espèce d'artiste. Je me souviens du spirographe, jouet avec pendule d'oscillation, sur point d'appui, qui créait de très belles images. Très jeune, j'ai compris que le calcul, la géométrie et l'art ne faisaient qu'un, car il s'agit en fait de notions abstraites. A l'université, je me suis rendu compte que le dessin industriel, symbiose de technologie, d'art, d'architecture, et d'humour, était exactement ce qui me convenait. Le fait de créer des produits m'a permis d'exploiter la surface 2-d, avec des résultats très intéressants. Cette notion d'illusion et de décoration post-pop est une manière d'aborder le fusionnement et le croisement de l'irréel et du réel, du virtuel et du physique.

optikal

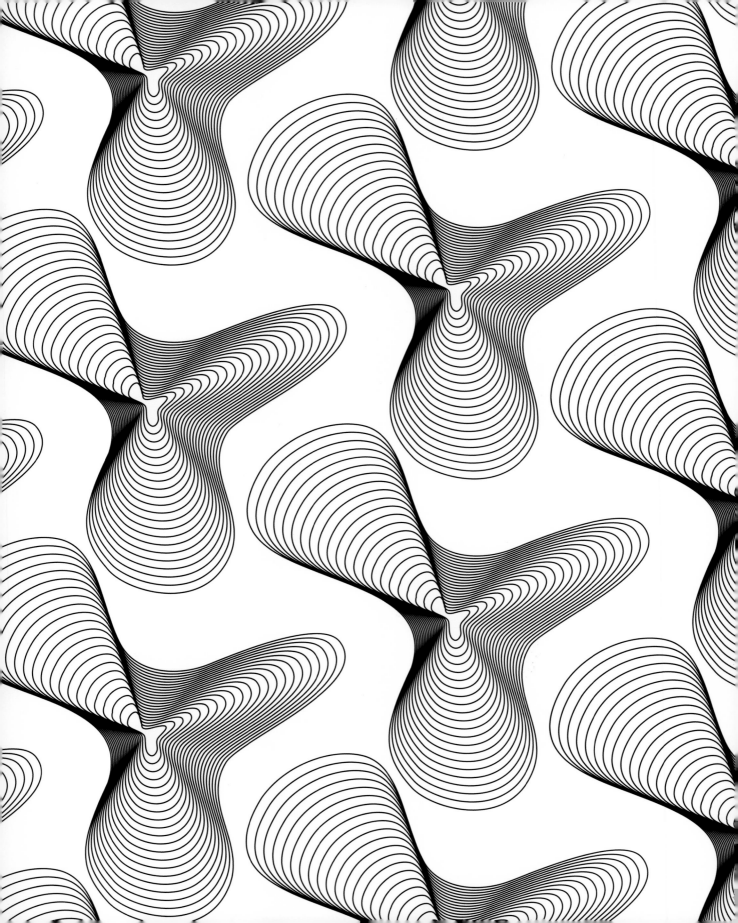

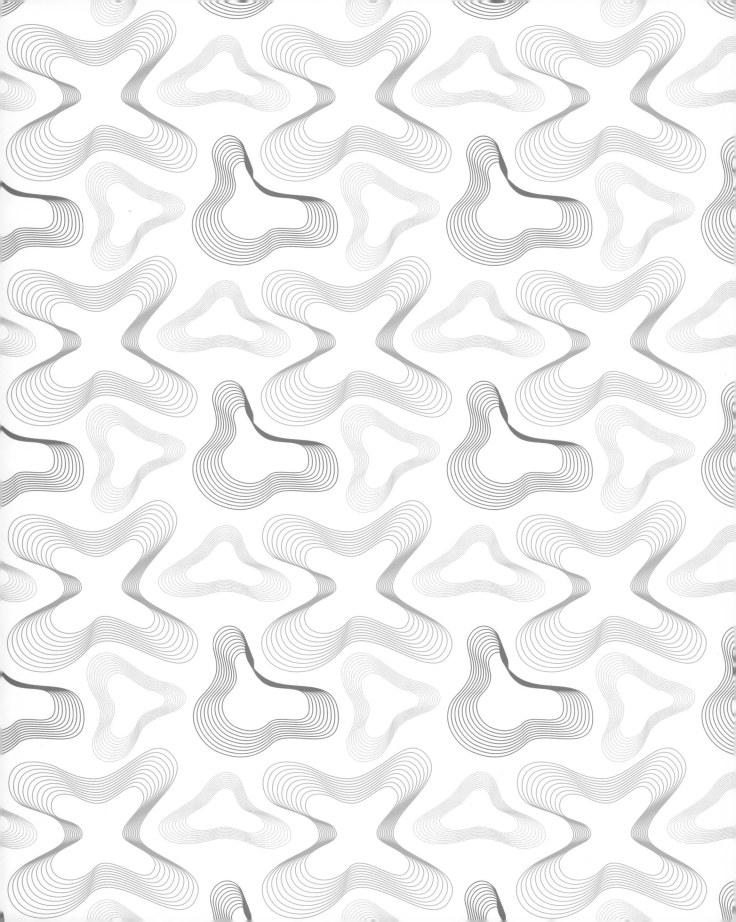

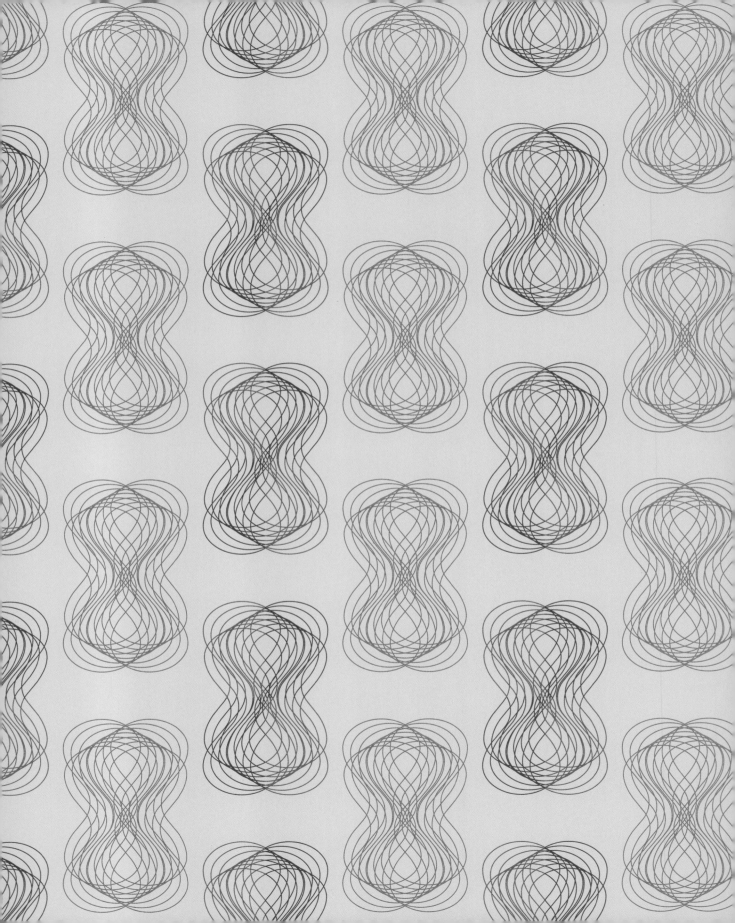

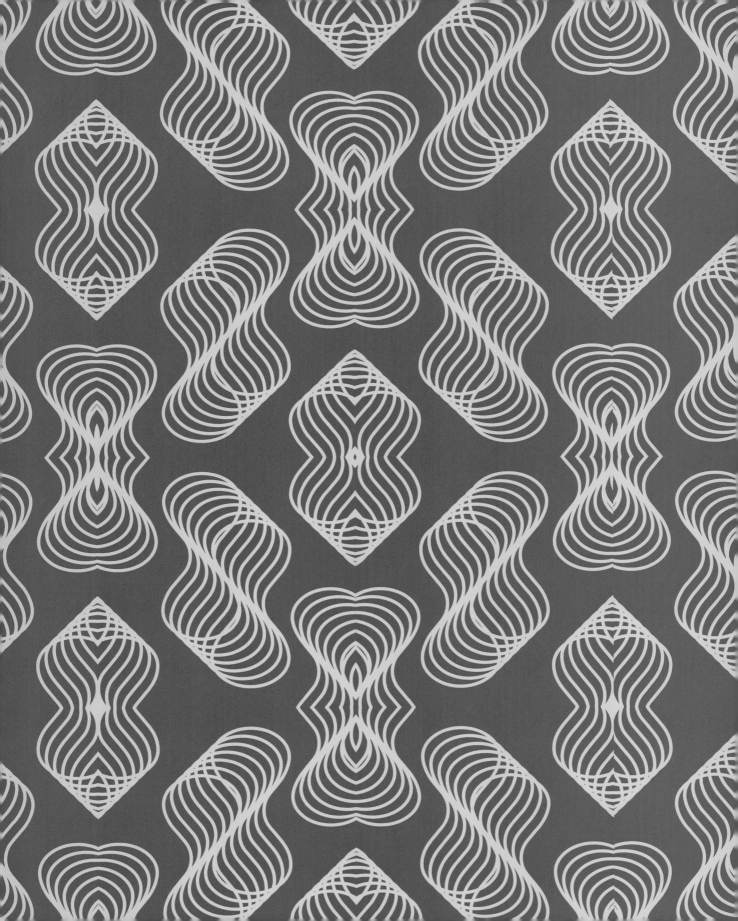

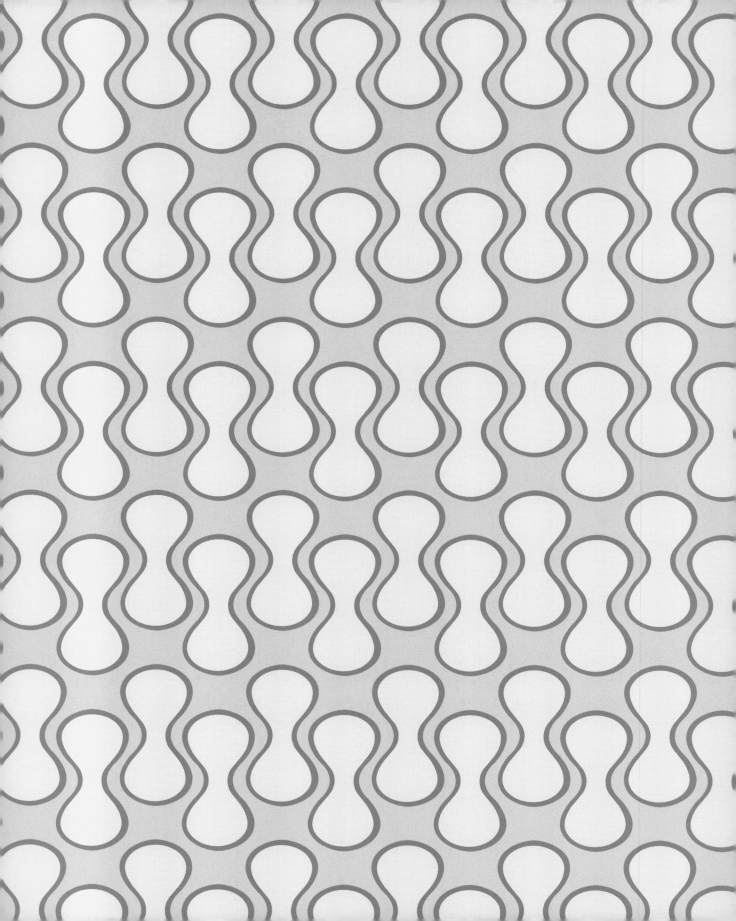

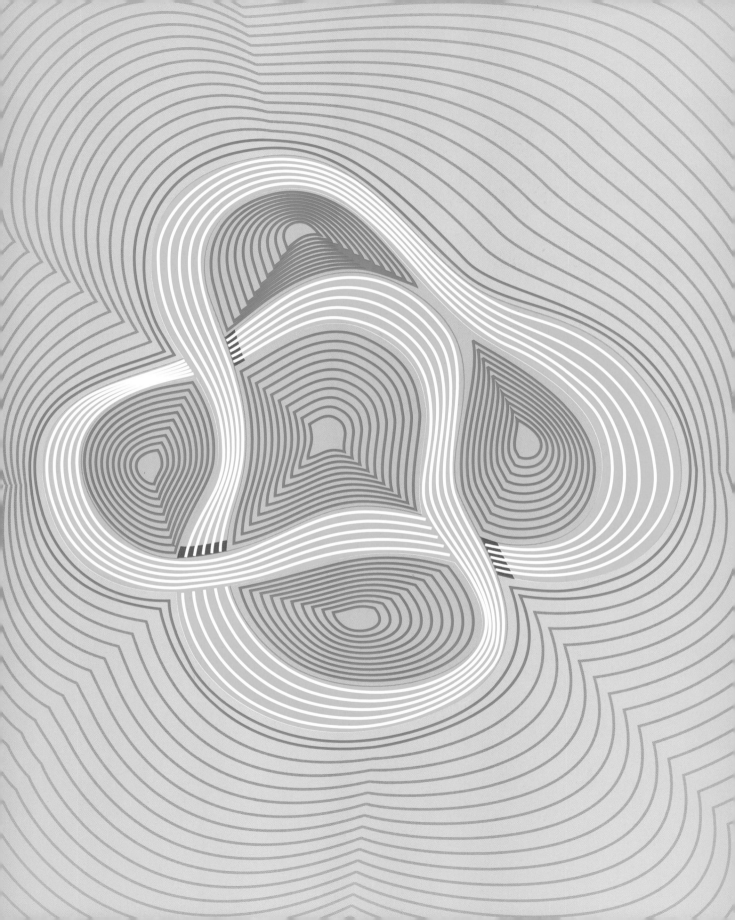

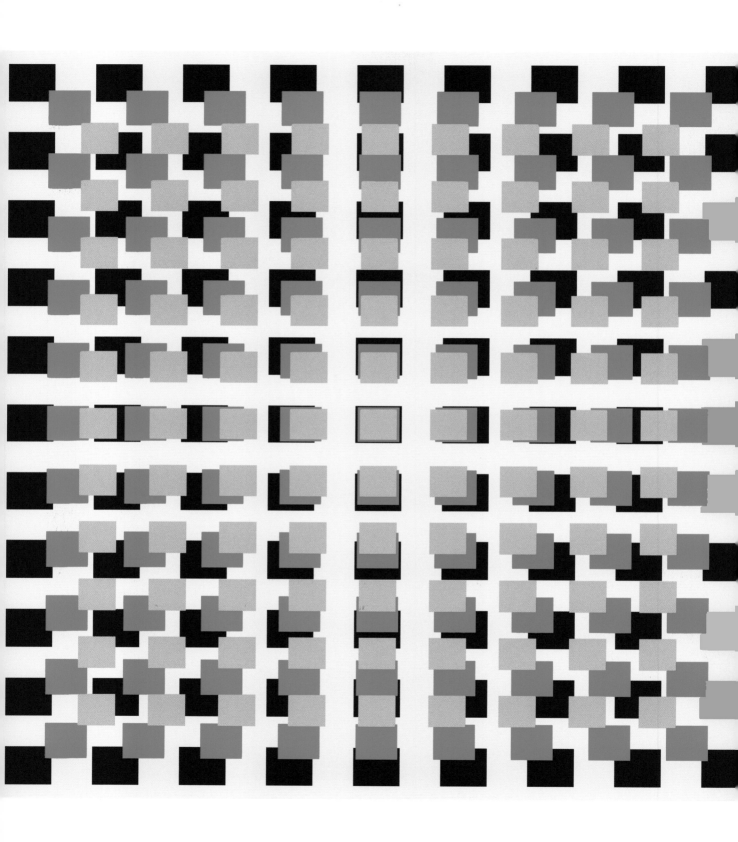

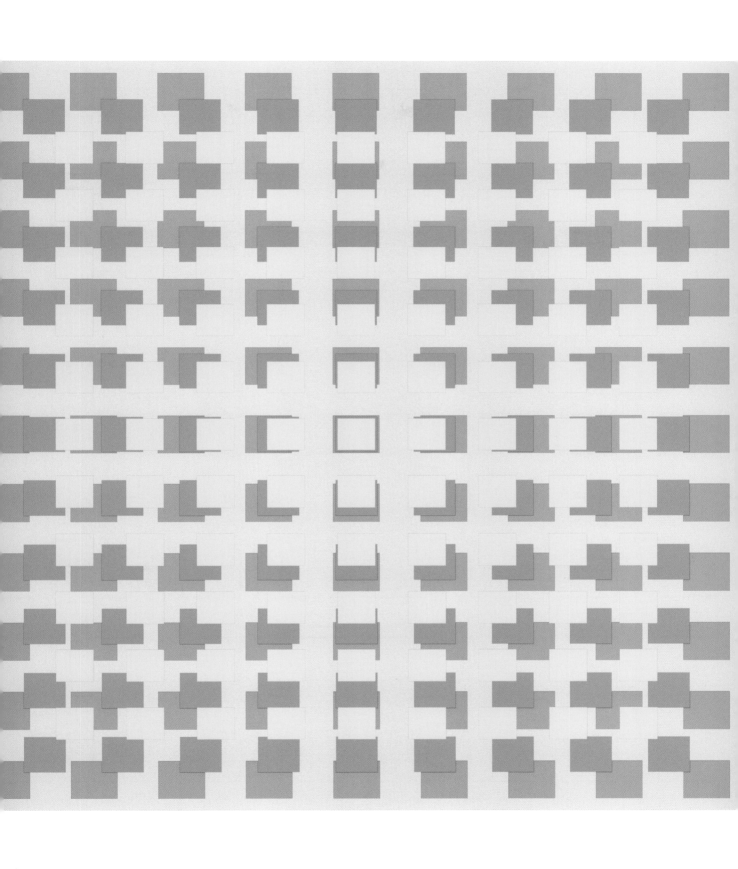

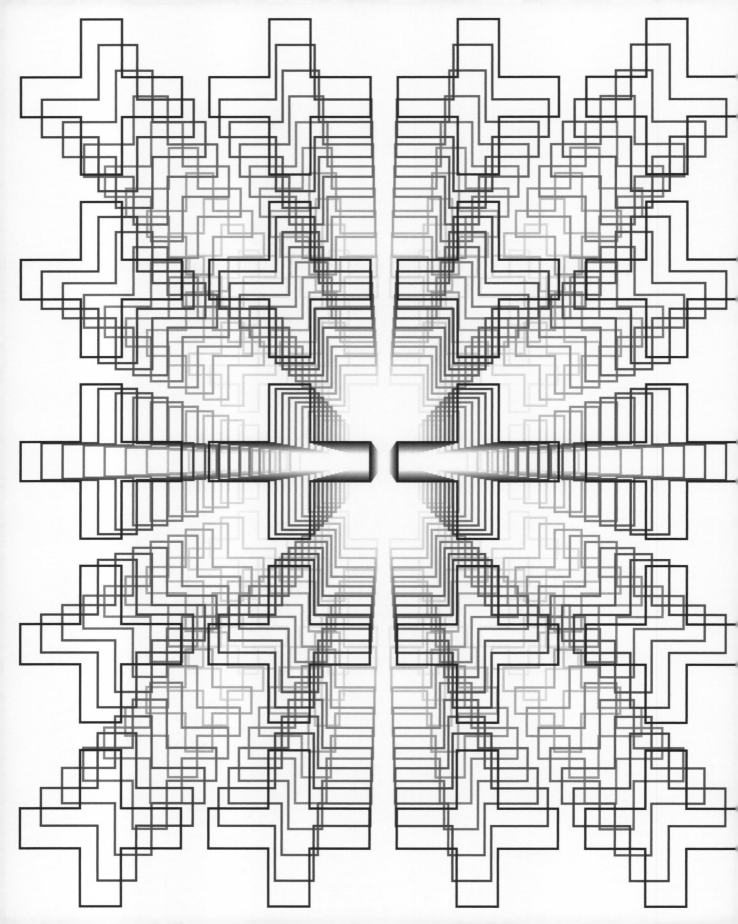

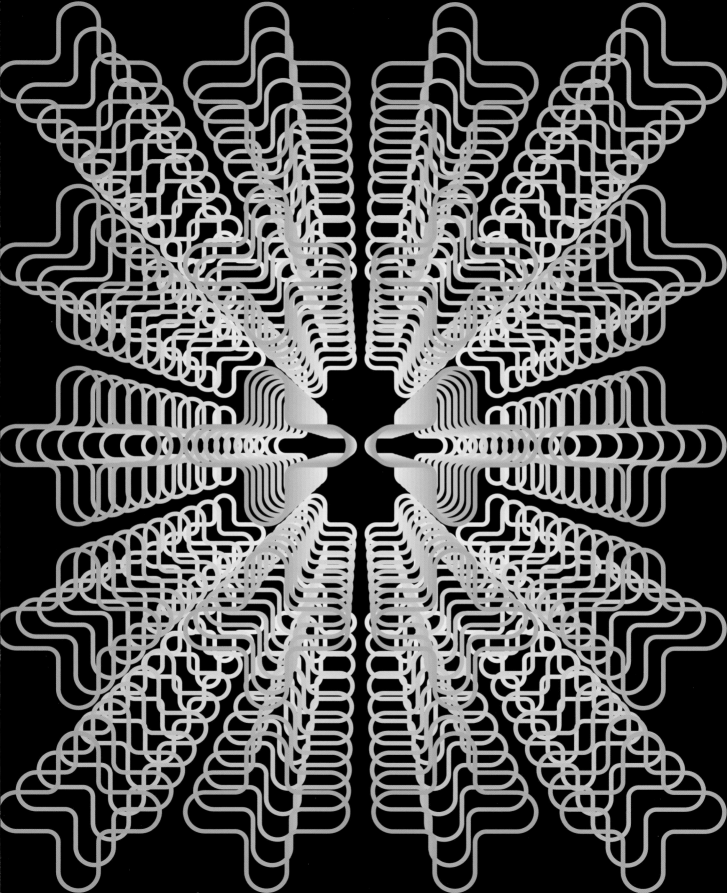

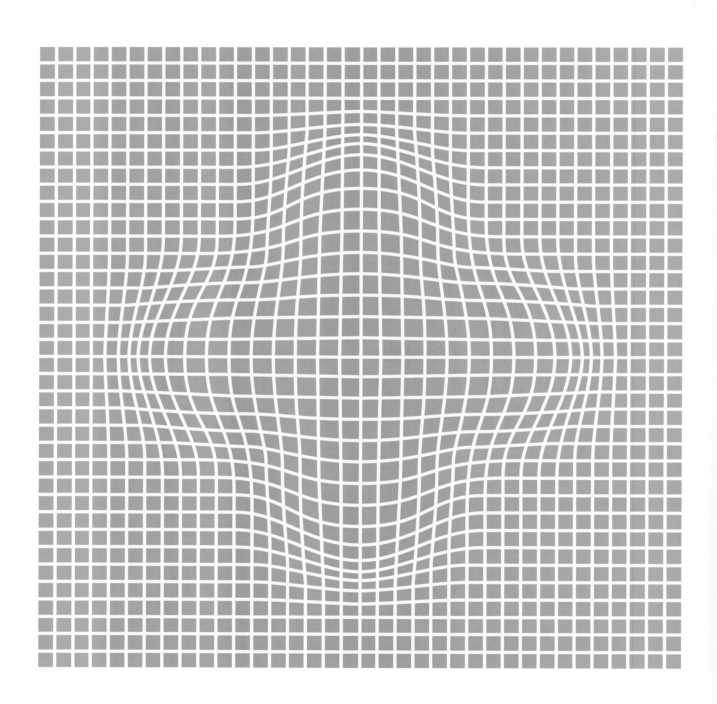

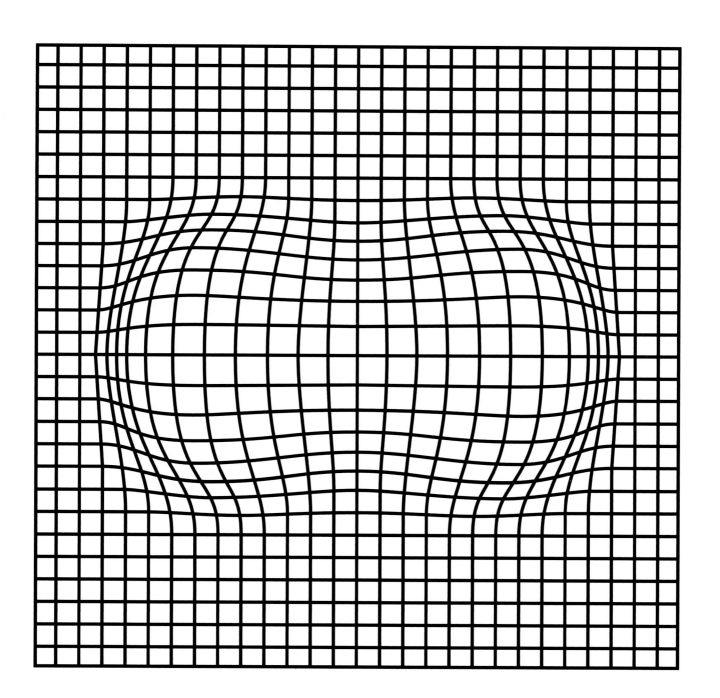

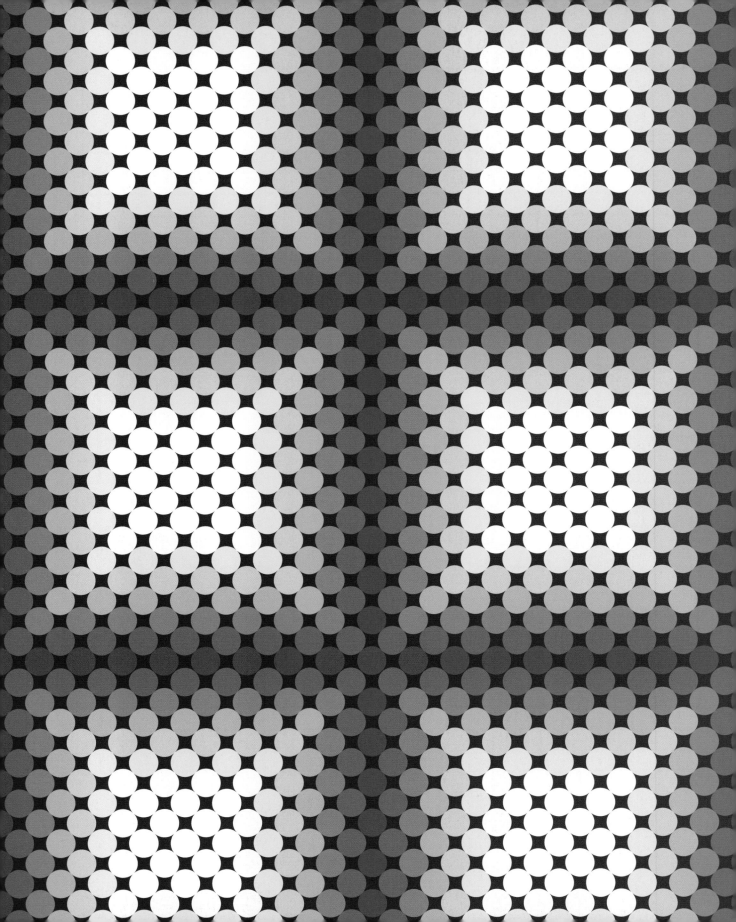

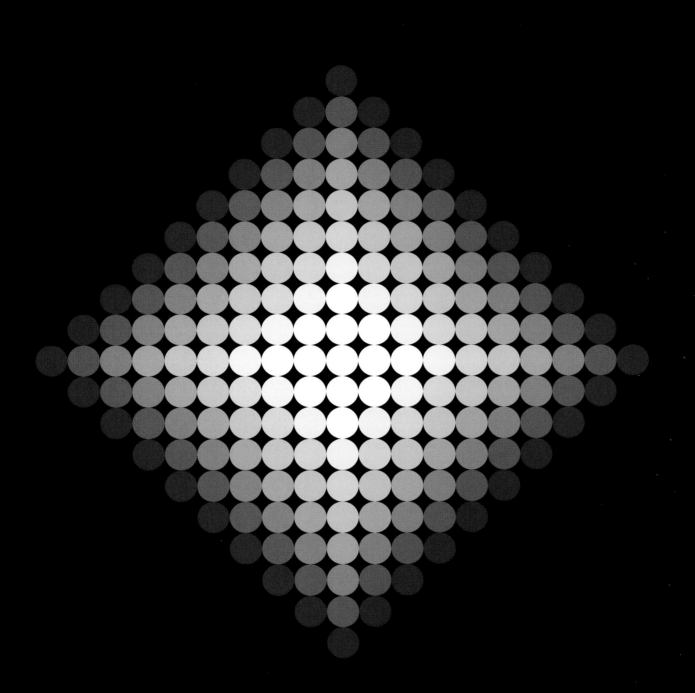

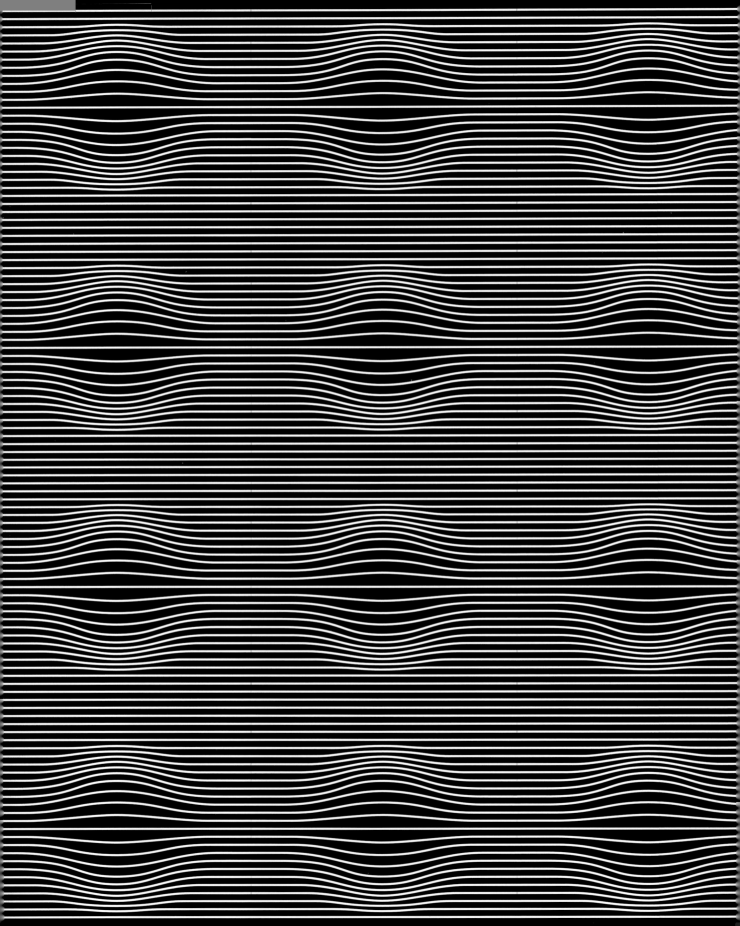

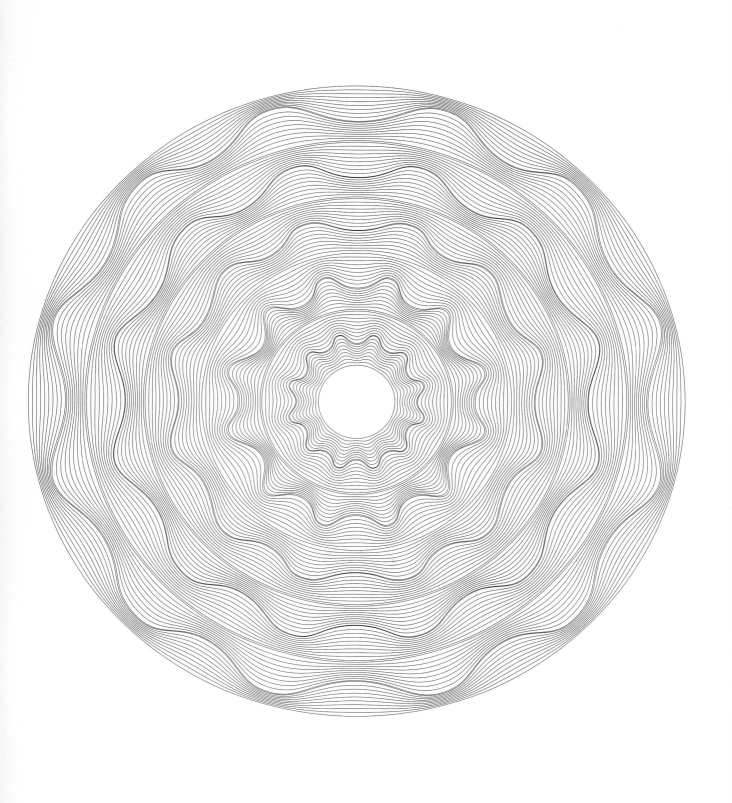

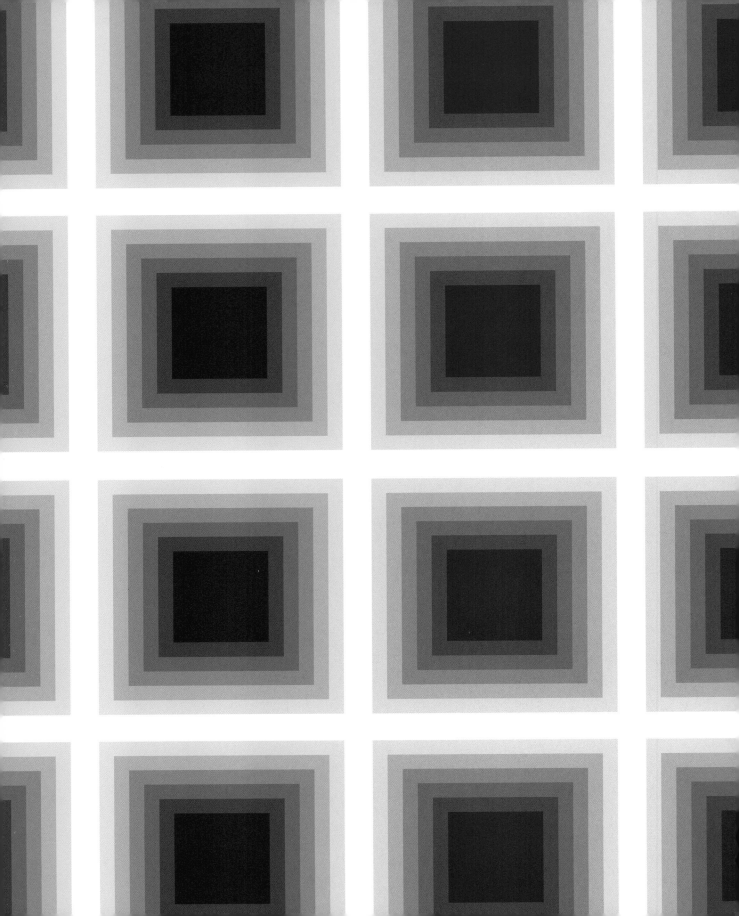

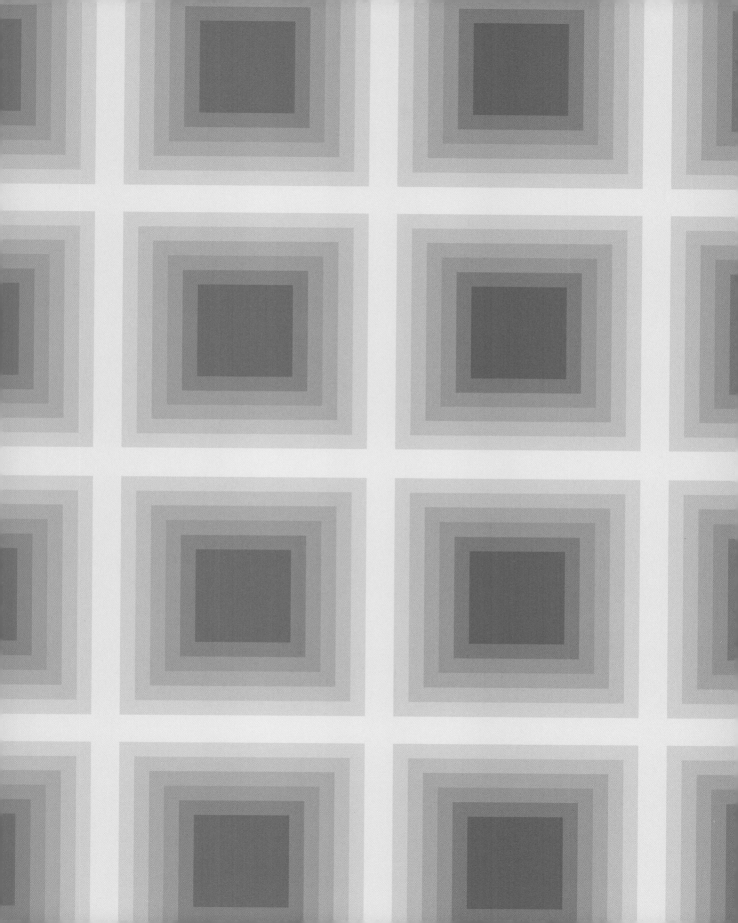

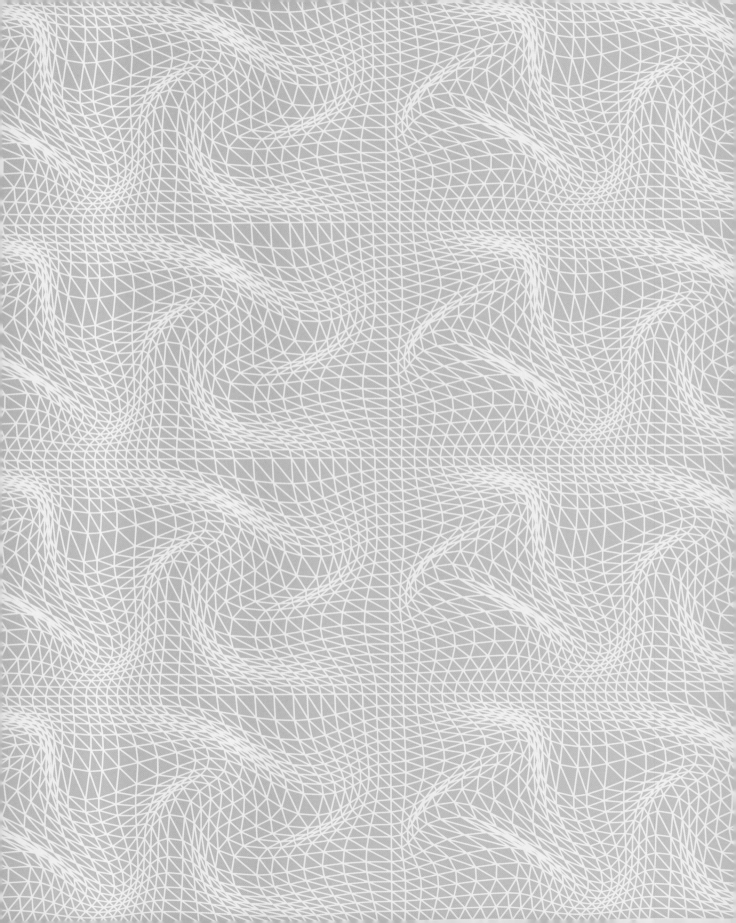

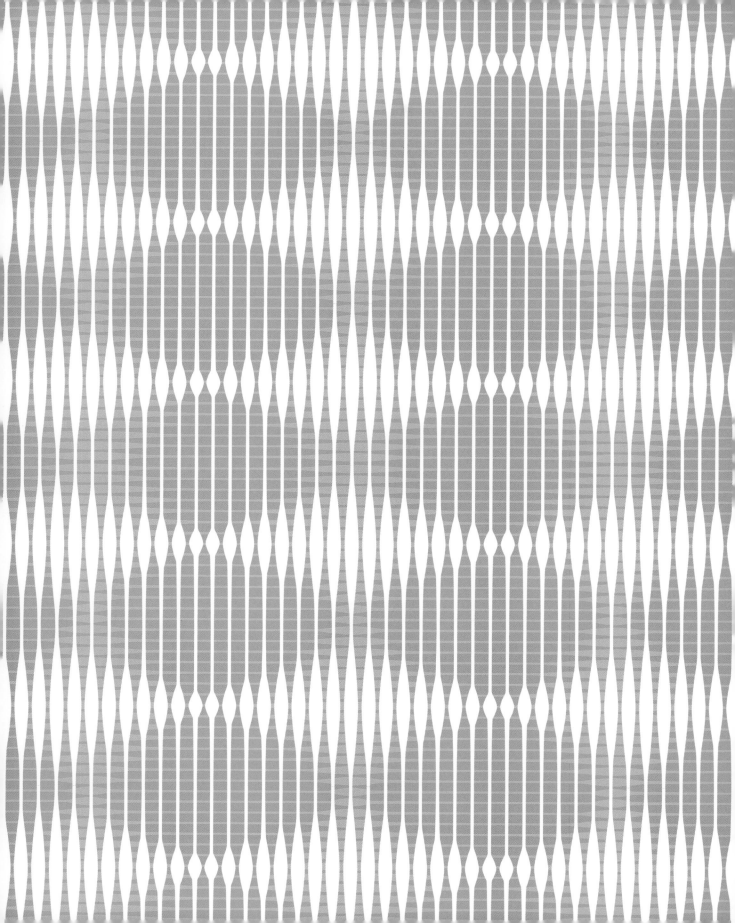

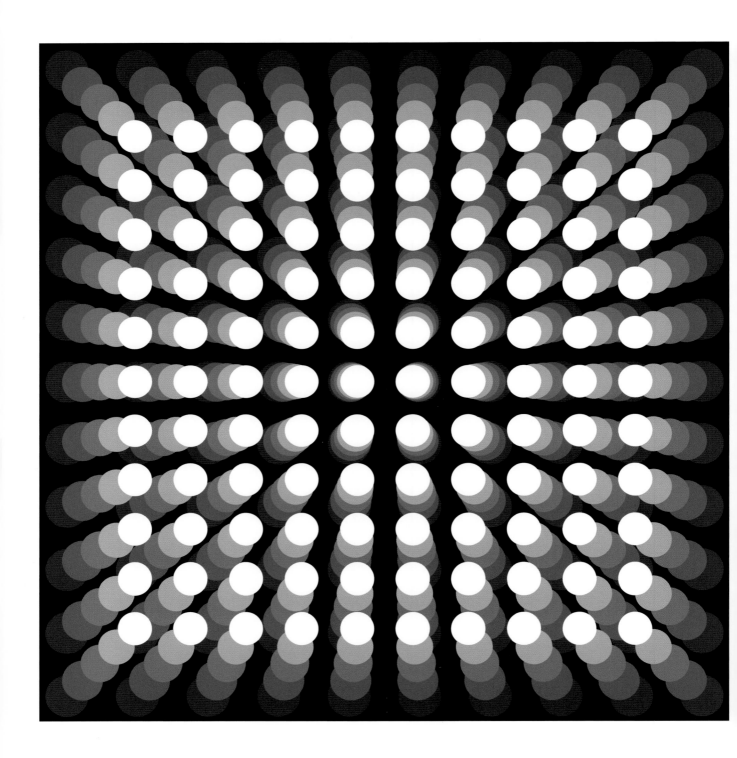

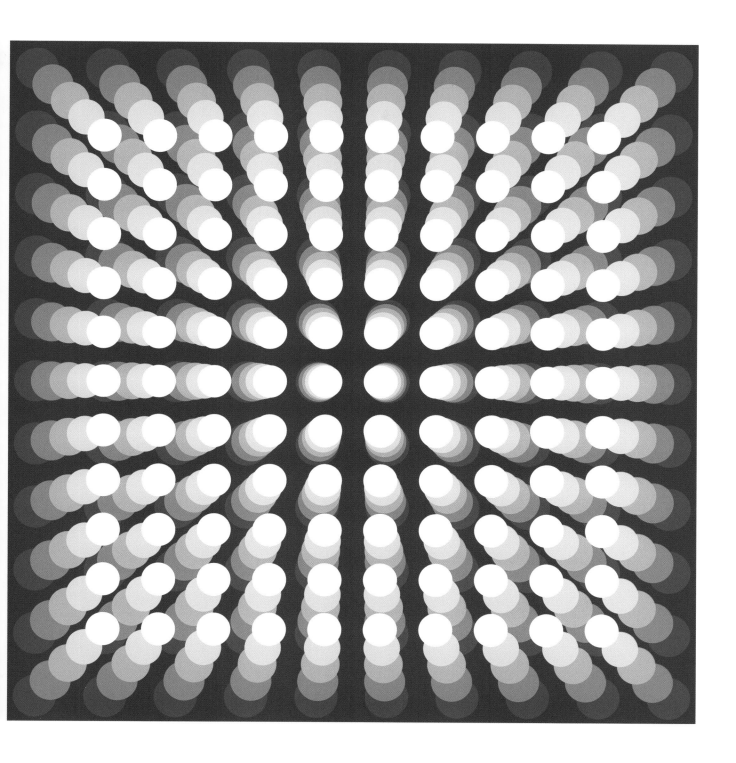

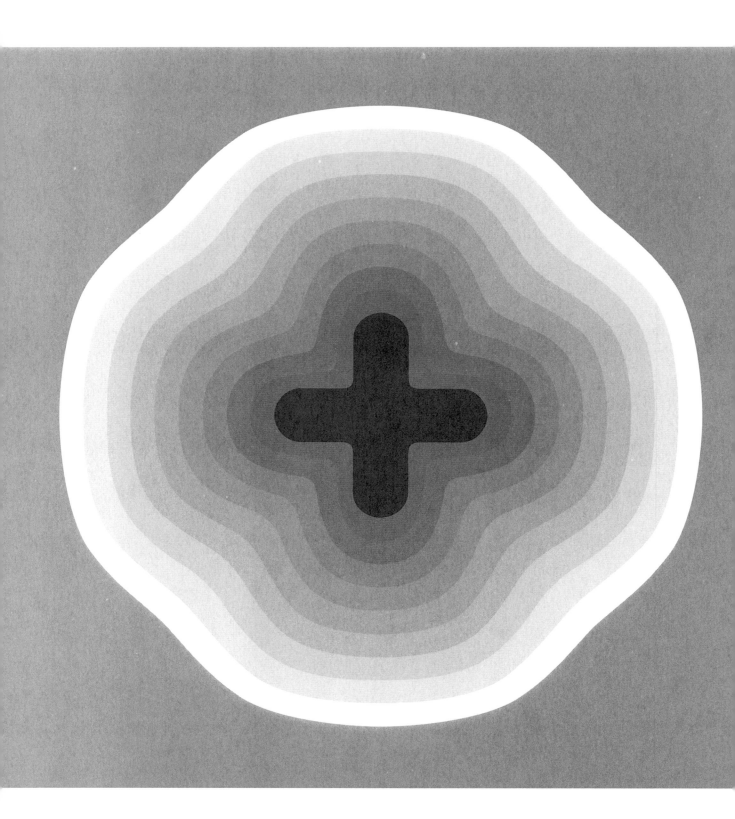

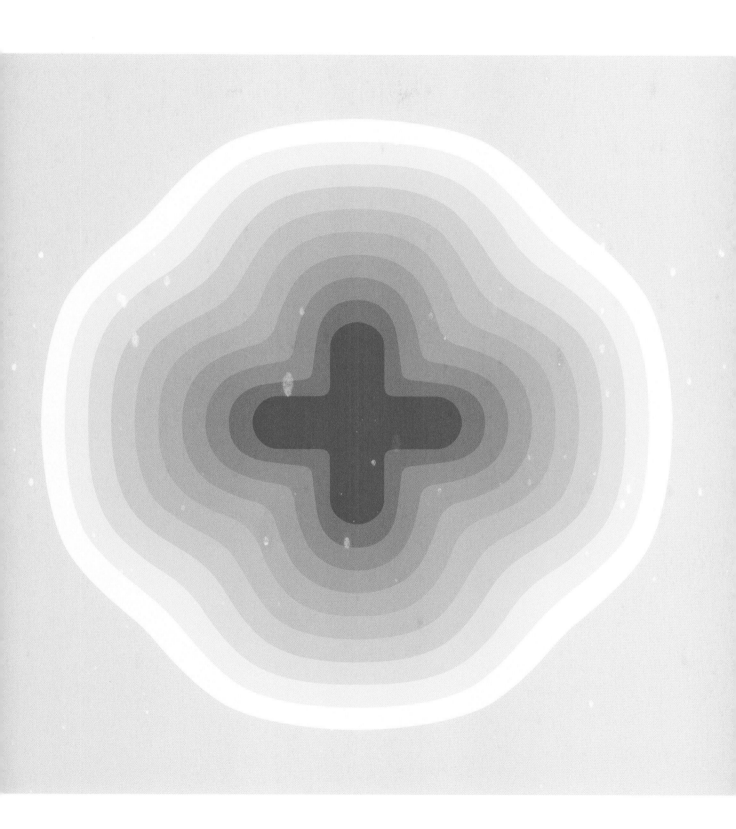

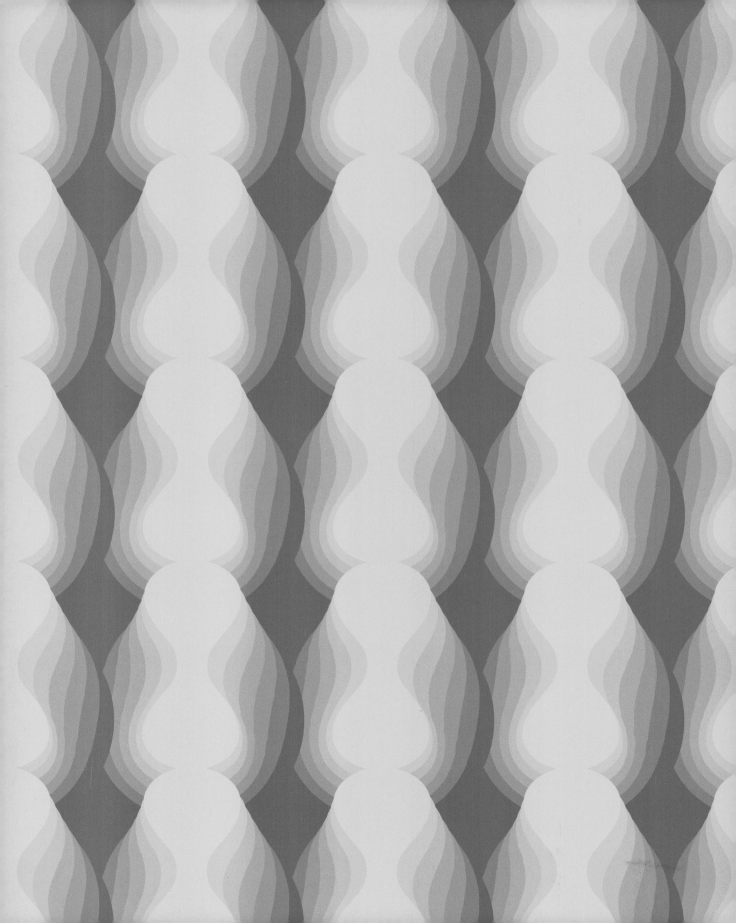

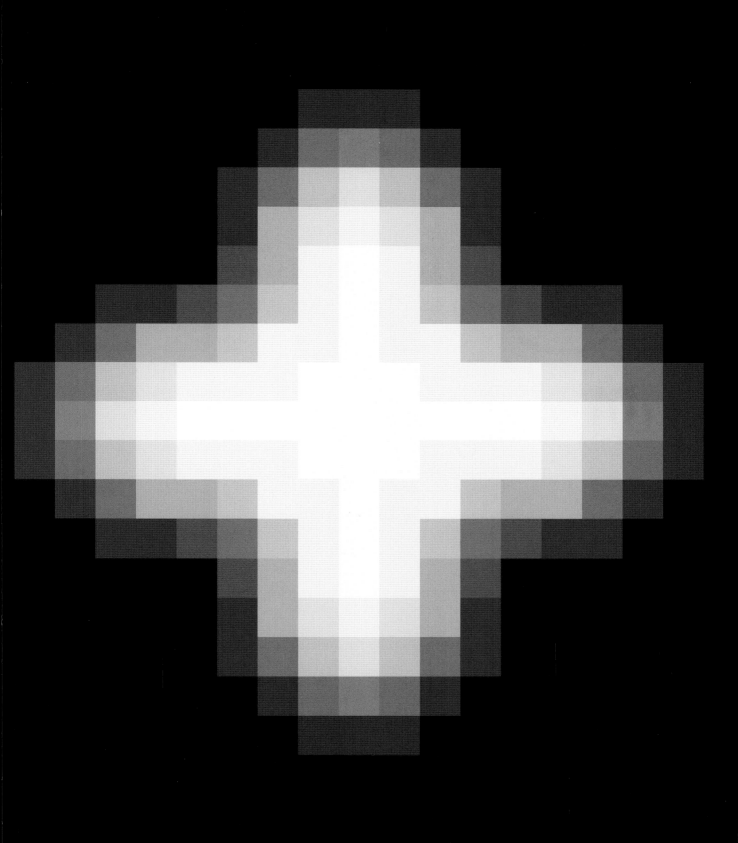

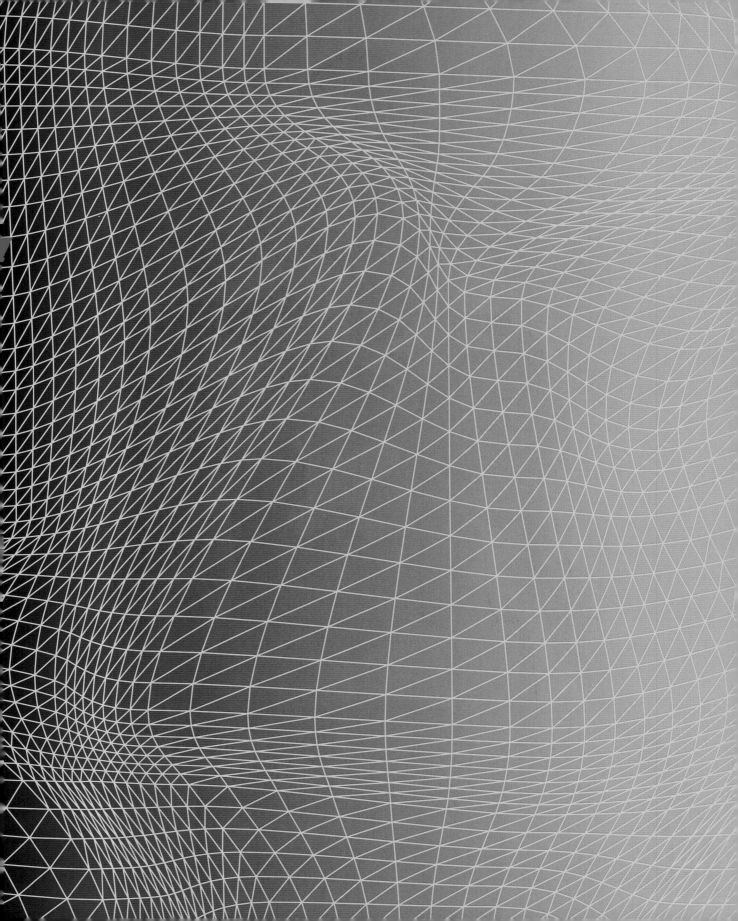

infostethiks

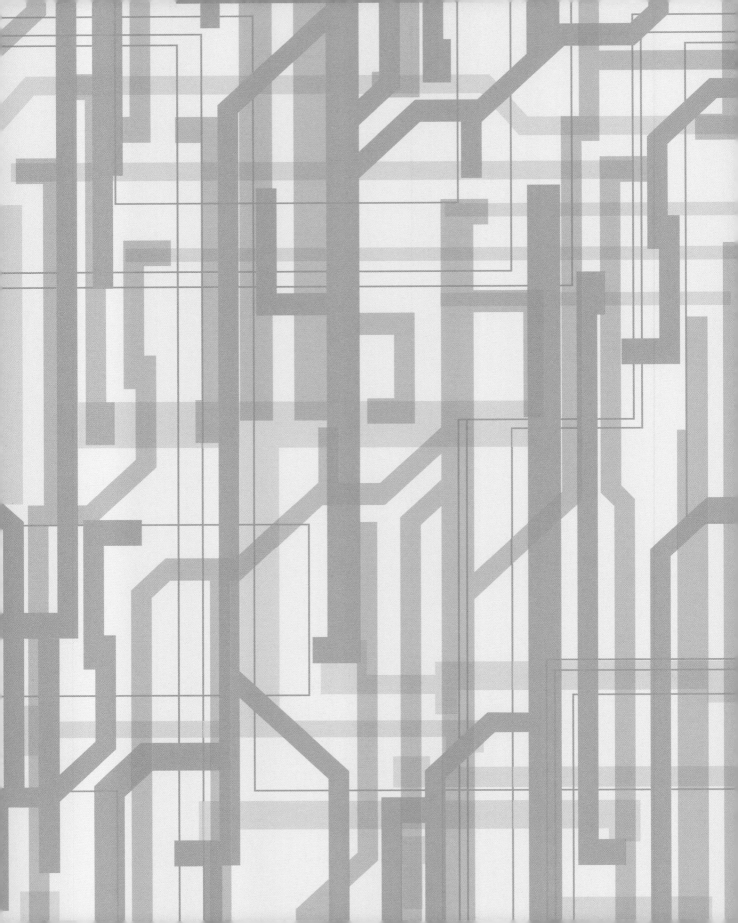

We live in an abundant information world. All the text, words, ideas, and imagery are so accessible and democratic that information has defined our time—the information society. But since information is intangible, can it be captured, retained, or transformed into form, shape, color, and visual languages? In the last decade I decided that somehow I wanted to speak about this digital info age—that possibly through color, decoration, code, pattern, texture, line, solid, plane, composition I could make the digits of binary notation manifest and communicate a new form of decoration that is current and aesthetic with new itinerant forms.

I love decoration when it has meaning. Historically, decoration always had meaning and status, generally referencing religious, moral, gentry, noble, upper class, or civil communication. It also developed from crafts, processes and techniques (herringbone came from a certain loom, likewise plaid from a method of weaving). Decoration was used as a form of language, as well as a means of denoting the capability of the human hand or tools, the richness and craft of a certain era, the workmanship of a period. Then, in mass-production, decoration became an expensive process, if not impossible, so the machine age parted with the ornate. With automation and the industrial revolution, decoration was developed to carry on the spirit of the past, and as a way of 'humanizing' industrial objects. But eventually production technology reached a point where decoration became more cost effective, a way of hiding flaws, a way of camouflaging defects, and a way of 'cheapening the product'. Decoration became the myth of value, a mode of making objects or products appear more valuable, more luxurious, a bourgeois paradigm. The irony is that it is now cheaper to create something decorated than something pure and clean. Simply surfacing the product was the fastest and simplest way of giving a consumer a choice and a tribe-niche (fascias for cell-phones, Fuji-wraps, car wraps, bus ads, 3-D labeling, tattooing, and a plethora of new technological communications). But decoration is also a great opportunity to communicate the time in which we live. With new technologies we can also create instant diversity, variation, and customization. New meanings have surfaced. Signs of technology, such as 'fake venting' (that originally started out as real vents for airflow), perforations, holes for speakers, have become synonymous with high-tech signifiers in products but are now banal. In the past few decades Op Art, Pop Art, illusory perception, graffiti have been means to mediate personalized or more rarified mass-goods. Now in our digital age, we see a new, digitally inspired, decorative language emerging, an extension of the glorified 'Mac rave flyer' movement, a techno-rave new world, where our images, symbols, argots, textures, are creating a digital pop vernacular, which speaks to our new spiritualism—the spirit of the digital age.

Decoration needs to revisit our product and architectural landscape to communicate our milieu, our time—I think the digital age has a new language, a vernacular I refer to as the Infostethic (the aesthetics of information). Work by John Maeda, Research Studios, and many other graphic artists study the ability of our new tools and our entropic age to capture signifiers and the visual motivators of the digital age—a characteristic of the movement of graphic design and application and the use of composition techniques made possible only by the use of new technologies and software. The new movement of technographics is creating an epistemic landscape that is hypertextual, hypergraphic, hypertrophic, and energetic.

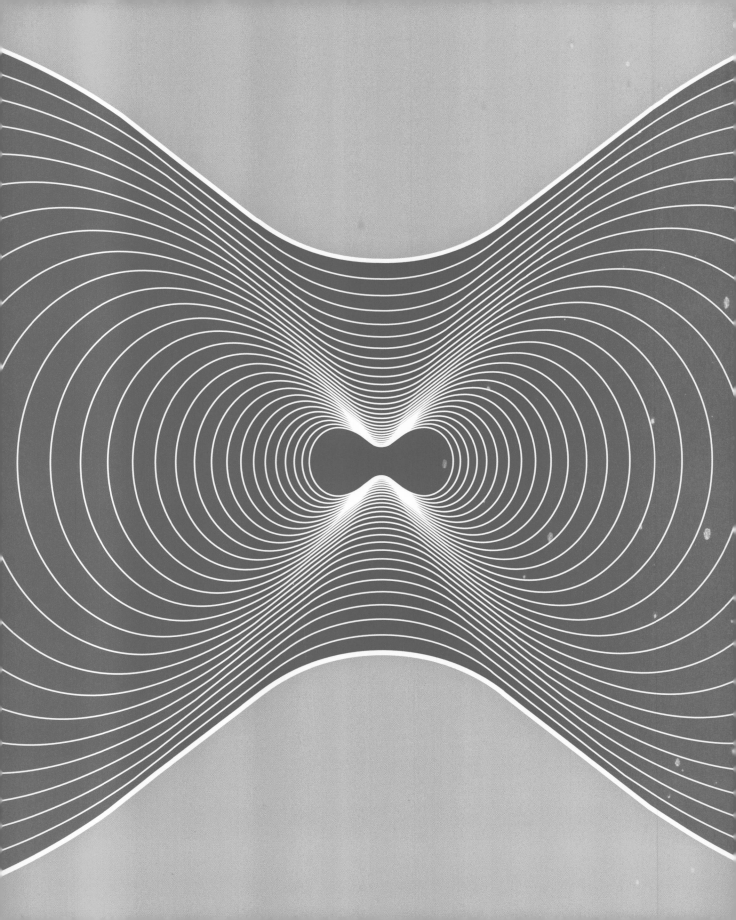

Wir leben mit einer Überfülle von Informationen. Texte, Worte, Ideen und Bilder sind so verfügbar und demokratisiert, dass sie unsere Zeit definiert haben – die Informationsgesellschaft. Information ist nicht greifbar: Kann man sie einfangen, aufbewahren oder in Form, Gestalt, Farbe und visuelle Sprachen umwandeln? Im letzten Jahrzehnt habe ich beschlossen, dass ich mich auf irgendeine Art zum digitalen Informationszeitalter äußern möchte – dass ich durch Farbe, Dekor, Code, Muster, Konsistenz, Linie, Fläche und Komposition die Ziffern der binären Notation erkennbar machen kann, um eine neue Form von Dekor zu vermitteln, eine aktuelle Ästhetik neuer, immer in Bewegung befindlicher Formen.

Ich liebe Dekor, das eine Bedeutung hat. Historisch betrachtet, hatte Dekor immer seinen Sinn, man konnte daraus auf Religion, Moral, Land und Leute schließen. Außerdem ergab es sich aus den Herstellungsprozessen und -techniken (Fischgrät entstand auf einem ganz bestimmten Webstuhl, Plaid war ebenfalls eine Webtechnik). Dekor fungierte als eine Art Sprache und ließ Rückschlüsse auf geschickte Hände oder Werkzeuge, den Reichtum oder die Kunstfertigkeit einer bestimmten Zeit, das handwerkliche Können einer Epoche zu. Mit der Massenproduktion wurde Dekor zu einem teuren Prozess, wenn nicht unmöglich, also trennte das Maschinenzeitalter sich vom Ornamentalen. Mit der Automatisierung und der industriellen Revolution entwickelte sich Dekor dahin, das Stilempfinden der Vergangenheit weiterzugeben, zum Mittel, industriell gefertigte Produkte „menschlicher" zu gestalten. Irgendwann kam die Produktionstechnologie an einen Punkt, wo Dekor kosteneffektiver wurde, zu einem Weg, Schönheitsfehler zu verstecken und Defekte zu kaschieren, ein Weg, Produkte zu verbilligen. Dekor wurde zum Mythos von Wert, zu einer Methode, Produkte oder Objekte reicher und luxuriöser erscheinen zu lassen, ein bourgeoises Paradigma. Die Ironie ist, dass es mittlerweile billiger ist, etwas reich Verziertes als etwas mit reinen und klaren Formen herzustellen. Einfach die Oberfläche des Produkts zu bearbeiten, war der schnellste und einfachste Weg, dem Verbraucher Wahlmöglichkeiten zu geben und Nischengeschmäcker zu bedienen (Handyabdeckungen, Flaschenummantelungen, Autoabdeckungen, Buswerbung, holografische Labels, Tätowierungen und eine Unmenge an neuer Kommunikationstechnologie). Dekor ist jedoch auch eine großartige Möglichkeit, den Geist der Zeit, in der wir leben, zu transportieren. Und mit neuen Technologien können wir auf Knopfdruck Vielfalt und Abwechslungsreichtum erzeugen oder bestimmte Kundenwünsche befriedigen. Es sind neue Bedeutungen aufgetaucht. Zeichen für Technologie wie „Fake-Lüfter" (die irgendwann einmal tatsächlich der Belüftung dienten), Perforationen, Öffnungen für Lautsprecher wurden zum Synonym für High-Tech-Produkte, sind heute jedoch banal. In den letzten Jahrzehnten sind Op-Art, Pop-Art, optische Spielereien und Graffiti allesamt dazu eingesetzt worden, individuell angepasste oder „exklusivere" Massenprodukte zu signalisieren. Heute in unserem digitalen Zeitalter sehen wir neue, digital inspirierte Designsprachen aufkommen, eine Erweiterung der glorreichen „Mac-Rave-Flieger"-Bewegung, eine schöne neue Techno-Welt, in der unsere Bilder, Symbole, Argots, Texturen und unser digitales Pop-Vokabular vorherrschen. Es interessiert mich, unsere neue Spiritualität zur Sprache zu bringen – den Geist des Digitalzeitalters.

Dekor erfordert immer wieder einen neuen Besuch in unserer Produkt- und Architekturlandschaft, um unsere Umgebung, unsere Zeit zu vermitteln – ich meine, das Digitalzeitalter verfügt über eine neue Sprache, ein Vokabular, das ich Infosthetik (die Ästhetik der Information) nenne. Das Werk von John Maeda, Research Studios und vielen anderen Grafikkünstlern erforscht immer noch den ganzen Umfang der Möglichkeiten unserer neuen Tools und unserer entropischen Ära, um die Anzeichen und visuellen Reize des Digitalzeitalters wiederzugeben.

Ein Charakteristikum der Bewegung von Grafikdesign und Gebrauchsgrafik ist der Einsatz von neuen Technologien und Programmen. Die neue Bewegung der Technografik erschafft eine epistemische Landschaft, die hypertextuell, hypergrafisch, hypertroph und energetisch ist.

infostethiks

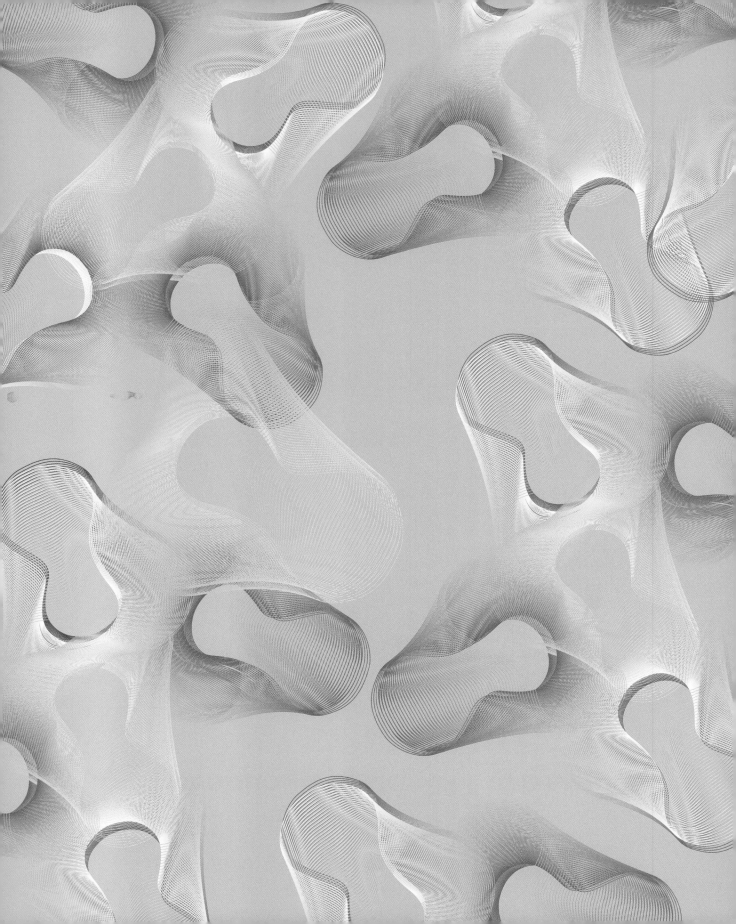

Nous vivons dans un monde regorgeant d'informations. Tout ce qui est texte, mots, idées ou imagerie est si accessible, si démocratique, que notre société a pris le nom de : « société d'information ». Mais l'information étant insaisissable, peut-elle être captée, retenue ou transformée en formes, couleurs ou langages visuels ?

Au cours de la dernière décennie, je me suis décidé à parler de cette ère de l'information numérique – sachant que par la couleur, la décoration, le code, le modèle, la texture, la ligne, la densité, le plan, la composition, je pouvais probablement exprimer cette notion binaire pour créer une forme de décoration qui soit valable et esthétique, s'appuyant sur ces nouvelles formes.

J'aime la décoration quand elle a une signification. Historiquement, elle a toujours eu une signification et un statut, généralement avec des références religieuses ou morales, en rapport avec la bourgeoisie ou la société en général. La décoration s'est également développée à partir de la fabrication, des processus et des techniques (le motif à chevrons provient d'un certain tissage, tout comme l'écossais). Elle a toujours été utilisée comme une forme de langage, un moyen de souligner les possibilités de la main humaine, les outils d'un savoir-faire ou l'habileté d'une certaine époque. A l'avènement de la production en masse, la décoration est devenue un processus cher, sinon inaccessible, et donc la mécanisation y a renoncé. Avec l'automation, la production en chaîne et la révolution industrielle, la décoration a cherché à retrouver l'esprit du passé, une manière « d'humaniser » les objets industriels. Mais par la suite, la production a atteint un point où la décoration est devenue plus rentable, une manière de cacher les failles, de camoufler des défauts, et « rentabiliser les produits ». Elle est donc devenue synonyme de valeur, une façon de faire paraître les objets ou les produits plus riches, plus luxueux : un paradigme bourgeois. L'ironie est qu'aujourd'hui, il revient moins cher de créer quelque chose de décoré, que quelque chose

de pur et de net. Mettre un produit lisse sur le marché, c'était la manière la plus rapide et la plus directe d'offrir au consommateur un choix et une niche identitaire (boîtiers pour mobiles, Fuji-wraps, carrosserie de voiture, publicité d'autobus, étiquetage 3-d, tatouage, et toute une pléthore de nouvelles technologies). Mais la décoration permet aussi d'exprimer l'époque à laquelle nous vivons. Ainsi, au moyen des nouvelles technologies, nous pouvons créer, de manière instantanée, diversité, variété et personnalité. De nouvelles significations ont émergé. Des signes technologiques tels que les « fausses aérations » (qui, à l'origine, répondaient à un besoin de ventilation), les perforations, trous pour haut-parleurs, devenus synonymes de high-tech pour les produits, sont aujourd'hui complètement banalisés. Ces dernières années, l'op-art, le pop-art, l'illusion, les graffitis, ont servi à distribuer des produits personnalisés ou peu courants. A notre époque numérique, nous voyons apparaître un langage nouveau, décoratif, digital, prolongation du mouvement « Rave flyer » du Mac, un monde « techno-rave », dans lequel nos images, symboles, argots, textures, et vocabulaire numérique créent un vernaculaire qui exprime notre nouvelle spiritualité : Le Numérique.

La décoration a besoin de revisiter nos produits et notre paysage architectural, pour exprimer notre milieu et notre époque. Je suis persuadé que le numérique est porteur d'un nouveau langage que je nommerais « Infostethic » : esthétique de l'information. Des oeuvres de John Maeda, Research Studios, et de beaucoup d'autres graphistes, s'intéressent à l'ampleur de nos nouveaux outils et de notre âge anthropique, et cherchent à rendre les signifiants et les motivateurs visuels de notre âge numérique. Seuls le design graphique, l'application et l'utilisation des techniques de composition ont permis l'utilisation de nouvelles technologies et de logiciels. Le nouveau mouvement technographique crée un paysage epistemique à la fois hypertextuel, hypergraphique, hypertrophique, et énergétique.

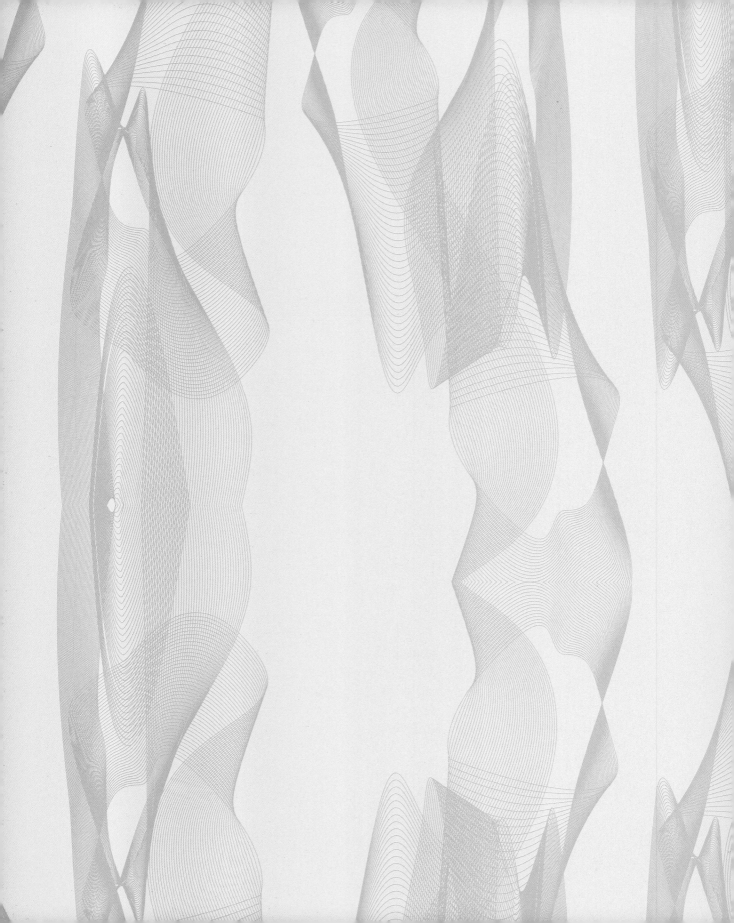

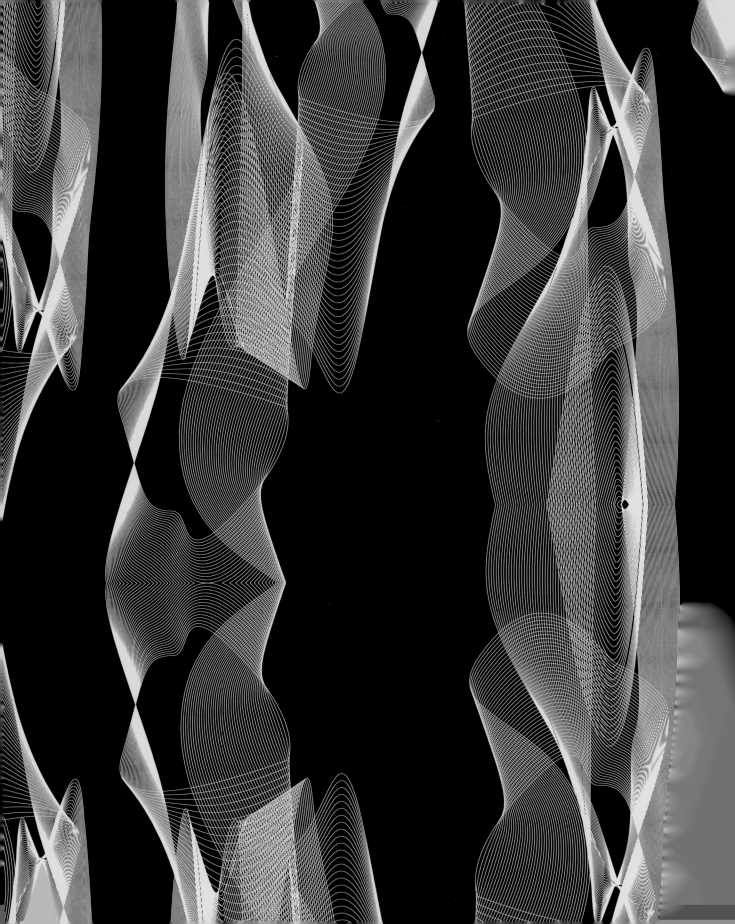

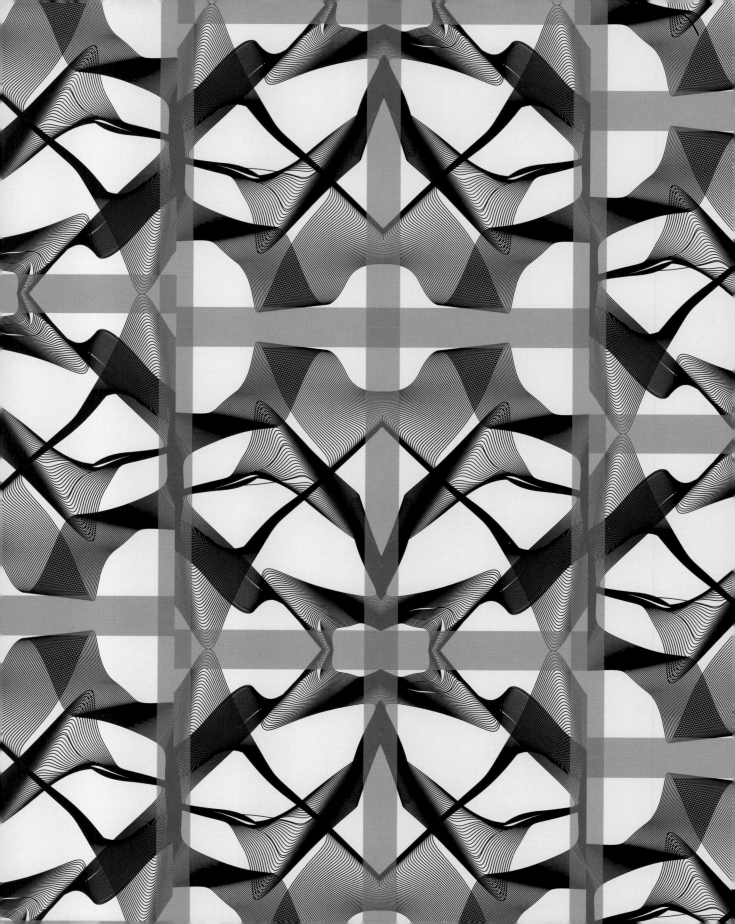

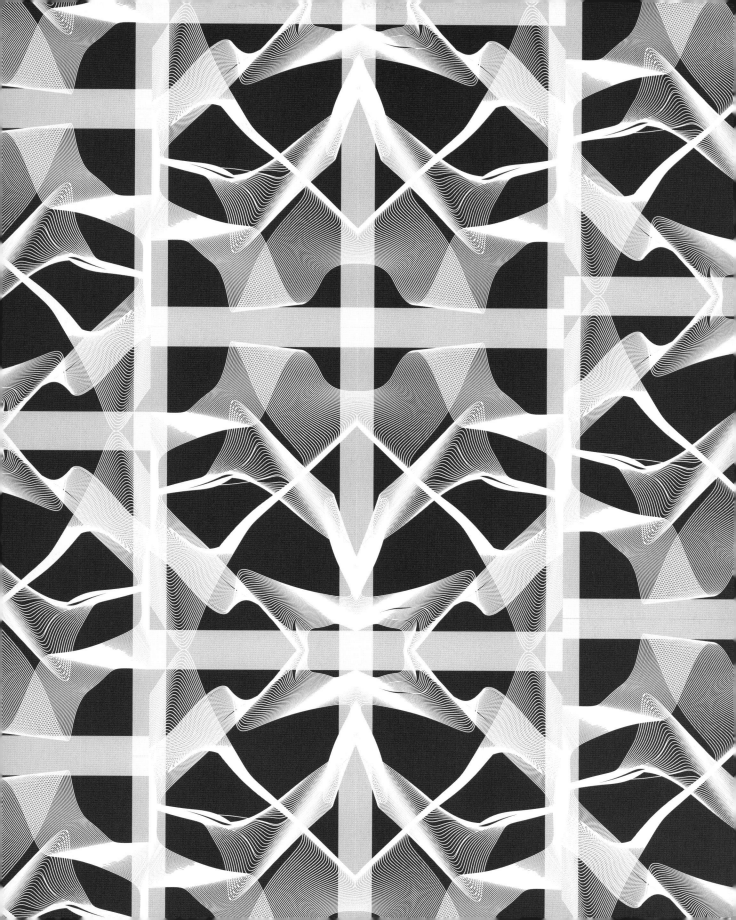

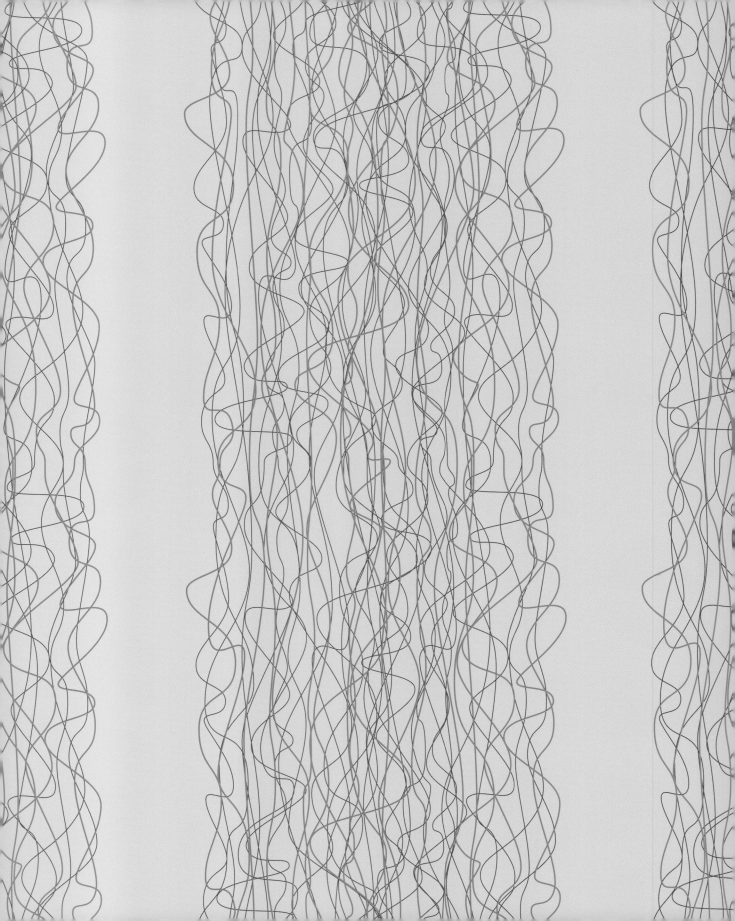

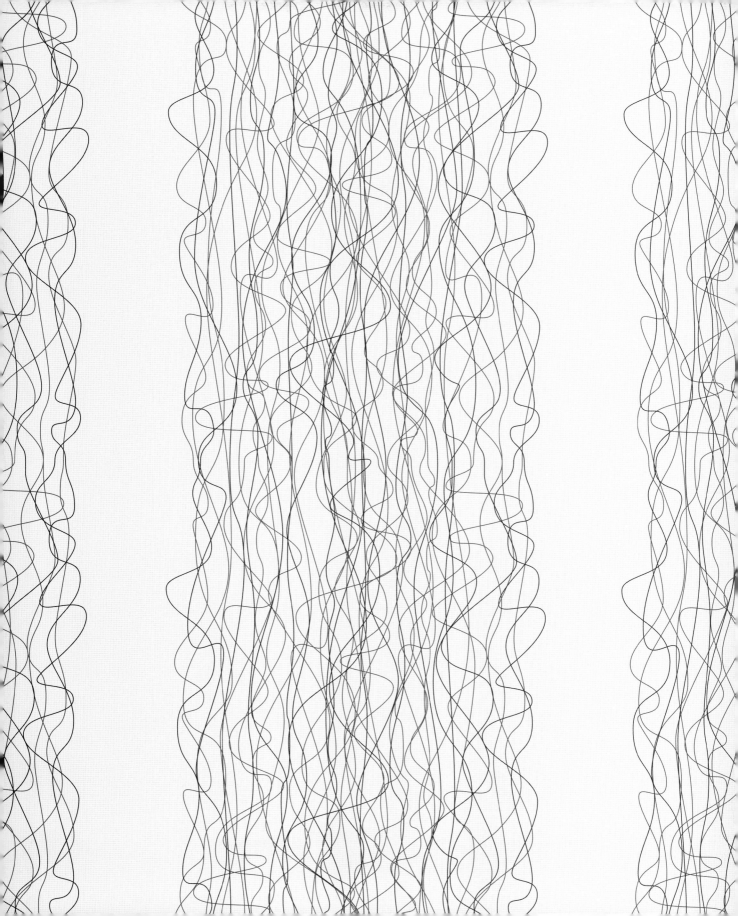

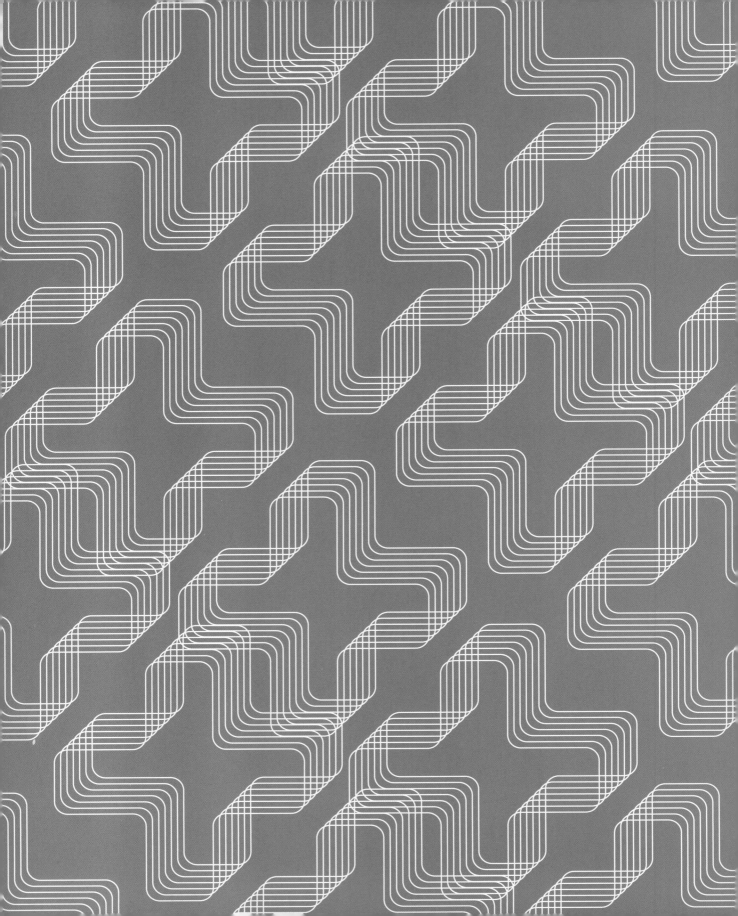

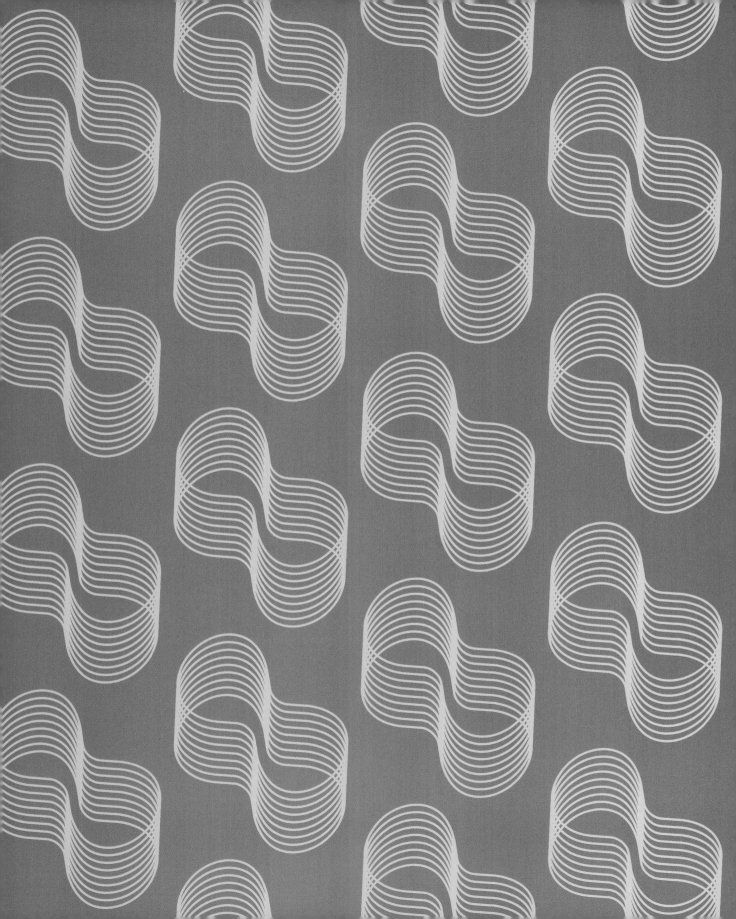

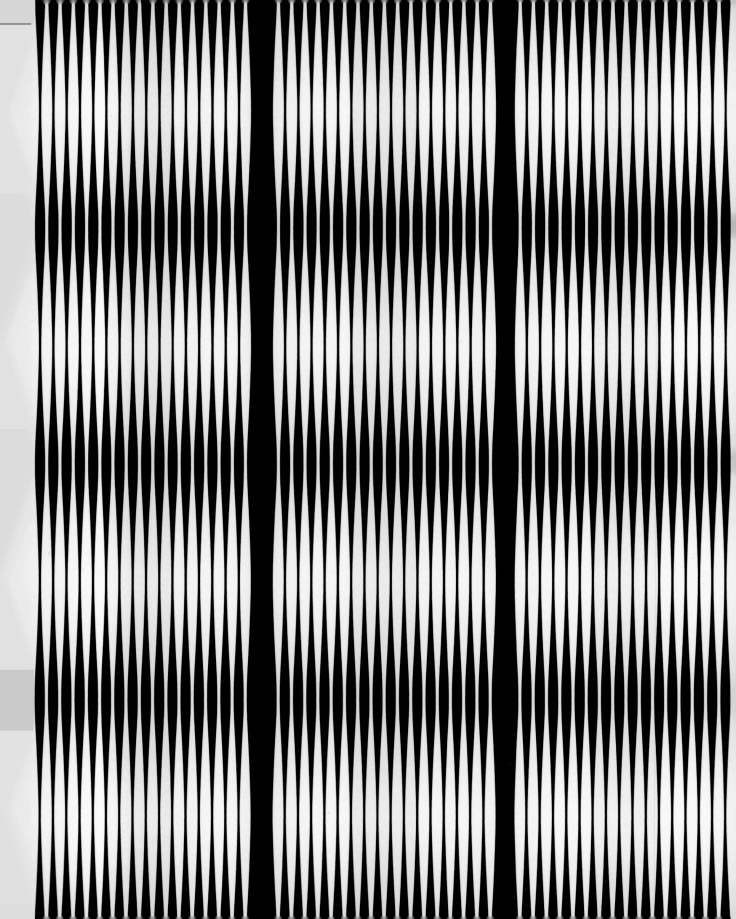

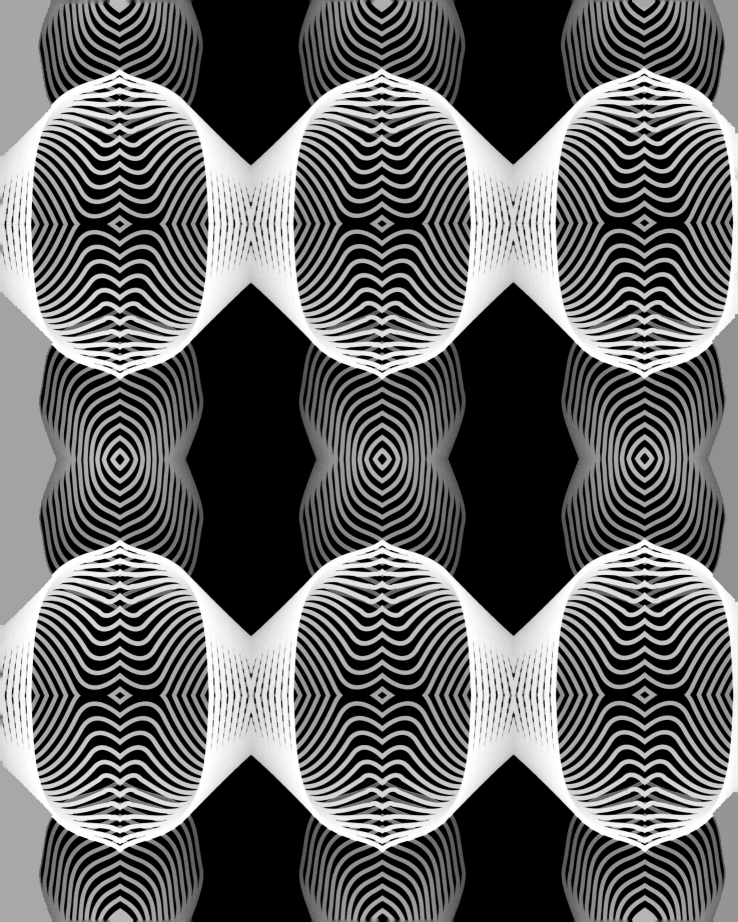

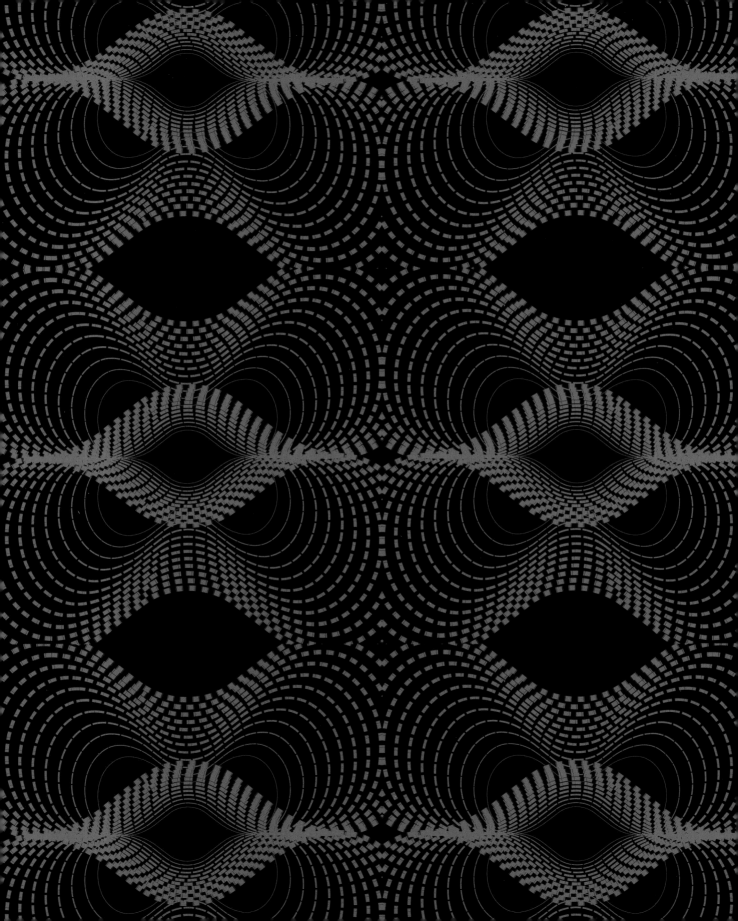

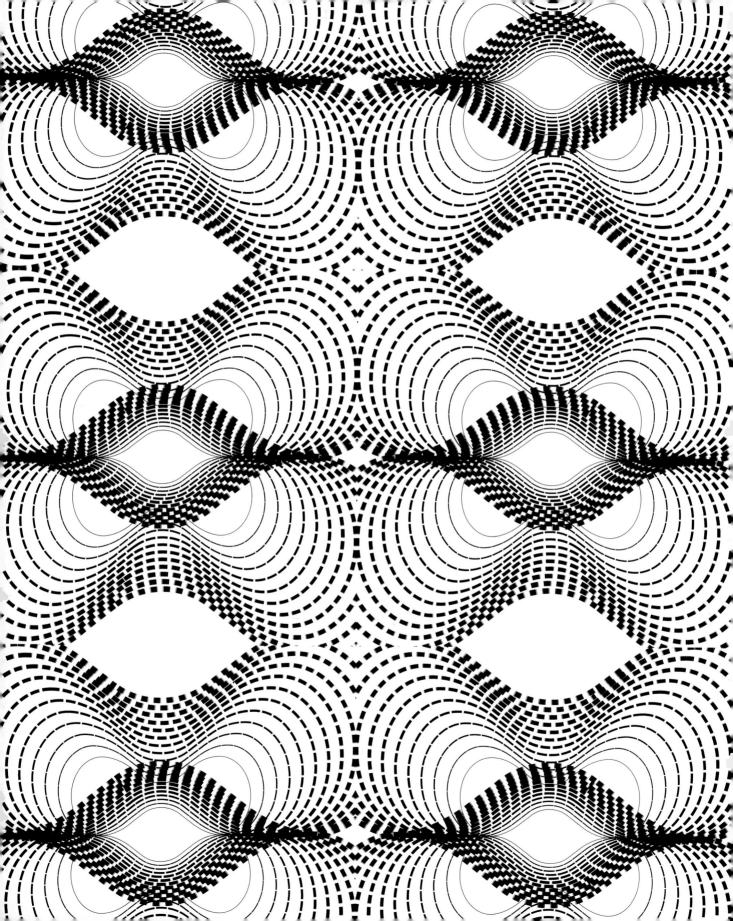

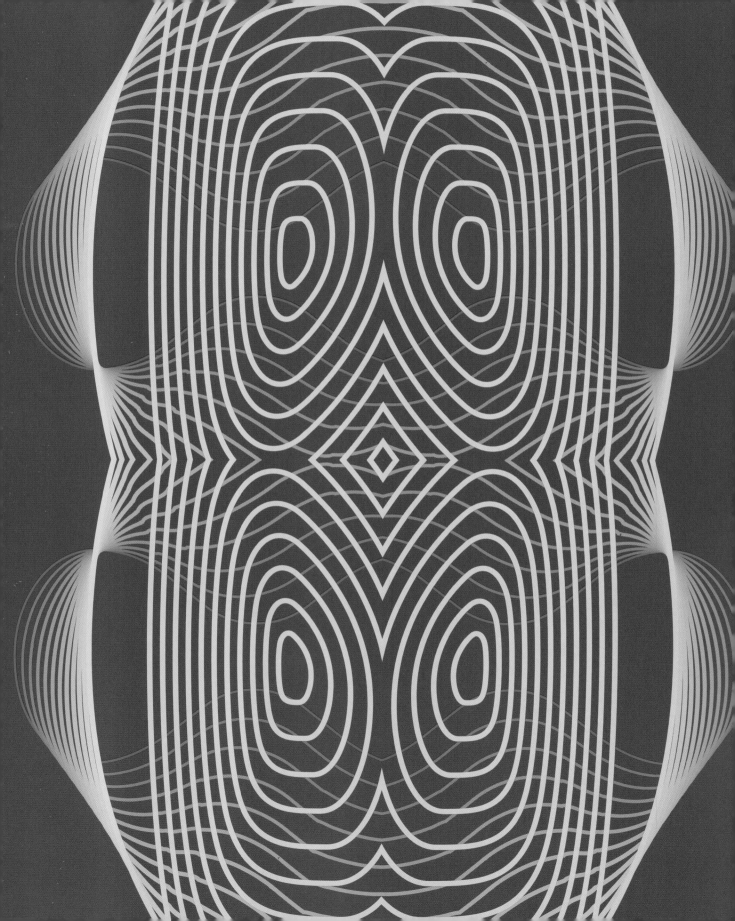

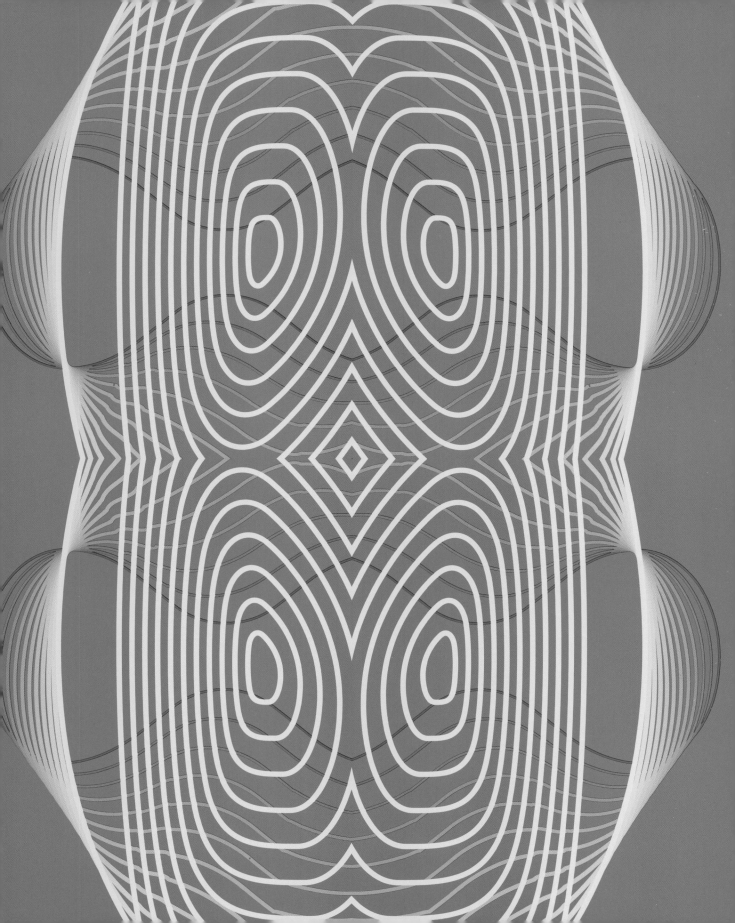

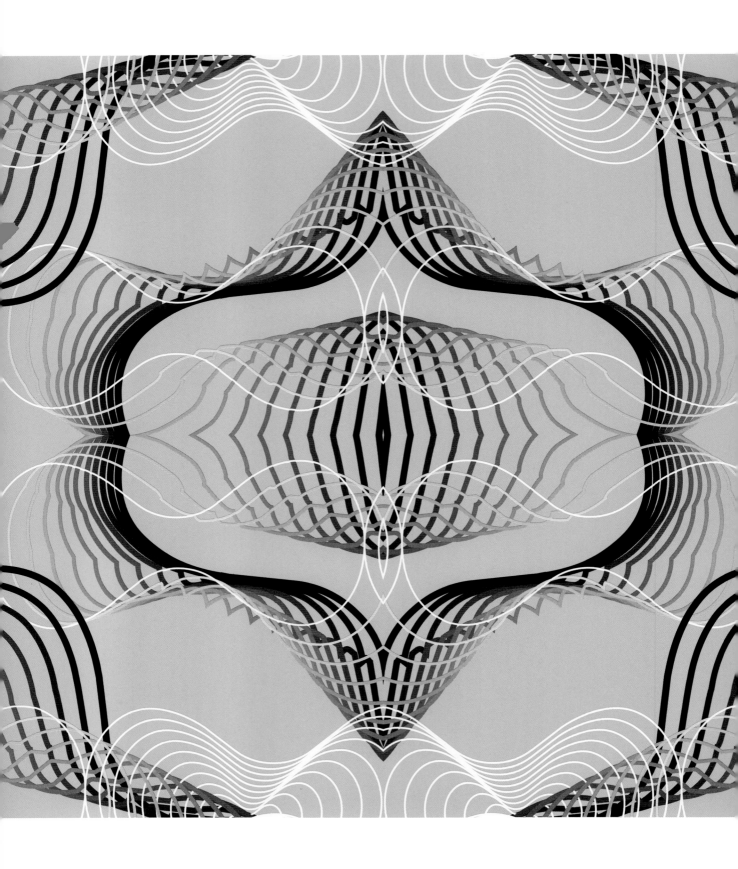

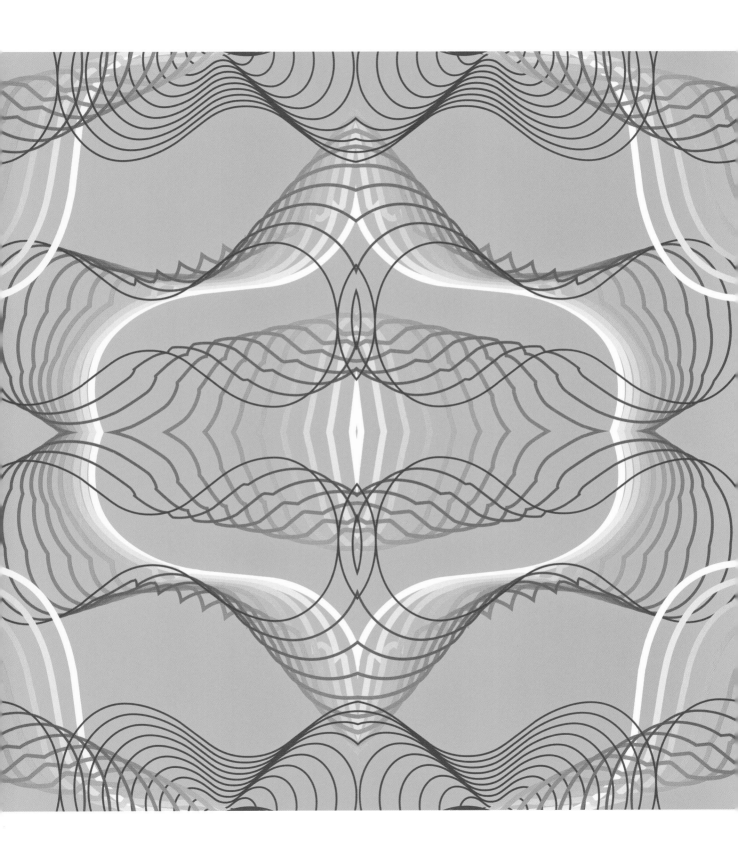

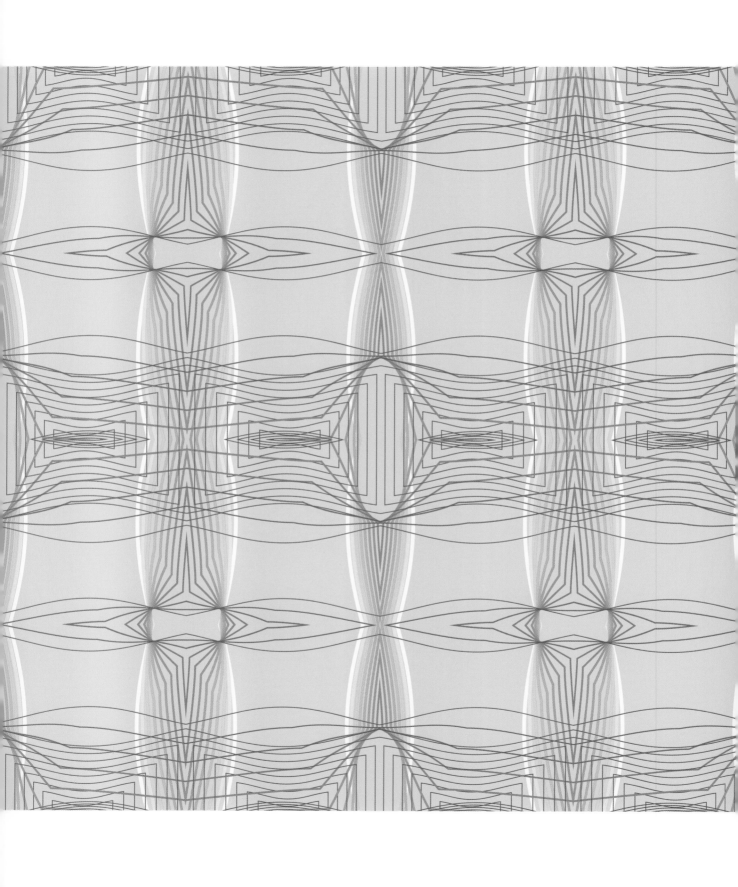

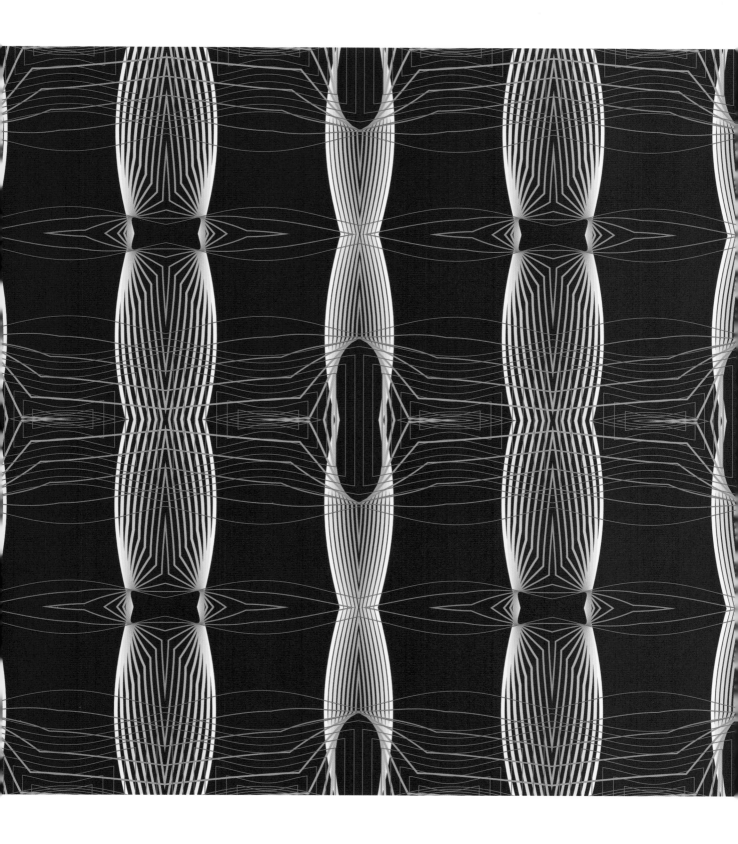

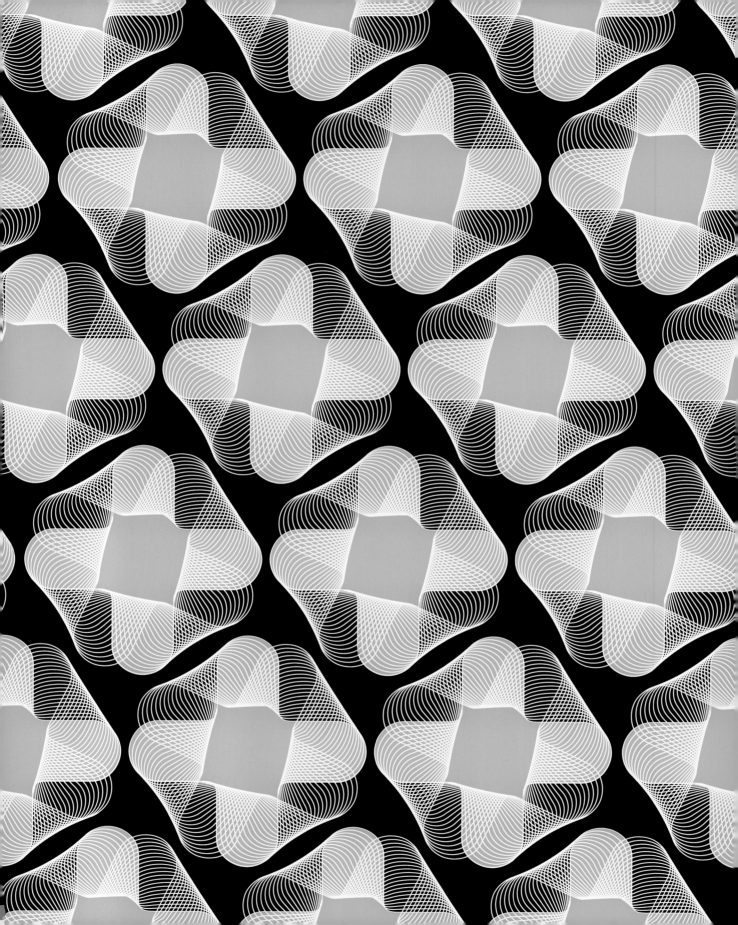

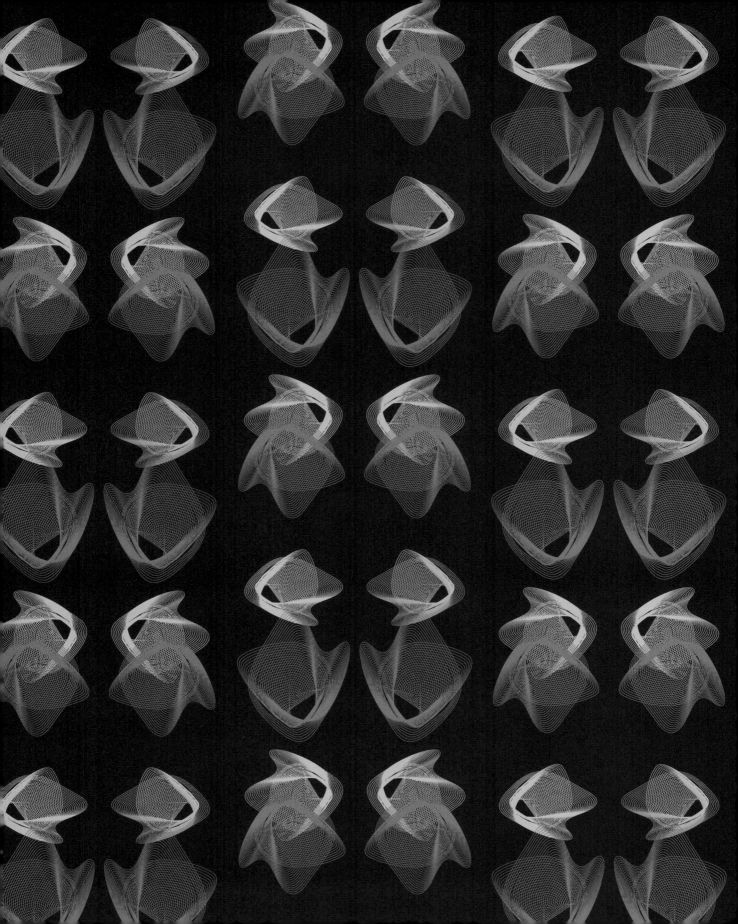

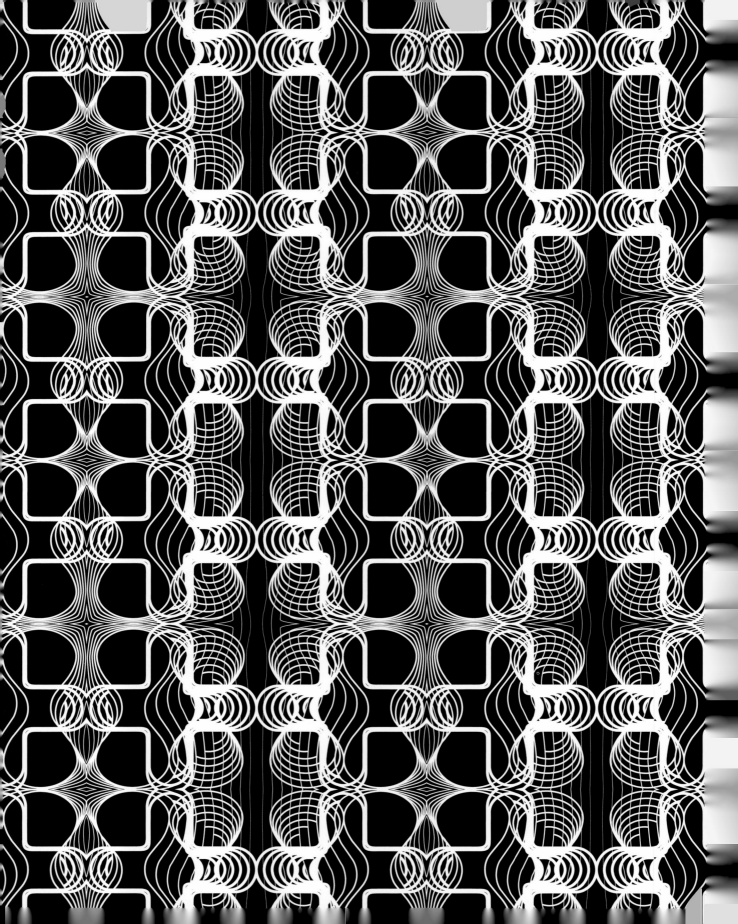

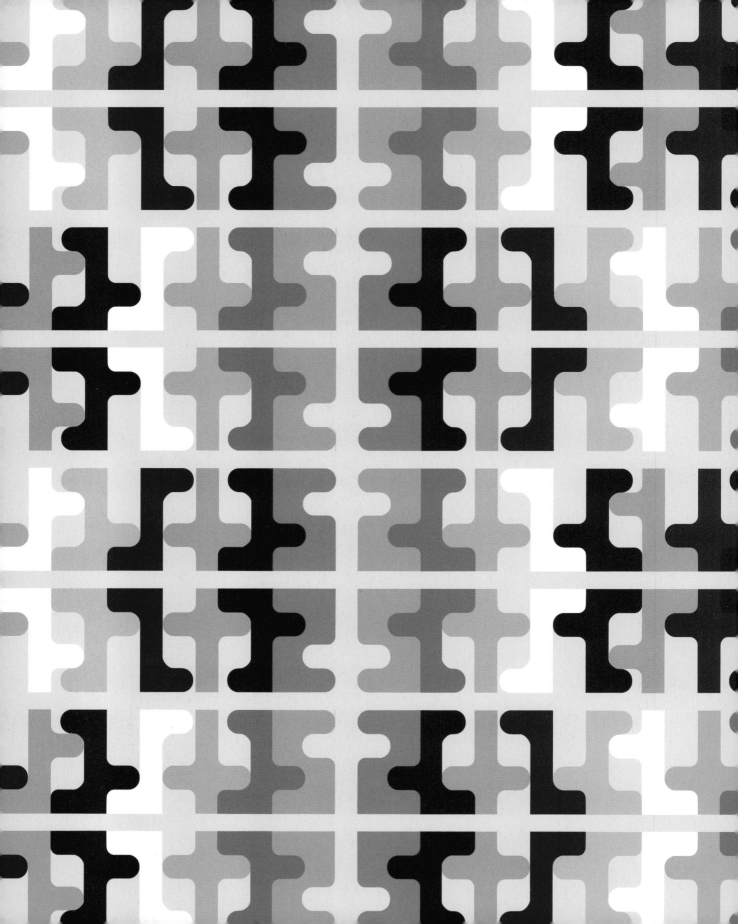

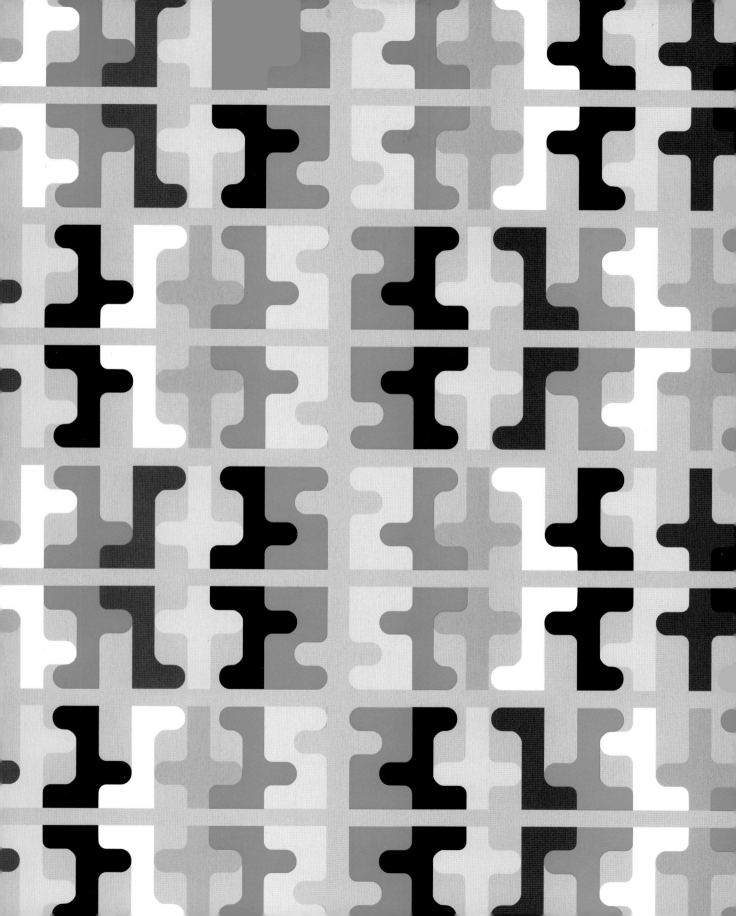

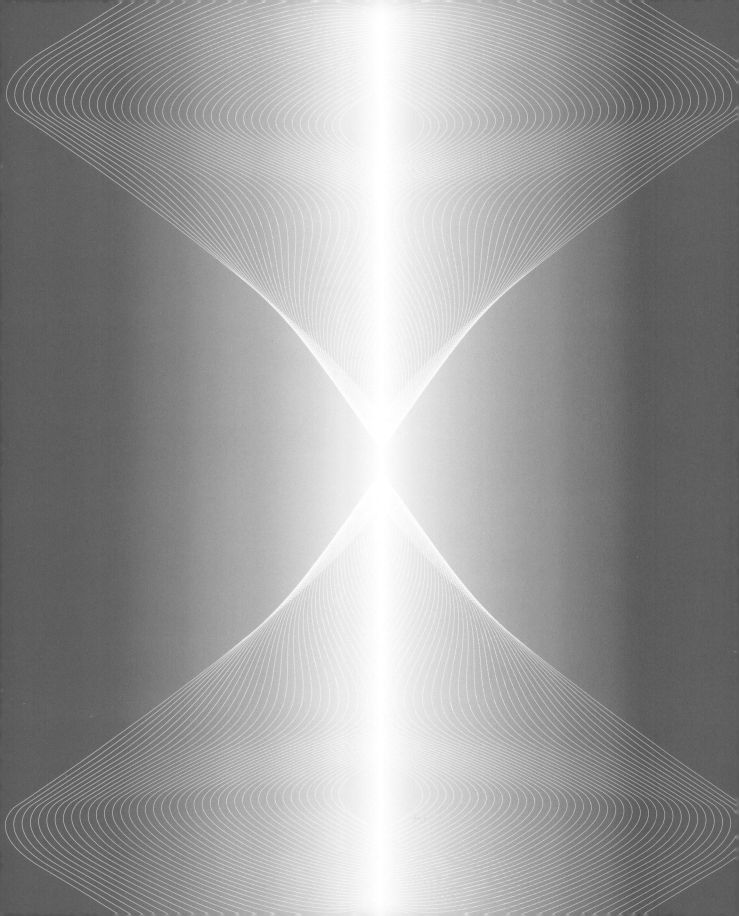

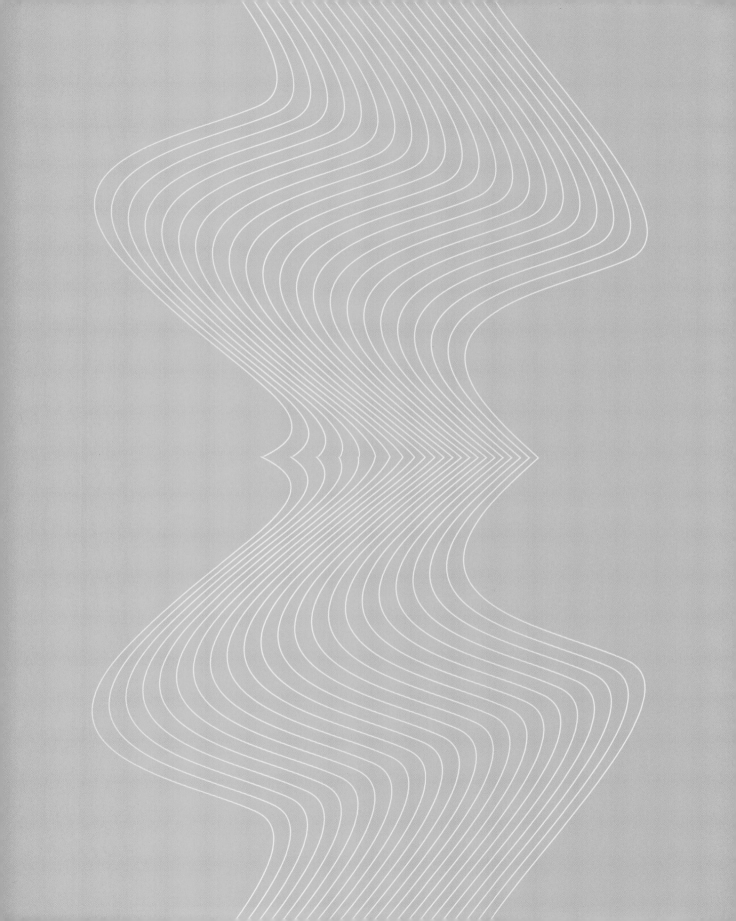

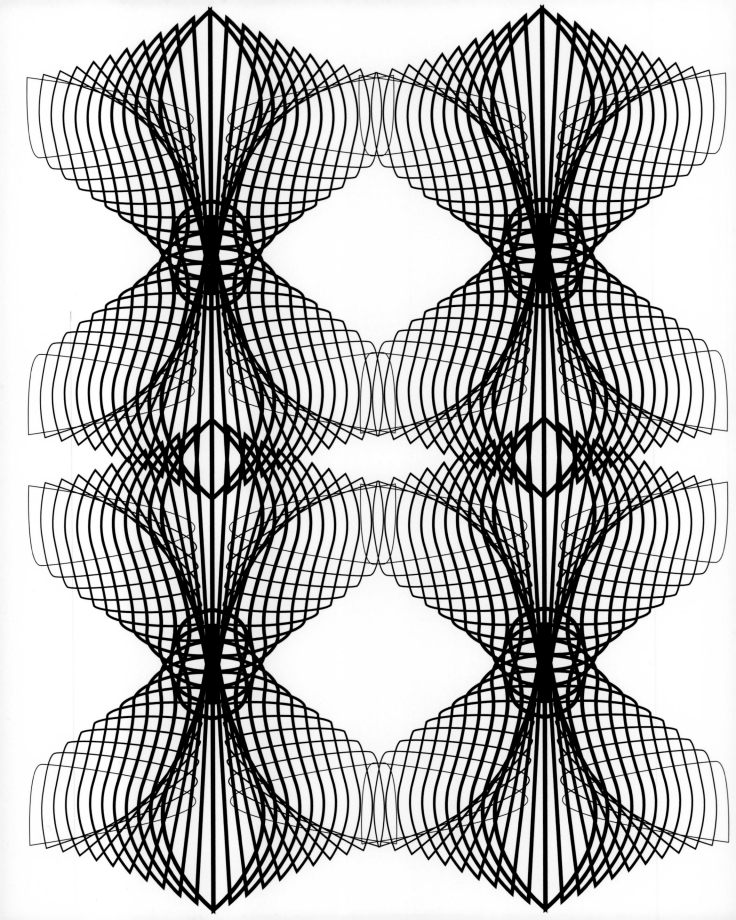

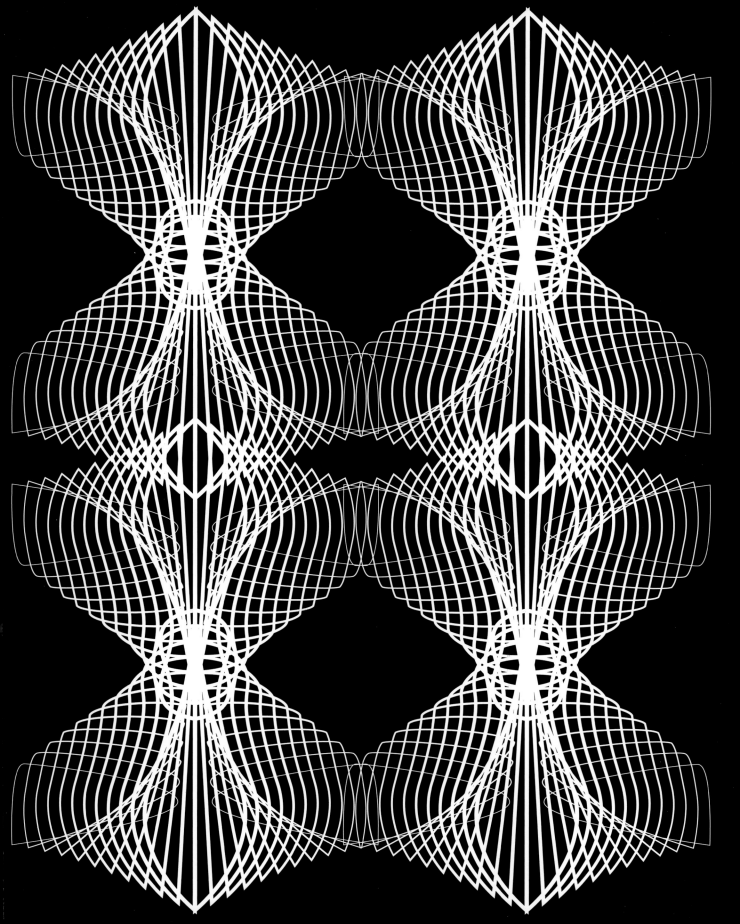

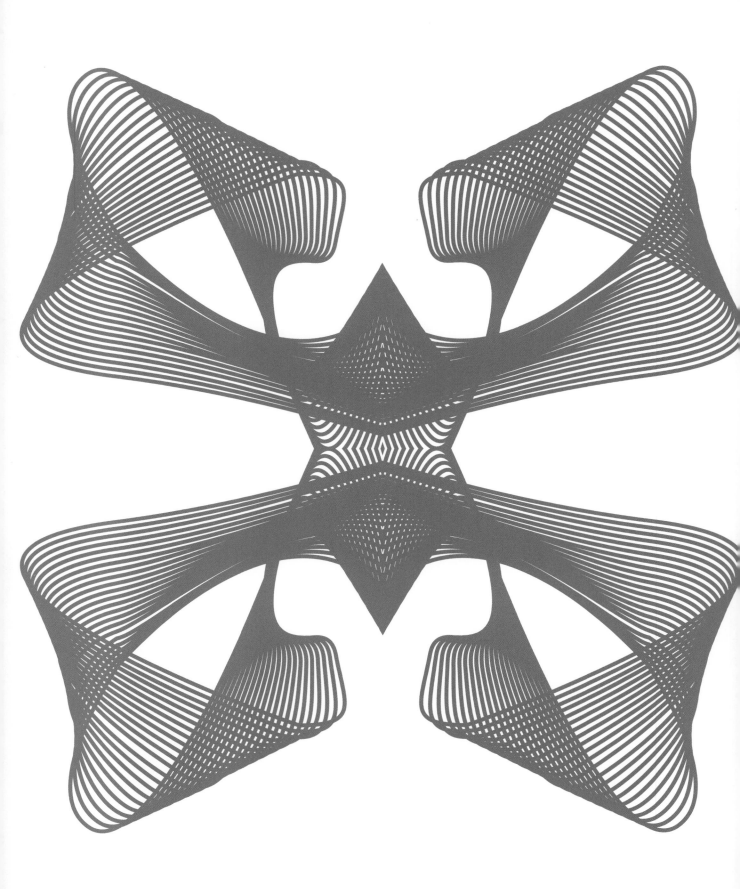

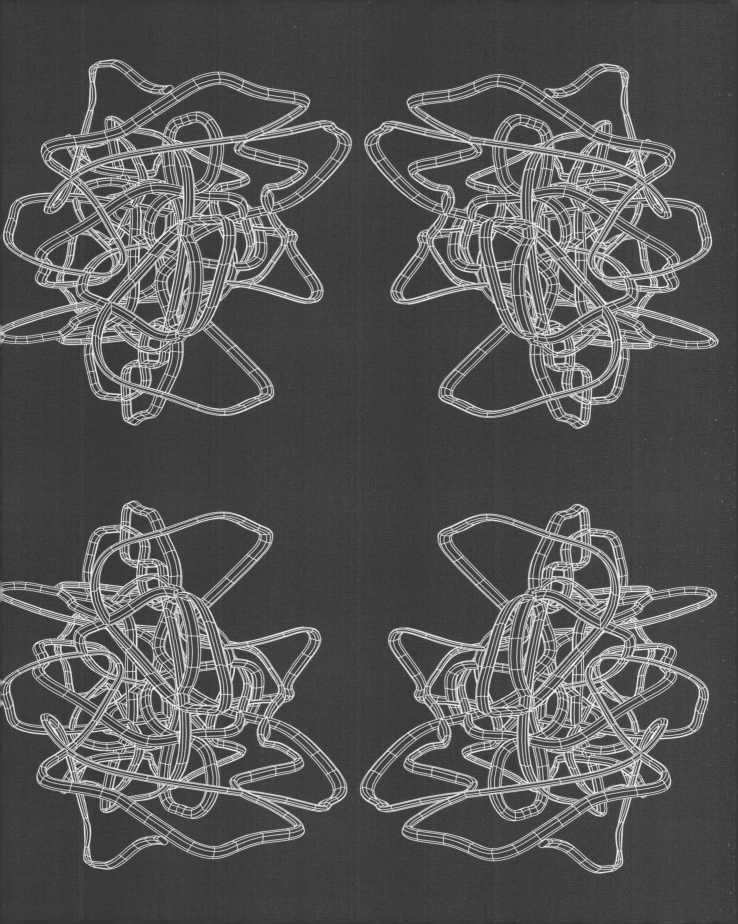

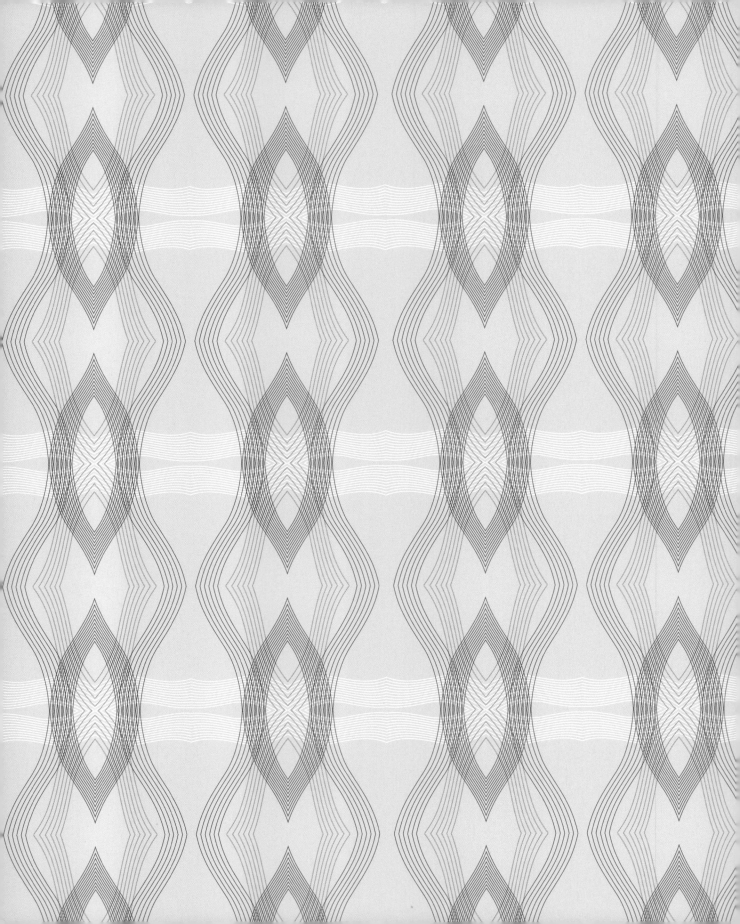

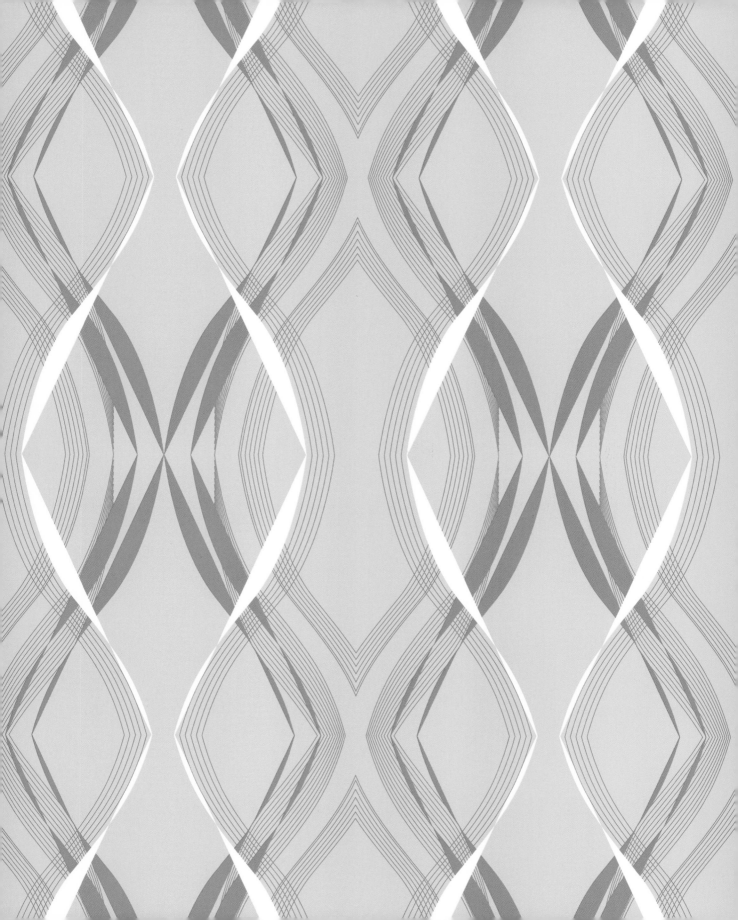

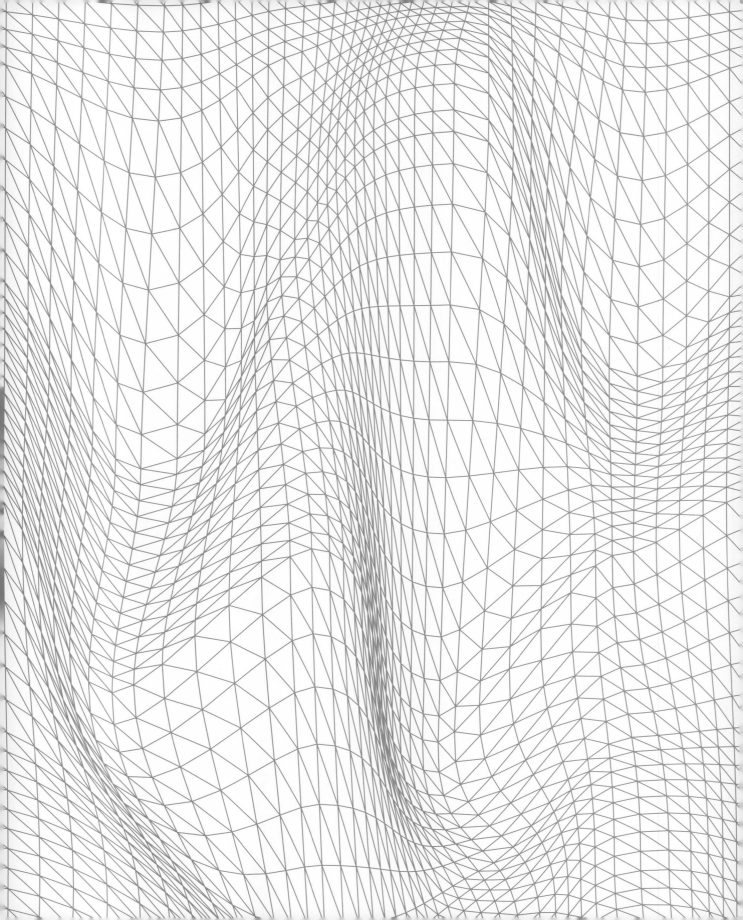

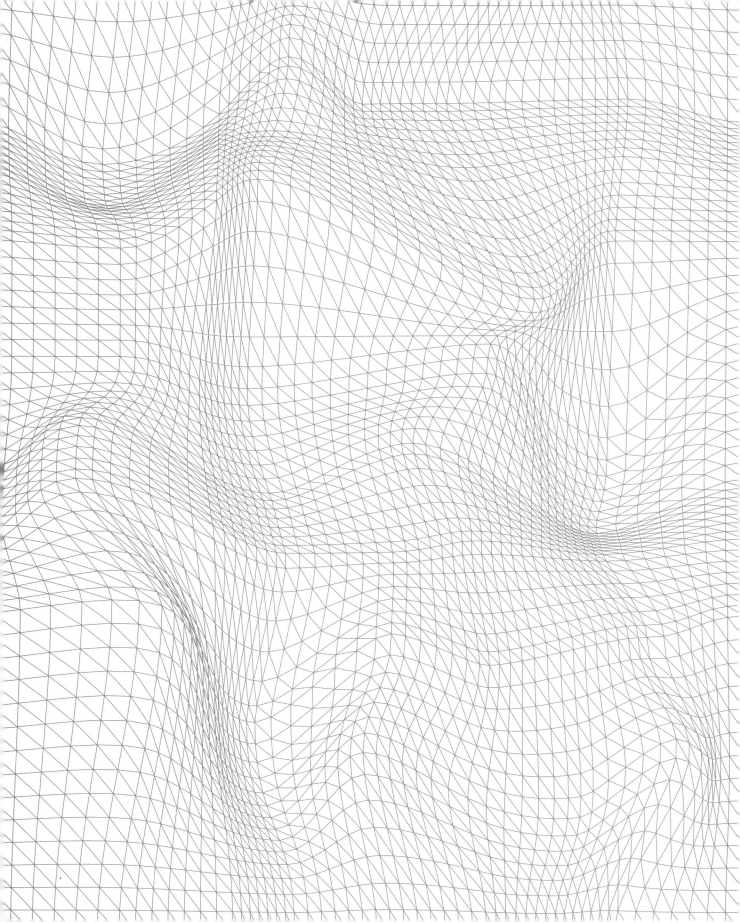

index

Karim Tag, 2000

Hypermix Female, 2002

2–3: **Flash**, pattern / Muster / motif, 1997

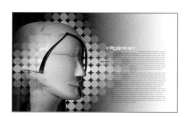

4–5: **Plastic Ego Female**, inkjet on canvas / Inkjet auf Leinwand / jet d'encre sur toile, Elga Wimmer Gallery, NYC, 2003

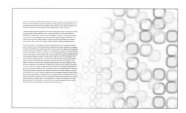

6–7: Concept, restaurant interior graphics / Grafiken für Restaurantinterieur / graphique pour intérieur de restaurant, Starr, Philadelphia, USA, 2000

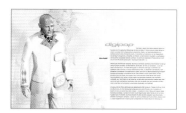

8–9: **Cybermix Male**, 2002

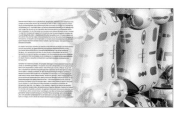

10–11: **Smarttoo**, inkjet on canvas / Inkjet auf Leinwand / jet d'encre sur toile, Elga Wimmer Gallery, NYC, 2003

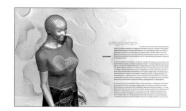

12–13: **Cybermix Female**, 2002

14–15: Fabric / Stoff / tissu, Label, Holland, 2004

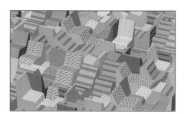

16–17: **Surfacescape**, furniture and textile design / Möbel- und Textildesign / mobilier et textile, Edra, Italy, 2001. Magazine print / Zeitschriftendruck / magazine print, *Surface*, USA, 2001

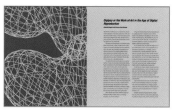

18: **Mobius Blue**, Roubini Rugs, USA, 2003

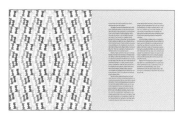

20: Concept, wall covering / Entwurf, Wandbehang / concept, tapisserie, Wolf-Gordon, USA, 2002

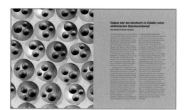

22: **Plombs**, triptych, inkjet on canvas / Tryptichon, Inkjet auf Leinwand / triptique, jet d'encre sur toile, Deitch Projects, NYC, 2002

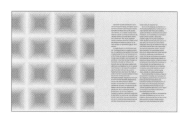

24: Concept, carpet / Entwurf, Teppich / concept, tapis, Roubini Rugs, USA, 2003

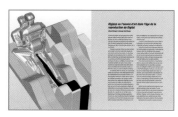

26: **Karimsutra**, inkjet on photo paper / Inkjet auf Fotopapier / jet d'encre sur papier photo, Sex Museum, NYC, 2004

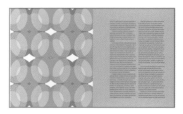

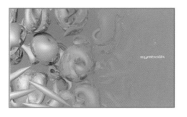

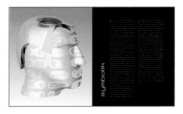

28: Carpet / Teppich / Tapis,
Step, Turkey, 2004.
Lamp pattern / Lampenmuster /
motif pour lampe,
Art Box, USA, 2003

30–31: **Mutablobs**, mosaic / Mosaik / mosaïque, Semiramis
Hotel, Athens, Greece, 2004

32: Self-portrait, inkjet on
canvas / Selbstporträt, Inkjet
auf Leinwand / auto-portrait,
jet d'encre sur toile, Elga
Wimmer Gallery, NYC, 2003

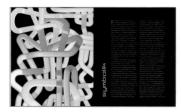

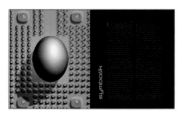

34: **Momo100**, inkjet on photo
paper / Inkjet auf Fotopapier /
jet d'encre sur papier photo,
Deitch Projects, NYC, 2001

36: **Sensorium**, Muzak,
Chicago, USA, 2002

38–39: **Hypermix Male**, 2002

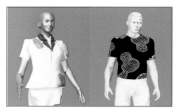

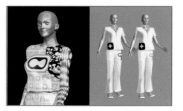

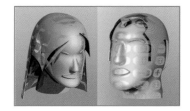

40: **Cybermix Female**,
2002 41: **Cybermix Male**, 2002

42: **Hypermix**, 2002 43: **Cybermix Twins**,
2002

44–45: **Megan and Karim**, inkjet on canvas / Inkjet auf
Leinwand / jet d'encre sur toile, Elga Wimmer Gallery, NYC,
2003

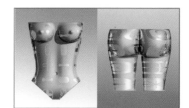

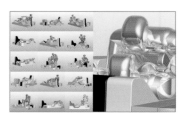

46–47: **Smarttoo**, inkjet on canvas / Inkjet auf Leinwand /
jet d'encre sur toile, Elga Wimmer Gallery, NYC, 2003

48–49: **Replikants**, inkjet on canvas / Inkjet auf Leinwand /
jet d'encre sur toile, Elga Wimmer Gallery, NYC, 2003

50–51: **Karimsutra**, inkjet on photo paper / Inkjet auf
Fotopapier / jet d'encre sur papier photo, Sex Museum, NYC,
2004

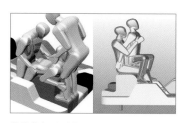

52–53: **Karimsutra**, inkjet on photo paper / Inkjet auf Foto-papier / jet d'encre sur papier photo, Sex Museum, NYC, 2004

54–55: **Momo100**, inkjet on canvas / Inkjet auf Leinwand / jet d'encre sur toile, Deitch Projects, NYC, 2001

56: **Accent on Design (AOD)**, corporate identity / Firmenlogo / identité commerciale, Gift Fair, GLM, NYC, 2004

57: Logo, EVO, USA, 2004

58: 3-D alphabet / 3-D-Alphabet / alphabet 3D, 2004

59: *Design or Die*, book cover / Bucheinband / couverture de livre, 2004

60–61: **Transpose**, inkjet on canvas / Inkjet auf Leinwand / jet d'encre sur toile, Elga Wimmer Gallery, NYC, 2003

62: **Kroma**, digital print, Futurism show/ digitaler Druck, Futurismus-Ausstellung / impression numérique, Exposition Futuriste , Totem Gallery, NYC, 2000

63: **Klusters**, 2004

64: **Karimella**, Natison, Italy, 2003

65: **Totems**, Futurism show / Futurismus-Ausstellung / exposition futuriste, Totem Gallery, NYC, 2000

66–67: **IKONY**, inkjet on canvas / Inkjet auf Leinwand / jet d'encre sur toile, Elga Wimmer Gallery, NYC, 2003

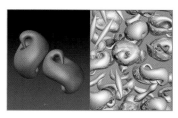

68: **Mutablobs**, inkjet on canvas, Organomica show / Inkjet auf Leinwand, Organomica-Ausstellung / jet d'encre sur toile, Exposition Organomica, Sandra Gering Gallery, NYC, 2002

69: **Kromablobs**, inkjet on canvas, Organomica show / Inkjet auf Leinwand, Organomica-Ausstellung / jet d'encre sur toile, Exposition Organomica, Sandra Gering Gallery, NYC, 2003

70–71: **Karimagos**, 1994

72: Carpet / Teppich / tapis, Idee, Japan, 1998

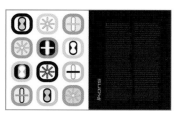

74: Coasters and mouse pads / Untersetzer und Mousepads / dessous de verre et tapis à souris / Totem, USA, 2000

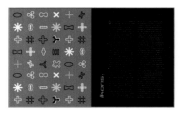

76: **Karimago**, vase pattern /
Vasenmuster / motif pour vase,
Egizia, Italy, 2003

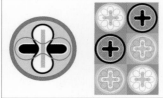

78: **Digilove**, Automotive
paint on canvas / Auto-
malerei auf Leinwand /
peinture automotive sur
toile, Sandra Gering Gallery,
USA, 2004.
Carpet / Teppich / tapis,
Step, Turkey, 2004

79: **Digilove**, studies / Entwürfe /
études, Sandra Gering Gallery,
NYC, 2004

80: Carpet study /
Teppichentwurf / tapis,
étude, Idee, Japan, 1997

81: Carpet / Teppich / tapis,
Step, Turkey, 2004

82: **Infiniti**, carpet / Teppich /
tapis, Idee, Japan, 1997

83: Carpet / Teppich / tapis,
Step, Turkey, 2004

84: Textile, storage products /
Textil, Aufbewahrungslösung /
textile, produits de range-
ments, IHW, USA, 2002

85: Carpet / Teppich / tapis,
Step, Turkey, 2004

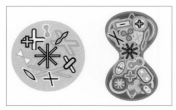

86: **Kosmo**, Carpet /
Teppich / tapis, Idee, Japan,
1997.
Mouse pad, Totem, USA,
1998

87: Mobile concept /
Mobile-Entwurf / concept
de mobile, Bozart, USA,
2002

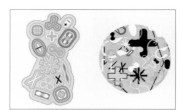

88: **Karkohpony**, Carpet /
Teppich / tapis, Post Design,
Italy, 2004

89: **Cibone Velo Taxi**,
graphics / Grafiken /
graphique, Tokyo Designers
Block, Japan, 2002

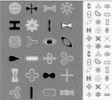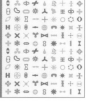

90: **Karimago**, paintings /
Gemälde / peintures, Elga
Wimmer Gallery, NYC, 2003

91: Graphic identity /
Grafischer Identitätsnachweis /
identité graphique, Semiramis
Hotel, Athens, Greece, 2004

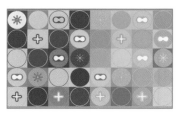

92–93: Vase patterns, silkscreen / Vasemuster, Siebdruck /
motifs de vases, sérigraphie, Egizia, Italy, 2003

94: Logo, Semiramis Hotel,
Athens, Greece, 2004

95: Logo, Oishii Restaurant,
Moscow, Russia, 2004

96: Logo studies / Logo-
Entwürfe / études pour
logos, Ronson, England,
2001

97: Logo, Madison Avenue
BID, NYC, 2004

98: Logo, Nooch Restaurant,
Singapore and NYC, 2004

99: Logo, Powder Dance
Club, NYC, 2003

100–101: **Kismet**, carpet / Teppich / tapis, Step, Turkey, 2004

102: **Zag**, concept, laminate pattern / Entwurf, Laminatmuster / concept, motifs pour stratifié, 2001

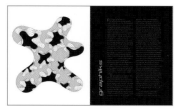

104: **Running Blue**, carpet / Teppich / tapis, Roubini Rugs, USA, 2003

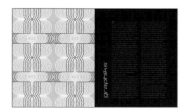

106: Concept, carpet / Entwurf, Teppich / concept, tapis, Roubini Rugs, USA, 2003

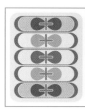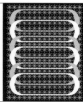

108: **5 Souls**, carpet / Teppich / tapis, Directional, USA, 1999

109: **Ubiquity**, carpet / Teppich / tapis, Directional, USA, 1999

110: Concept, carpet / Entwurf, Teppich / concept, tapis, Roubini Rugs, USA, 2003

111: Lamp pattern / Lampenmuster / motif pour lampe, Art Box, USA, 2003

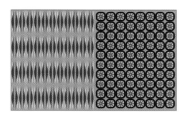

112: **Wex**, textile / Stoff / textile, EDRA, Italy, 2001

113: **Astriky**, carpet / Teppich / tapis, Directional, USA, 2000

114: Carpets / Teppiche / tapis, Drechsle, Germany, 2003. Lamp pattern / Lampenmuster / motif pour lampe, Art Box, USA, 2003

115: Lamp pattern / Lampenmuster / motif pour lampe, Art Box, USA, 2003. Plastic laminate proposal / Entwurf für Kunststofflaminat / concept pour stratifié, Wilson Art, USA 1998

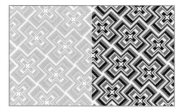

116–117: Ashtray graphic and tile design / Aschenbechermuster und Kacheldesign / graphisme pour cendrier et carrelage, Ritzenhoff, Germany, 1997

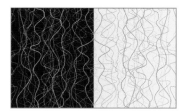

118–119: **Wired**, carpets / Teppiche / tapis, Drechsle, Germany, 2003

120: **Speed**, blanket / Decke / couverture, Frighetto, Italy, 2003

121: Textile / Stoff / textile, Edra, Italy, 2001

122: Carpet / Teppich / tapis, Drechsle, Germany, 2003

123: **Rekon**, pattern / Muster / motif, 2001

 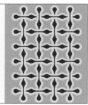 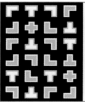 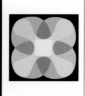

124: **Undul**, carpet / Teppich / tapis, Directional, USA, 1999

125: **Flash**, pattern / Muster / motif, 1997

126: **Freestyle**, custom made carpet / Spezialanfertigung, Teppich / tapis personnalisé, Deitch Projects, NYC, 2000

127: **Konnect**, carpet / Teppich / tapis, Idee, Japan, 1998

128: **Dakis**, concept / Entwurf / concept, 2000

129: **Kaleidoscope**, carpet concept / Teppichentwurf / tapis concept, Roubini Rugs, USA, 2003

130: Concept, bathmat / Entwurf, Badematte / concept, tapis de bains, Step, Turkey, 2004

131: Shower curtain design / Duschvorhangdesign / motif pour rideau de douche, Octopus, Germany, 1998

132: Bathmats / Badematten / tapis de bains, Step, Turkey, 2004

133: **Bleep**, pattern / Muster / motif, 2004

134: **Nebula**, carpet / Teppich / tapis, Roubini Rugs, USA, 2003

135: Lamp pattern / Lampenmuster / motif pour lampe, Art Box, USA, 2003. **Wirebear**, concept / Entwurf / concept, Roubini Rugs, USA, 2003

 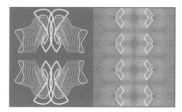

136: **Matriks**, pattern / Muster / motif, 2004

137: Shopping bag / Einkaufstasche / sac pour shopping, Frighetto Milan Fair, Italy, 2003

138: Table pattern / Tischmuster / motif de table, 2004

139: **Infinity**, painting / Gemälde / peinture, Semiramis Hotel, Athens, Greece, 2003

140: **Synth**, pattern / Muster / motif, 2002

141: **Electroclash**, pattern / Muster / motif, 2002

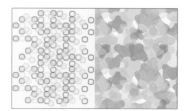 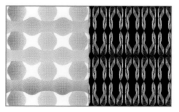 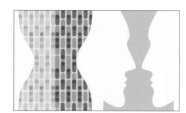

142: Concept, restaurant interior graphics / Entwurf, Grafiken für Restaurantinterieur / concept, graphique pour intérieur de restaurant, Starr, Philadelphia, USA, 2000

143: **Kamouflage**, textile / Textilarbeit / textile, Edra, Italy, 2001

144: **Globalectro**, pattern / Muster / motif, 2004

145: Concept, wall covering / Entwurf, Tapete / concept, tapisserie, Wolf-Gordon, USA, 2002

146–147: **Kosmos**, blocks / Blöcke / blocs, Bozart, USA, 2003

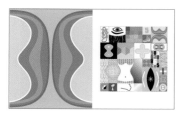

148–149: **Kosmos**, blocks / Blöcke / blocs, Bozart, USA, 2003

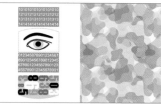

150: **Kosmos**, blocks / Blöcke / blocs, Bozart, USA, 2003

151: **Kamouflage**,textile / Textilarbeit / textile, Edra, Italy, 2001

152: **Plods**,textile / Textilarbeit / textile, Felice Rossi, Italy, 2004

153: **Efemera**, painting / Gemälde / peinture, 2004

154: Laundry hamper pattern, textile / Muster für Wäschekorb, Textil / Motif pour panier à linge, textile, IHW, USA, 2003

155: Concept, carpet / Entwurf, Teppich / concept, tapis, Step, Turkey, 2004

156–157: **Orakami**, textile / Textilarbeit / textile, Label, Holland, 2004

158–159: Carpets / Teppiche / tapis, Step, Turkey, 2004

160–161: Bathmats / Badematten / tapis de bains, Step, Turkey, 2004

162–163: Carpet tile / Teppichfliese / carrelage, Tarkett Sommer, France, 2002

164–165: Concept, carpet tile / Entwurf, Teppichfliese / concept, carrelage, Tarkett Sommer, France, 2002

166–167: Concept, carpet tile / Entwurf, Teppichfliese / concept, carrelage, Tarkett Sommer, France, 2002

168–169: Concept, carpet tile / Entwurf, Teppichfliese / concept, carrelage, Tarkett Sommer, France, 2002

170–171: Concept, carpet tile / Entwurf, Teppichfliese / concept, carrelage, Zanotta, Italy, 1996

172–173: Concept, carpet / Entwurf, Teppich / concept, tapis, Step, Turkey, 2004

174: **Skape**, textile / Textilarbeit / textile, Edra, Italy, 2001

175: **Hitkick**, carpet / Teppich / tapis, Directional, USA, 1999

176: **Bi-Blobs**, conceptual 3D wire frame / konzeptueller 3D-Drahtrahmen / concept encadrement métallique 3-D, 2003

177: **Cyber Couture**, patterns designed with Pia Myrvold / Muster, designt mit Pia Myrvold / motifs, en collaboration avec Pia Myrvold, France, 2002

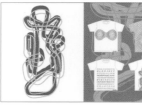

178: **Momo100**, sketch / Skizze / esquisse, Belgium, 1999

179: T-shirts, White Label, Sweden, 2003

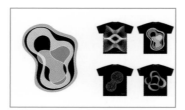

180: **Korgo**, carpet / Teppich / tapis, Step, Turkey, 2004

181: T-shirts, Entrex, Japan 2004. (Top left) **Fear**, T-shirt, Future Design Days, Sweden, 2004

182–183: Flooring / Bodenbelag / revêtement de sol, Nooch Restaurant, Singapore, 2004

184: Concept, vase silkscreen / Entwurf, Vase, Siebdruck / concept, sérigraphie pour vase, Egizia, Italy, 2004

186: Concept, Ottoman textile / Entwurf, Stoff für Ottomane / concept, textile ottoman, Step, Turkey, 2004

188: **Breakin'**, bed wear / Bettwäsche / couvre-lit, Bozart, USA, 2001.
Lamp pattern / Lampenmuster / motif pour lampe, Art Box, USA, 2003

190–191: Concept, textile / Entwurf, Stoff / concept, textile, Felice Rossi, Italy, 2003

192–193: Pattern concepts / Entwürfe für Muster / Motif concepts, 2004

194: Carpet / Teppich / tapis, Step, Turkey, 2004

195: **Fusion**, carpet / Teppich / tapis, Roubini Rugs, USA, 2003. Lamp pattern / Lampenmuster / motif pour lampe, Art Box, USA, 2003

196–197: Lamp pattern / Lampenmuster / motif pour lampe, Art Box, USA, 2003

198: **Square Cross Tunnel**, pattern / Muster / motif 2004

199: **Round Cross Tunnel**, pattern / Muster / motif, 2004

200: **Morphscape Kross**, clock face / Zifferblatt / cadran de pendule, Benza, USA, 1998–2004

201: **Morphscape Figure 8**, pattern, laminate and napkins / Muster, Laminat und Servietten / motif, stratifié et serviettes, Gallery 91, NYC, 2004

202–203: **Hypno**, carpets / Teppiche / tapis, Step, Turkey, 2004

204: Vase silkscreen / Vase, Siebdruck / sérigraphie pour vase, Egizia, Italy 2003. Plastic flooring / Kunststoff-bodenbelag / revêtement de sol, Nooch Restaurant, NYC, 2004

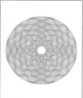

205: **Spiral**, concept / Entwurf / concept, Danese, Italy, 2003

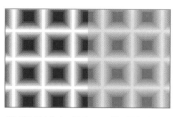

206–207: **21st Century Plaid**, carpet / Teppich / tapis, Roubini Rugs, USA, 2003

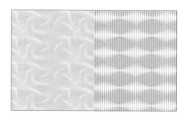

208: **Flexuous2**, pattern / Muster / motif, 2004

209: **Radioactivity**, fabric pattern / Stoffmuster / motif pour tissu, 2003

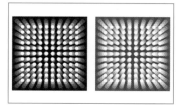

210–211: Lamp pattern / Lampenmuster / Motif pour lampe, Art Box, USA, 2003. Dishware, Vase silkscreen / Geschirr, Vase, Siebdruck / vaisselle, sérigraphie pour vase, Egizia, Italy, 2004

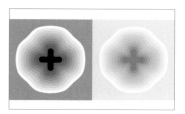

212–213: Concept, carpet / Entwurf, Teppich / concept, tapis, Roubini Rugs, USA, 2003

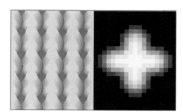

214: Graphic pattern / Grafisches Muster / motif graphique, 2003

215: **Kross**, wall covering / Tapete / tapisserie, Marburg, Germany, 1995–2004

216–217: **Flexuous**, wall covering / Tapete / tapisserie, Wolf-Gordon, USA, 2002

218: **I.R.T.**, carpet / Teppich / tapis, Roubini Rugs, USA, 2003

220: **Digipop**, image / Bild / image, 2003

222: Concept, magazine cover / Entwurf, Zeitschriften-titel / concept, couverture pour magazine, *Form*, Germany, 2003

224–225: **Replicant**, wall covering / Tapete / tapisserie, Wolf-Gordon, USA, 2002

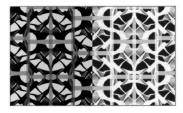

226–227: **Space Frame**, wall covering / Tapete / tapisserie, Wolf-Gordon, USA, 2002

228–229: **Zenith**, wall covering / Tapete / tapisserie, Wolf-Gordon, USA, 2002

230–231: Carpeting / Teppichboden / moquettes, Semiramis Hotel, Athens, Greece, 2003

232–233: Handkerchiefs / Taschentücher / mouchoirs, United Arrow, Japan, 2001

234–235: Concepts, carpets / Entwürfe, Teppiche / concepts, tapis, Roubini Rugs, USA, 2003

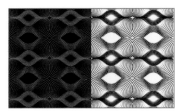

236–237: **Gamma**, carpets / Teppiche / tapis, Roubini Rugs, USA, 2003

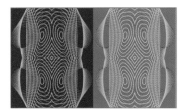

238–239: **Data**, graphic concept / Grafikkonzept / concept graphique, 2003

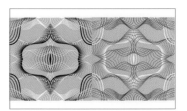

240–241: **Voxel**, carpets / Teppiche / tapis, Roubini Rugs, USA, 2003

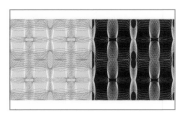

242–243: **Spectra**, carpets / Teppiche / tapis, Roubini Rugs, USA, 2003

244: **Quantum**, carpet / Teppich / tapis, Roubini Rugs, USA, 2003

245: **Rosetta**, wall covering / Tapete / tapisserie, Wolf-Gordon, USA, 2002

246–247: **Myriad**, carpet / Teppich / tapis, Roubini Rugs, USA, 2003

248–249: **5 Senses**, textile / Textilarbeit / textile, EDRA, Italy, 2002

250: Concept, wall covering / Entwurf, Tapete / concept, tapisserie, Marburg, Germany, 2003

251: **E**, font design / Schriftdesign / police de caractères, 2004

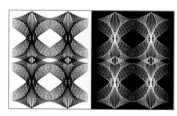

252–253: **Vecto**, carpet / Teppich / tapis, Roubini Rugs, USA, 2003

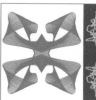
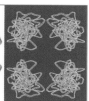

254: Lamp pattern / Lampenmuster / motif pour lampe, Art Box, USA, 2003

255: **Kaos**, concept, wall covering / Entwurf, Tapete / concept, tapisserie, Wolf-Gordon, USA, 2002

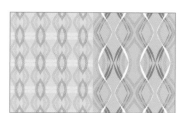

256–257: Concepts, carpets / Entwürfe, Teppiche / concepts, tapis, Roubini Rugs, USA, 2003

258–259: **Flexuous**, pattern variations, wall covering / Mustervariationen, Tapete / variation de motifs, tapisserie, Wolf-Gordon, USA, 2002

Modlobs, textile concept / Stoffentwurf / concept textile, 2003

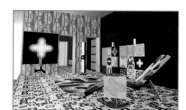

Digitalia, Memphis, Italy, 2003

© 2005 TASCHEN GmbH
Hohenzollernring 53, D-50672 Köln
www.taschen.com

All artwork © Karim Rashid Inc.

Art direction: Karim Rashid, New York
Artwork design team: Yoon Chung, Rui Morisawa / Karim Rashid Inc.
Book design: Stephen Schmidt / Duuplex, San Mateo, CA

Editorial coordination: Simone Philippi, Cologne
Production coordination: Stefan Klatte, Cologne
German translation: Clara Drechsler, Cologne
French translation: Simone Manceau, Paris

Printed in Spain
ISBN 3-8228-3995-7

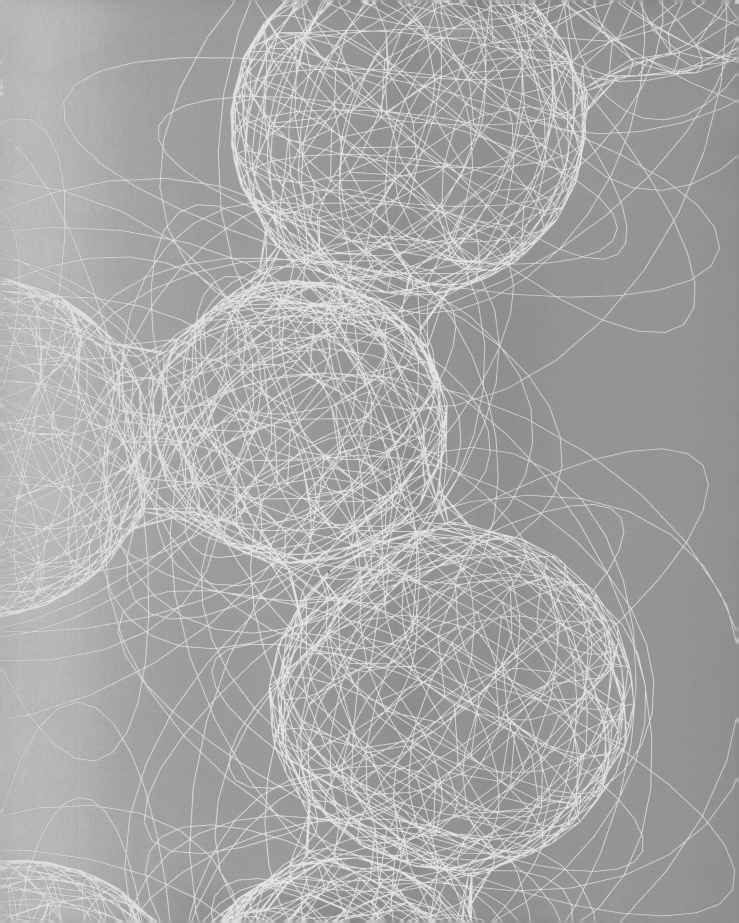